RHYTHMS OF MODERN LIFE

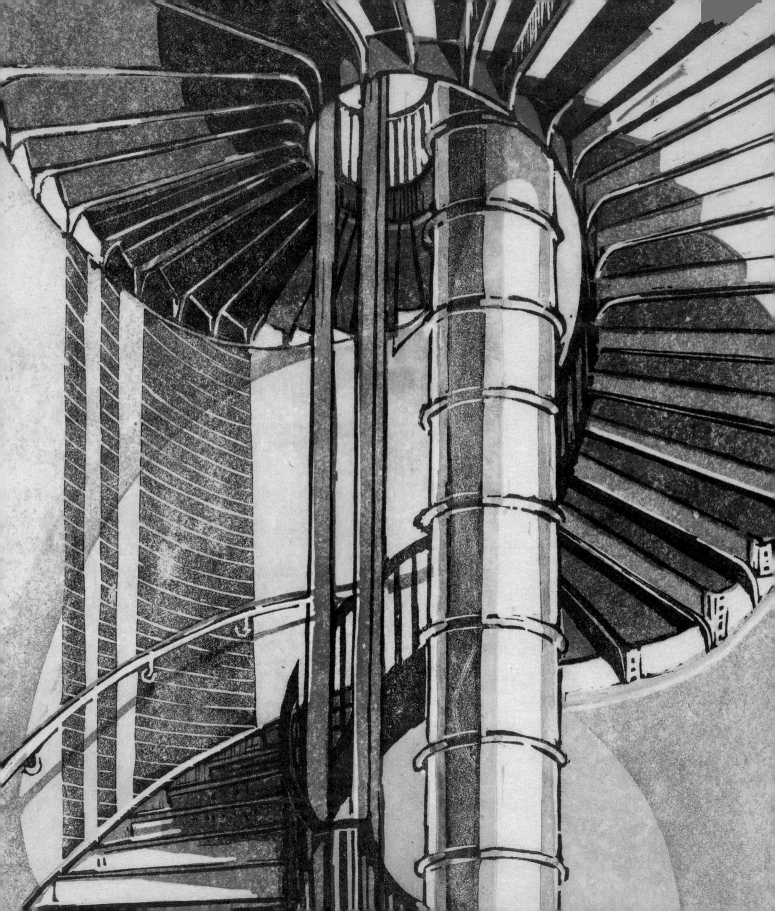

RHYTHMS OF MODERN LIFE

BRITISH PRINTS 1914–1939

EDITED BY CLIFFORD S. ACKLEY

WITH CONTRIBUTIONS BY STEPHEN COPPEL,

SAMANTHA RIPPNER, THOMAS E. RASSIEUR, STEPHANIE LUSSIER, AND RACHEL MUSTALISH

MFA PUBLICATIONS | MUSEUM OF FINE ARTS, BOSTON

CONTENTS

CATALOGUE

WITH SECTION INTRODUCTIONS BY SAMANTHA RIPPNER AND THOMAS E. RASSIEUR

LINOCUT: HISTORY AND TECHNIQUE

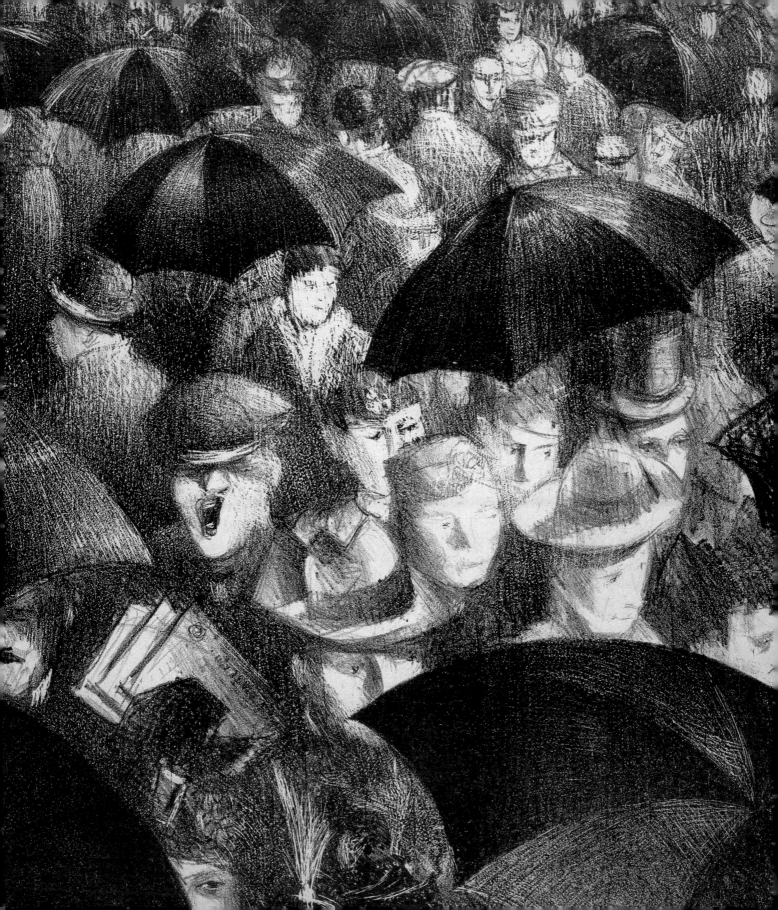

"Rhythms of Modern Life: British Prints 1914–1939," co-organized by the Museum of Fine Arts, Boston, and the Metropolitan Museum of Art, New York, and curated by Clifford S. Ackley with the assistance of Thomas E. Rassieur and Samantha Rippner, introduces the American public to still-unfamiliar facets of early twentieth-century British modernism: creative printmakers who adapted Continental Futurism and Cubism to new forms of abstraction, to the illustration of the first fully mechanized war, and to the portrayal of the hectic energy and vitality of urban life. Their works range from the optically dazzling black and white of Edward Wadsworth to the bold, lively color of the Grosvenor School artists. The inspiration for this exhibition has been the superb collection assembled by Johanna and Leslie Garfield. Our own holdings of these avant-garde British prints are relatively small, and the promised gifts from the Garfields included in the exhibition will transform both museums' collections with works that are full of social and historical resonance and artistic inventiveness. As always, gifts from private collectors are the building blocks of American museum collections, which ensure that such treasured possessions are shared with a broad public.

The third venue of the exhibition, the Wolfsonian-Florida International University, is a singularly appropriate one, because of that unique institution's profound commitment to art and design of the first half of the twentieth century.

Malcolm Rogers
Ann and Graham Gund Director
Museum of Fine Arts, Boston

Philippe de Montebello
Director
The Metropolitan Museum of Art, New York

Our primary debt is to Johanna and Leslie Garfield, whose deep collection of modern British prints was the initial inspiration for this catalogue and the exhibition it accompanies. We are equally grateful to Stephen Coppel of the British Museum, who served as unofficial adviser to the project. We appreciate his sharing of his knowledge of these artists and their prints but absolve him of responsibility for any errors we have made. We would also like to thank Caroline Tavelli-Abar, Curator of the Johanna and Leslie Garfield Collection, who has been integral to the development and realization of this complex project.

The exhibition includes several loans of important works from both public collections and private individuals that are essential to the picture we have constructed of the work of these artists. For their help in securing and organizing these loans, we are indebted to Antony Griffiths and Stephen Coppel of the British Museum; Monique Westra, Barbara Greendale, and Jacqueline Eliasson of the Glenbow Museum; Philippe

de Montebello, George R. Goldner, and Gary Tinterow of the Metropolitan Museum; Marianne Lamonaca and Sarah Schleuning of the Wolfsonian-Florida International University; Amy Meyers and Elisabeth Fairman of the Yale Center for British Art; and a Boston-area private collector. A number of friends and scholars who were not directly involved with this project were nevertheless enormously helpful in offering direction, insights, ideas, and information that helped to shape its evolution: Barbara Stern Shapiro, Mary Ryan, Gordon Cooke, and Gordon Samuel.

At the Museum of Fine Arts, Boston, we extend our thanks to Malcolm Rogers, Ann and Graham Gund Director; Katherine Getchell, Deputy Director; Patrick McMahon, Director of Exhibitions and Design; and Danielle Berger, Manager of Touring Exhibitions, for supporting the exhibition and its tour. In MFA Publications, we are indebted to Mark Polizzotti, who supported the development of this catalogue, and to Sarah McGaughey Tremblay, who worked tirelessly to

ensure the consistency of the text. We are grateful to production manager Terry McAweeney and designer Susan Marsh for creating a bold design that conveys the vitality of the works of art. In Digital Image Resources, we thank Debra LaKind for her enthusiastic support of the exhibition and Damon Beale for his superior photography of the works from both the Garfield Collection and the MFA. Annette Manick, Head of Paper Conservation, answered many of our inquiries concerning the material aspects of the works of art. Gail English, Manager of Exhibition Preparation and Collections Care, and Katherine Sanderson prepared the majority of the works for photography and installation. In Exhibitions and Design, Jamie Roark created a vibrant setting for the works. In Museum Learning and Public Programs, we are indebted to Barbara Martin, Lois Solomon, and Ben Weiss. In External Relations, thanks are due to William McAvoy, Heidi Rosenfeld, and Sara Cofrin. Registrar Helen Connor ably met the demands of various co-organizers, lenders, and venues. In Art of Europe, we thank Marietta Cambareri. In the Department of Prints, Drawings, and Photographs, our gratitude goes to Patrick Murphy, Christine Peterson, and above all Kate Harper, who served as full-time assistant on the project, kept its many parts in dynamic motion, and compiled the checklist and bibliography.

At the Metropolitan Museum of Art, we thank Philippe de Montebello, Director, for supporting the exhibition. We are grateful to George R. Goldner, Drue Heinz Chairman of the Department of Drawings and Prints, for his continuing support of the project and his thoughtful counsel at every step. In the Editorial Department, we would like to thank John P. O'Neill, Editor in Chief and General Manager of Publications, for his careful consideration of the catalogue. We extend our gratitude to Linda Sylling, Manager for Special Exhibitions, Gallery Installations and Design, and Patricia Gilkinson, Assistant Manager for Special Exhibitions and Gallery Installations, for coordinating the complex details of the exhibition's installation. In the Secretary and General Counsel's Office, we are indebted to Rebecca L. Murray, Associate Counsel, and Beth Vrabel, Assistant Counsel. We offer thanks to Martha Deese, Senior Administrator for Exhibitions and International Affairs, for her assistance with various administrative queries. We are indebted to Nina Maruca, Senior Associate Registrar, for overseeing the shipping and packing of the works in the exhibition. In Drawings and Prints, we are grateful to David del Gaizo and Ricky Luna for their expert framing and installation of the exhibition. We also thank Kit Basquin, Elizabeth Zanis, Neal Stimler, and Marilyn Mandel for their dedicated assistance with myriad administrative and organizational duties. In Paper Conservation, our thanks go to Marjorie Shelley, Sherman Fairchild Conservator in Charge, and Samantha Hallman. In the Photograph Studio, we acknowledge the work of Robert Goldman. And, lastly, we are grateful to Erika Mosier, Associate Conservator, and Scott Gerson, Assistant Conservator at the Museum of Modern Art, as well as to Jean Dommermuth, Paintings Conservator and Lecturer at the Institute of Fine Arts, New York University, for their research assistance.

The Authors

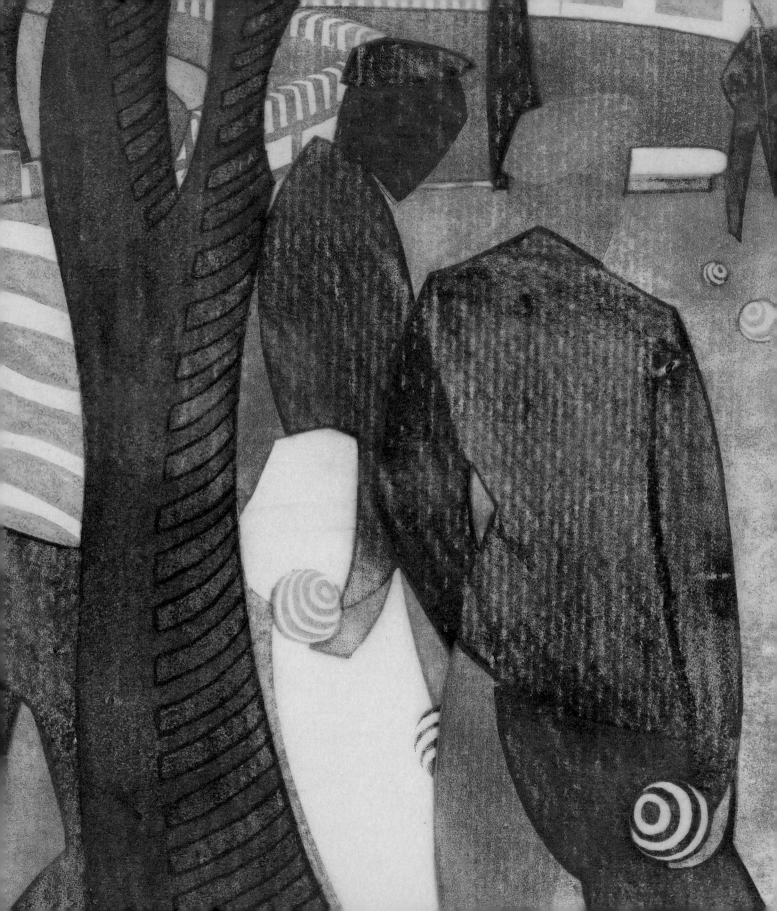

COLLECTING MODERNIST PRINTS:
THE GARFIELDS

My first contact with the collector Leslie Garfield was in September 1994, when I received a letter from him, introducing himself as a print collector in New York and a member of the Acquisitions Committee of the Department of Prints and Illustrated Books at the Museum of Modern Art. He and his wife, Johanna, were coming to London and wanted to see the Grosvenor School prints at the British Museum. Unfortunately, I could not be in the Museum when the Garfields arrived, but all the boxes of Grosvenor School linocuts were made available for them to view in the Print Room. A letter of thanks followed shortly, saying how much they had gained from looking at the British Museum's holdings; an invitation to contact them and see their print collection when I was next in New York was kindly extended to me.

A year later, in September 1995, I was in New York on a quick loan trip for the Museum. My only free time was a Saturday, and Leslie invited me to breakfast at their brownstone house on the Upper East Side. Apart from Grosvenor School linocuts, I had no idea what to expect. The walls of the Garfields' large, comfortable house, I soon discovered, were covered with framed prints. In the kitchen and adjoining rooms was an astonishing collection of German Expressionist prints. Breakfasting on bagels, I looked up to rows of Max Beckmann, Karl Schmidt-Rottluff, and Erich Heckel. Leslie's collecting, I learned, had begun with the purchase of a small Heckel woodcut when he was posted to Germany as a GI in the 1950s. But the German Expressionists had been overtaken by an equally impressive collection of Jasper Johns lithographs that hung in the living room, and some of these were in color. And it was color that now commanded Leslie's attention. The spiral staircase winding up the three floors of the house was ablaze with the color woodcuts of Blanche Lazzell and the Provincetown Printers. In the rooms upstairs were the pick of the color

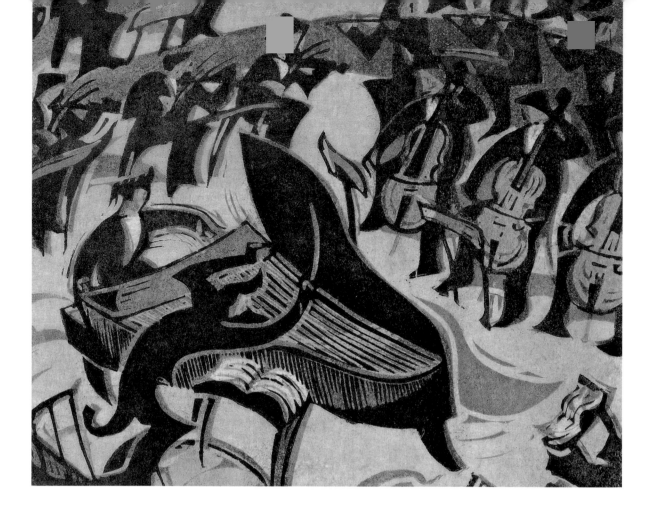

linocuts of Claude Flight, Cyril Power, Sybil Andrews, and Lill Tschudi. Elsewhere hung Vorticist woodcuts by Edward Wadsworth, lithographs and drypoints by C. R. W. Nevinson, as well as lithographs by Paul Nash, all from the period of the First World War and a natural bridge to the Grosvenor School linocuts of the 1920s and '30s. My book on the Grosvenor School was about to be launched in London, and I was excited to see such a fine selection in New York. Indeed, it was unusual to find an American collector who took such an informed and passionate interest in British modernist prints.

In February 1998 I was again in New York, and the Garfields invited me to the Grolier Club to view a small display of color woodcuts by the women artists of Provincetown from their collection. The Garfields' spiral staircase had been temporarily stripped. Leslie was passionate about Blanche Lazzell's prints, and the Grolier Club display was an opportunity to give the Provincetown Printers a preliminary airing to test the viability of mounting a more extensive exhibition. Before too long the Museum of Fine Arts, Boston, became involved, and in January 2002 it launched

"From Paris to Provincetown: Blanche Lazzell and the Color Woodcut," with a fine scholarly catalogue by Barbara Shapiro. In all there were 121 works in the exhibition, of which 85 were by Blanche Lazzell, including a few of her early decorated ceramics and Art Deco hooked rugs. The Lazzell woodcuts were supplemented by those of her Provincetown contemporaries, including Ada Gilmore Chaffee, Edna Boies Hopkins, Ethel Mars, Maude Hunt Squire, and Grace Martin Taylor, and nearly all the works came from the Garfields' collection. In rehabilitating these formerly overlooked American women modernists, the exhibition proved an outstanding success; in the course of 2002, it traveled to the Cleveland Museum of Art in Ohio and then to the Elvehjem Museum of Art at the University of Wisconsin-Madison, the alma mater of both Leslie and Johanna.

Shortly before "From Paris to Provincetown" moved to Cleveland in May 2002, the Garfields were back in London for a brief visit. They came to see an exhibition I had prepared at the British Museum of Richard Hamilton's illustrations to James Joyce's *Ulysses*, a project begun in the late 1940s that has preoccupied the artist on and off for the last sixty years. "Imaging Ulysses" proved to be an epiphany for the Garfields. Leslie immediately began to collect Richard Hamilton prints with an unstoppable enthusiasm. At the beginning of 2002, he had not owned any of Hamilton's

prints; by 2005, he had acquired more than fifty. This tenacious pursuit of prints by an artist who has gripped his imagination is characteristic of Leslie's collecting, which he calls his "disease."

British prints, both modern and contemporary, are a major focus of the Garfields' collection, which ranges from the First World War to the Young British Artists of today. No other collector in the United States has continued to pursue this area with as much energy and single-mindedness. Long before the current high visibility of contemporary British art, the Garfields were collecting British avant-garde prints, at a time when American museums were generally reluctant to acquire them. British modernist artists were perceived as standing outside the mainstream of European modernism represented by the School of Paris, German Expressionism, and the Russian avant-garde. This at last is changing. Thanks to the Garfields' independent vision, the wider American public will now have an opportunity to see the expressive vitality of British printmaking, from the First World War to the urban dynamism of the interwar years, in the work of some of its finest artists.

Stephen Coppel
Curator of the Modern Collection
Department of Prints and Drawings
The British Museum

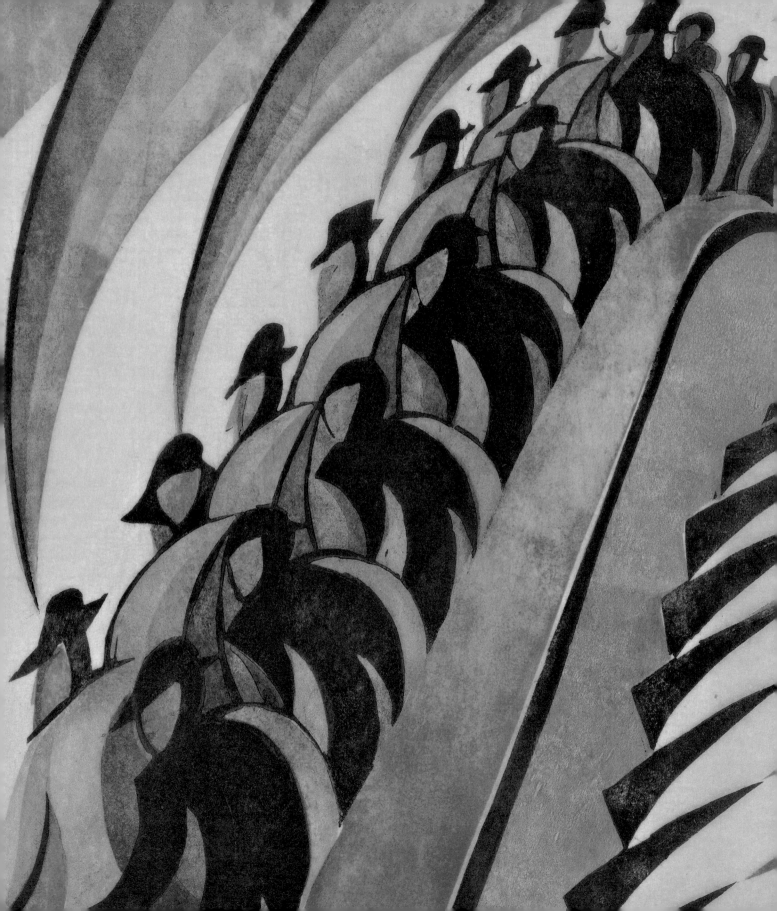

CLIFFORD S. ACKLEY

Motor-omnibuses passing and re-passing in the crowded streets, covered with letters, red, green, white, are far more beautiful than the canvases of Leonardo or Titian.

GINO SEVERINI[1]

Between the outbreak of World War I in 1914 and Britain's entry into World War II in 1939, a number of British printmakers created bold new works that reflect, whether directly or indirectly, pioneering art movements imported from the Continent, such as Italian Futurism or French Cubism. This catalogue traces these artists' responses to radical modernism, from Edward Wadsworth's austere, highly abstract woodcuts, through C. R. W. Nevinson's adaptation of Futurism to the illustration of the bleakness of the first mechanized war, to the Grosvenor School linocut artists' "Pop" Futurism with its colorful renditions of modern urban life. This selective survey of these prints is organized thematically, rather than chronologically, so as to focus more intensely on subject matter and stylistic directions (abstraction, speed and motion, urban life) that particularly engaged these artists. It tells the story of how the 1910–14 invasion of Continental modernist styles produced the British avant-garde reaction of Vorticism and, later, the absorption and recycling of modernism in works aimed at a broader audience — works representing a between-the-wars, streamlined fusion of traditional representation and the spirit of the new.

British Printmaking: Futurism and Vorticism

The prewar years 1910–14 in London were a time of transition from a complacent but moribund old world order to a new, vital, but often confusing one. They also represented a period of heady artistic ferment. Exhibitions

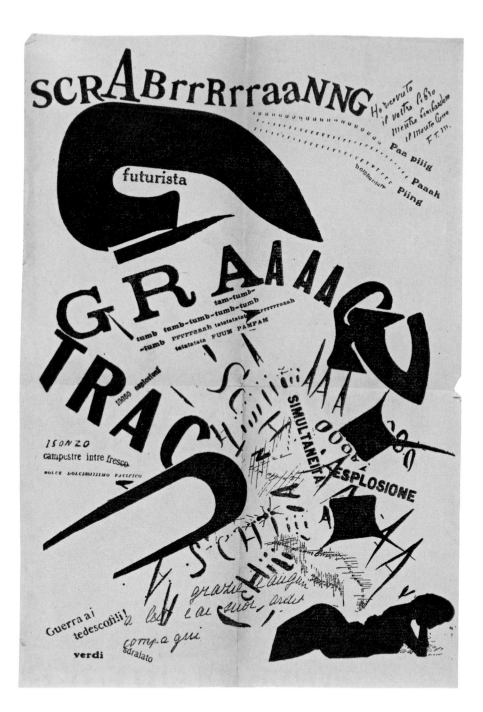

Figure 1. Filippo Tommaso Marinetti (Italian, 1878–1944), "In the evening, in her bed, she reread the letter from her artilleryman at the front," 1917, fold-out page published in *Les mots en liberté futuristes* (Futurist Words-in-Freedom) (Milan: Edizioni futuriste di "Poesia," 1919), 19.2 x 12.7 cm (7⁹⁄₁₆ x 5 in.), Museum of Fine Arts, Boston, Gift of Elmar W. Seibel, 1984.800

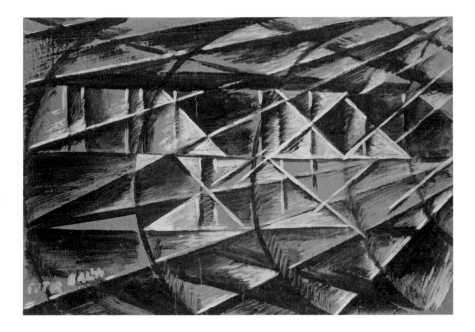

Figure 2. Giacomo Balla (Italian, 1871–1958), *Study of the Materiality of Light and Speed*, 1913, opaque watercolor on gold leaf paper, 27.9 x 41.8 cm (11 x 16⁷⁄₁₆ in.), Museum of Fine Arts, Boston, Bequest of Betty Bartlett McAndrew, 1986.492

of Post-Impressionism, such as critic Roger Fry's very French *Manet and the Post-Impressionists* (1910–11) and his second, more international Post-Impressionist survey (1912–13), as well as the two Futurist exhibitions of 1912 and 1914 — among many other groundbreaking shows — introduced the British art world to Continental modernism in all its startling and frequently bewildering variations, including Cubism, German Expressionism, Cézanne, Picasso, Matisse, Kandinsky, and Brancusi. The excitement and cultural debate generated by these revelatory exhibitions were not unlike the sensation created by New York's 1913 Armory Show, which introduced European modernism to America. Even more attention-getting for London's cultural audience were the public lectures and dramatic recitations of

Futurist verse by the radical poet — and self-appointed prophet of Italian Futurism — F. T. Marinetti in 1910 and 1914. On the printed page, Marinetti's poems, or "words-in-freedom," often assumed wildly unconventional visual forms (fig. 1).

Marinetti's published manifestos of 1909 and 1910 actually preceded the creation of canvases and sculptures by leading Italian Futurist artists such as Giacomo Balla and Umberto Boccioni. These artists conceived of the world as in a constant state of flux, as ceaseless dynamic movement. Much of their imagery focuses on modern urban life, the machine (automobiles, trains, airplanes), speed, and locomotion. Conventional, rationally constructed space dissolves, and solid forms become transparent, interpenetrating one

another. One might broadly characterize the style as Cubism in motion. Stylized lines of force give intangible dynamic elements such as light and motion a more concrete material existence (fig. 2). Marinetti regarded London as the ideal Futurist city, perhaps because of its vast scale, dense population, bustling street life, and many new mechanical means of transportation.

The only artist included here who officially allied himself with Futurism is C. R. W. Nevinson, who even assisted at one of Marinetti's performances by rhythmically beating a drum behind the scenes as the poet energetically declaimed. Nevinson, who was also close to the Italian Futurist painter Gino Severini, took the Futurist style to the battlefields and created a new style of illustration suitable for portraying the first mechanized war. With its relentlessly trudging French soldiers and transparent, overlapping planes, the drypoint *Returning to the Trenches* (cat. no. 19), of 1916, is the nearest approach to a pure Futurist work in the present selection. Nevinson's postwar images of New York and London, made at a time when he was losing faith in radical modernism, were still tinged with a Cubist or Futurist vision of space and rhythmic pattern.

Other British artists confronted Italian Futurism but then developed their own radically abstract geometric style as a reaction against it: Vorticism. The leader of the Vorticists was the fiery, temperamental writer and painter Wyndham Lewis (1882–1957), who made no original prints. The Vorticist style in its purest form essentially lasted just a brief two years, 1914 to 1915: the years in which the only two issues of the explosively titled Vorticist magazine *BLAST* appeared. *BLAST No. 1* featured bold, poster-like typography in its opening manifesto section that was as innovative and influential as its illustrations (cat. no. 11). Inspired in its aggressive, declamatory rhetoric by Marinetti's style, *BLAST*'s manifesto with sublime inconsistency outrageously "blasted" and "blessed" various aspects of England's weather, culture, industry, and public figures in order to provoke and energize an audience presumed to be complacent or asleep.

Wyndham Lewis was briefly associated with Roger Fry's Omega Workshops, which produced decorative arts such as draperies, rugs, screens, and painted furniture in a somewhat soft, watered-down version of French modernism inspired by Matisse and Cubism. Lewis regarded his own aggressive, hard, angular, assertively masculine style as fiercely opposed to this rather ingratiating, more feminine style created by Fry and the artists who were the cultivated, pacifist citizens of "Bloomsbury." The two art czars, Fry and Lewis, came to a violent parting of the ways, and the Vorticist movement was born.

The confusing name "Vorticism" was proposed in 1913 by Lewis's colleague the American expatriate poet Ezra Pound. Rather than suggesting whirlpool-like motion, as in Cyril Power's later linocut *The Vortex* (1929, cat. no. 16), a virtual caricature of the conventional meaning of the term, Pound and Lewis's "Vortex" referred to the *still* point of concentrated energy at the eye of the storm. Vorticism rejected the restless fluidity and dynamism of Futurism in favor of a hard, mecha-

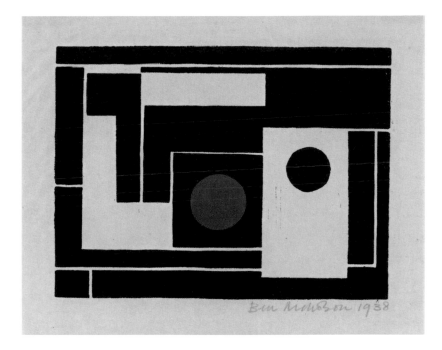

Figure 3. Ben Nicholson (English, 1894–1982), *Abstract with Red Circle*, 1938, color linocut, 13.7 x 18.4 cm (5⁵⁄₁₆ x 7¼ in.), Museum of Fine Arts, Boston, Lee M. Friedman Fund, 1984.175

nistic clarity and precision that evokes architectural and engineering drawings.

The purest examples of Vorticist style to be seen here are the small-scale woodcuts of Edward Wadsworth, son of a mill owner from England's Black Country, the northern coal-mining district. Wadsworth had studied mechanical draftsmanship in Munich and was exposed at the same time to the aesthetic of the modern German woodcut. It is a cliché of the modern or Expressionist woodcut, from Edvard Munch and the 1890s on, that such prints should characteristically exploit the texture and patterns of the wood grain itself. Wadsworth rejected this "romantic" approach to materials, emphasizing smooth, unbroken planes and absolute, sharp-edged precision in the cutting of his blocks. His prints do not have a handmade look. In this, he may have followed the lead of his artistic hero, the Russian-born artist Wassily Kandinsky, active in Munich, whose woodcuts seldom emphasize the grain of the wood. As Wadsworth stated, "woodcut appeals because it leaves nothing to accident."[2] His woodcuts often have a Cubist-related spatial ambiguity and a staccato rhythm of patterning that presages the Op Art of the early 1960s. Even though his editions were quite small, Wadsworth sometimes experimented with creative variations from impression to impression, printing on different colored papers or inking his blocks with diverse combinations of colors. His

woodcut *Illustration (Typhoon)* (cat. no. 10), inspired by a passage in a Joseph Conrad novel describing ship's architecture, is a perfect example of pure Vorticist style in its hard geometric purity and layered asymmetrical complexity. Because so many of the large-scale Vorticist paintings have been lost, Wadsworth's elegant early woodcuts, published in quite small editions, are today important surviving documents of this radically abstract, uniquely British style.

The Vorticist concept of the human figure was often a fusion of man and machine, exemplified by the artillerymen of Wyndham Lewis's drawing *Before Antwerp,* which was reproduced on the cover of the 1915 *War Number* of BLAST (cat. no. 12). Soldier and rifle are one, the perfect mating of man and mechanism, as in the notorious *Rock Drill* sculpture of 1913–15 by Jacob Epstein (1880–1959), one of two innovative figurative sculptors closely associated with the Vorticist movement, the other being Henri Gaudier-Brzeska. Other examples of Vorticist figures closer to inanimate matter than flesh are Wadsworth's mysteriously crystalline, bird-like *Street Singers* (cat. no. 2) and David Bomberg's rigid dancing stick figures in the color lithographic illustrations to his poetic booklet of 1919, *Russian Ballet* (cat. nos. 4–5).

The disruptions of the war signaled the end of the heyday of Vorticism. Brief as it was, Vorticism was the first radically modern, inherently abstract British art movement. Not until the 1930s, with the work of artists such as Ben Nicholson (fig. 3) and Henry Moore, would pure abstraction again take the lead.

Printmakers on the Battlefield: World War I

F. T. Marinetti advocated war as "hygiene," as the violent purging and cleansing of the old and decadent in favor of the new and vital. While his British Futurist follower Nevinson initially advocated similar attitudes, when exposed firsthand to the brutality of the first mechanized war he acknowledged in his images its grim reality. In Nevinson's 1916 drypoints, anonymous troops — massed cannon fodder — march in formation toward the front, arrowing toward an unknown future. In the 1918 lithograph *The Road from Arras to Bapaume* (cat. no. 17), ant-like convoys in an endless ribbon traverse a bleak, wasted landscape. Nevinson's printed war images are generally creative variations in reverse of his paintings. Their identity as original prints is underlined, however, by the artist's aggressive attack on the printing surface, whether scratching directly into the copper of the printing plate with the drypoint needle or scraping out lighter lines and areas from dense crayon work in the lithographs.[3] When exhibited at the time, Nevinson's modified application of Futurist and Cubist design principles to the illustration of a new, less heroic kind of mechanized war was surprisingly successful with a public that grasped the relevance of a modern style to a modern war.

Both Nevinson and Paul Nash served as government-sponsored official war artists. Nash's art was transformed by his battlefield experience. His earlier landscapes were part of a lyrical English pastoral tradition, but his startling war lithographs recording the new

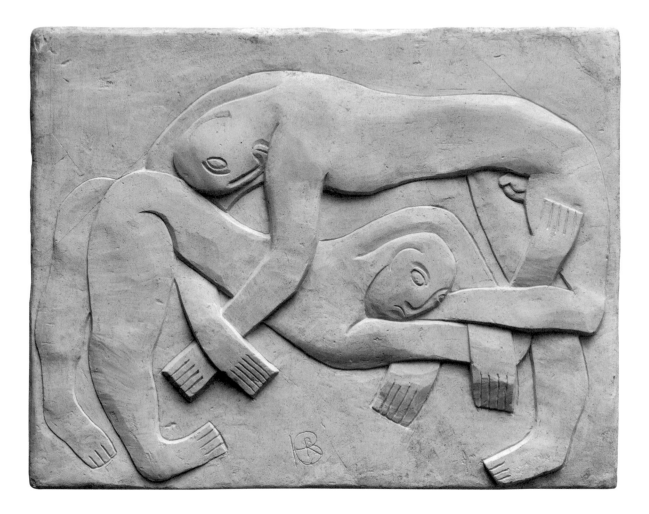

Figure 4. Henri Gaudier-Brzeska,
Wrestlers, 1914, cast plaster, 71.8 x 92.1
cm (28¼ x 36¼ in.), Museum of Fine Arts,
Boston, Otis Norcross Fund, 65.1683.1

landscape, or moonscape, of splintered trees, bomb craters, and mud and rain present us with a haunted terrain never before seen, the product of the new technological violence. Like Nevinson, Nash made extensive use of scraping to model the contours of the tortured earth or to define streaks of rain. Images such as these by Nash, or Nevinson's 1918 lithograph of a large and grotesquely ominous tethered observation balloon (cat. no. 22), depict a literally surreal world that anticipates the later imaginative flights of the literary and visual Surrealists of the 1920s and '30s.

The innovative use of flying machines as weapons in World War I introduced aerial perspectives that encouraged new abstract visions. Nevinson's aviation lithographs from the collective propaganda portfolio *The Great War: Britain's Efforts and Ideals* embody some of the machine euphoria of Futurism. Edward Wadsworth's Vorticist woodcut abstractions were similarly stimulated in part by his exposure to the mosaic patterns of aerial photographs while serving as a naval intelligence officer.

Wadsworth's period as a supervisor of the wartime program for the camouflaging of ships (the so-called Dazzle Ships) in the Liverpool dry docks inspired his somewhat larger-scale woodcuts of 1917 and 1918, which are among the greatest achievements of early twentieth-century English graphic art. In these, there are no intermediate gray tones: absolute black and white produce a vibrant optical dynamism that mimics the camouflage program itself. The underlying image is now much more literal and realistic in conception than in Wadsworth's earlier woodcuts, but it is constantly undercut and dissolved visually by the counterpoint provided by abstract patternings.

One of the most artistically tragic consequences of the war was the death in action of a gifted twenty-three-year-old French-born sculptor allied with the Vorticists. Henri Gaudier-Brzeska's death was announced in the 1915 *War Number* of *BLAST,* the same issue that contained a Vortex prose poem by the sculptor inspired by his experience of trench warfare. His friend Horace Brodzky (1885–1969) had previously encouraged him to try the new printmaking medium of linocut. Printed posthumously by Brodzky, Gaudier-Brzeska's black-and-white linocut *Wrestlers* (cat. no. 1), of 1914, was the first major British modernist work in this very new and very accessible technique. The design, in which grappling figures are conceived of as flat, interwoven ribbons, was based on Gaudier-Brzeska's plaster relief of the subject (fig. 4). The print has a curvaceous fluidity appropriate to the soft, easily carved material, which would be exploited more fully by Claude Flight and the Grosvenor School artists in the 1920s and '30s.

The Grosvenor School Linocut:
Handmade in the Machine Age

The linoleum cut, a modern block print medium with a relatively brief and discontinuous history, finally found a point of dynamic focus in the prints of Flight and his principal pupils: Cyril Power, Sybil Andrews, and

the Swiss artist Lill Tschudi. In 1926, Flight joined the faculty of London's Grosvenor School of Modern Art, a private institution founded in 1925, where he began to introduce students to his highly individual approach to the linocut medium. Although he had made linocuts in a more conventional, representational style as early as 1919, his first linocut in a distinctly modern style dates from 1921. *Swing-Boats* (cat. no. 34) was made that year and was soon followed by prints such as *Speed* (1922, cat. no. 46). Both of these images reveal a Futurist-related preoccupation with speed and the machine, one of the central themes of the Grosvenor School artists included here.[4] Other early works by Flight such as *Street Singers* (cat. no. 3), of 1925, and *Spring* (cat. no. 95), of 1926, testify to a fascination with pure abstraction that resonates with Vorticist design principles and show the artist's characteristic obsession with concentric curvilinear forms. Flight's devotion to the linocut medium, and his fervent desire to convert others to its use, is apparent in his authoring of two introductory manuals, *Lino-Cuts: A Hand-Book of Linoleum-Cut Colour Printing* (1927, American edition 1928) and *The Art and Craft of Lino Cutting and Printing* (1934).

Flight regarded the relatively virgin medium of linocut as eminently suitable to expressing thoroughly modern ideas. He believed that because it encouraged simplification and stylization of imagery, it also encouraged personal expression, all of which he considered significant aspects of truly modern art. Flight identified the linocut's beginnings with its use in early twentieth-century Vienna by the Czech artist Franz Cižek (1865–1946). Because of its ease of execution, cheapness, and accessibility, Cižek regarded the medium as an ideal means of introducing children to modern design and personal expression. A fascination with the directness and purity of expression of children's art is one of the characteristic aspects of early twentieth-century modernism.

The late nineteenth and early twentieth century had seen an international movement devoted to the decorative color block print. All of these works, whether by Emil Orlik in Munich or Blanche Lazzell in Provincetown, ultimately owe their existence to the West's discovery of the Japanese color woodblock print in the mid-nineteenth century. Although Flight acknowledged the Japanese print as the ultimate ancestor of his color linocuts, he rejected the Anglo-Japanese woodcuts of artists such as Frank Morley Fletcher (fig. 5) as being too imitative of earlier Japanese prints in design and technique and insufficiently modern in style and image.

Flight rejoiced in the fact that the linocut was not hampered by the weight of artistic tradition, that it brought with it no baggage of style or subject matter, no Rembrandts, leaving the artist free to express fresh ideas and fresh imagery. He firmly believed in the early twentieth-century gospel of truth to materials: a linocut should look like a linocut; it should not be too large in size or too complicated in design. It should be built up by the "superimposition of flat masses of colour and lines."[5] In fact, he recommended the abandonment of the key block, the line block that traditionally served to unify a multicolor block print by providing the major

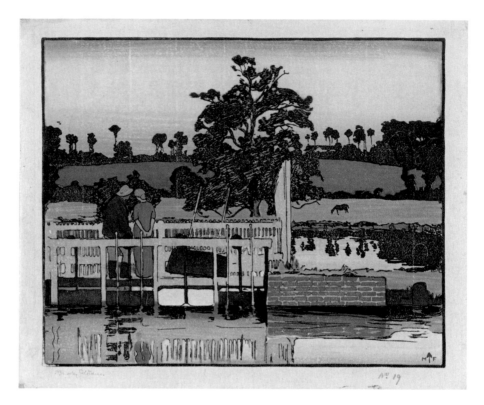

Figure 5. Frank Morley Fletcher (English, 1866–1949), *Flood Gates,* 1899, color woodcut, 20 x 25.5 cm (7⅞ x 10 1/16 in.), Museum of Fine Arts, Boston, Museum purchase with general funds, 1899, M15196

elements and details of the design. Flight rejected this device in favor of the gradual buildup of the image by the overlaying of successive blocks, each providing broad areas of tone and color as well as detail. Some of his early linocuts, such as *Swing-Boats* and *Speed* (cat. nos. 34 and 46), did, however, still show a reliance on the armature provided by a key block.

Flight saw the decorative color linocut as a means of educating a wider audience about modern art and design and introducing them to explicitly modern imagery. He rather idealistically (and unrealistically) conceived that the linocut, intentionally scaled to mod-

est living quarters, would also be priced in accordance with a working man's means — the price of a beer or a cinema ticket. As Stephen Coppel has pointed out, the actual selling price was rather above and beyond the average working man's budget.[6] But Flight's democratic, or socialist, intentions are fully in tune with a Depression-era concern for the spiritual as well as the bare subsistence needs of the common man. In a similar vein, Flight proposed the idea of "libraries" of standard-size original linocuts (with standard mounts and frames) that could be made available to schools and to the general public.

Flight's interest in interior decoration extended beyond the linocut print itself. He described in his first manual how linocuts could be used for printing patterns on textiles. Together with his companion, textile artist Edith Lawrence, he set up an interior decoration business that provided coordinated modern schemes of decoration, including draperies, painted screens, and linocut prints. Swiss artist Lill Tschudi, who was from a textile-producing area, sometimes printed her designs on cloth for use as cushions (see the two larger-scale, wide-format, black-and-white designs from 1935, *Tour de Suisse* and *Jazz Orchestra,* cat. nos. 70 and 87). This is yet another example of these artists' desire to make the linocut an integral part of daily life.

The Grosvenor School linocuts are very much part of a between-the-wars, "modernistic" phase of modern art that blends traditional representation and modern design. An artistic landmark of this period was the 1925 Paris exhibition "L'Exposition Internationale des Arts Décoratifs et Industriels Modernes," which showcased international decorative arts in what would come to be known as the Art Deco style. Part of the conservative "return to order" after the stylistic extremes that modernism had attained in the second decade of the twentieth century, artists of the Art Deco movement produced decorative art objects that married traditional forms and functions with sleekly up-to-date modern lines and surface decoration. Equally international, and of great social impact, was the concurrent economic downturn signaled in England by postwar inflation and in America by the stock market crash of 1929. One response to the economic downturn was the streamlining of commercial products such as kitchen appliances, radios, and automobiles in an effort to stimulate the economy and create new hope for the future. The Grosvenor School linocuts are one facet of this popular movement to accommodate modernism to mass taste. Even when their imagery is laced with irony, as in a few of Cyril Power's linocuts, the decorative impact of their stylized design and vibrant color still lends them a distinctly positive energy.

The representation of Grosvenor School linocuts in this catalogue is by intent selective rather than fully inclusive, so as to focus more closely on certain artists and certain modern themes. The spotlight is on the four principal artists (Flight, Power, Andrews, and Tschudi), excluding the several Australian adherents of the school. Also absent are the later works of Sybil Andrews (after her parting from Cyril Power in 1938 and her immigration to Canada in 1947) and those of Lill Tschudi, whose prints from the second half of the twentieth century are sometimes wholly abstract and painterly in character. The traditional religious subjects by Power (fig. 6), and the many more by Andrews, have also been omitted. Additionally, it should be noted that the printmakers of the Grosvenor School did not always confine themselves to the medium of linocut: early monochromatic etchings by Andrews provide an interesting comparison in their space and rhythmic patterning with her later linocuts (fig. 7), and Power's unique painterly monotypes of urban subjects parallel his linocuts in design (fig. 8).

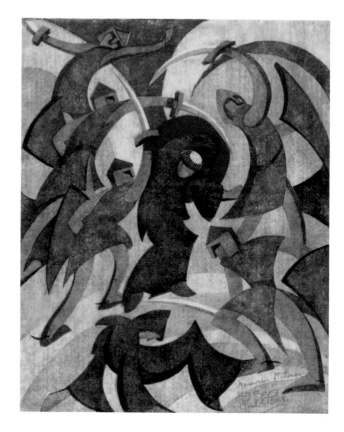

Figure 6. Cyril E. Power, *Monseigneur St. Thomas (Assassination of St. Thomas Becket)*, 1931, color linocut, 35.8 x 28.3 cm (14⅛ x 11⅛ in.), Private Collection

Figure 7. Sybil Andrews, *Pickle Herring Street, Southwark*, 1923–29, etching, 30.2 x 20.1 cm (11⅞ x 7¹⁵⁄₁₆ in.), Private Collection

Figure 8. Cyril E. Power, *London Flats No. 1*, 1930s, color monotype, 27.8 x 20.1 cm (10¹⁵⁄₁₆ x 7¹⁵⁄₁₆ in.), Thomas E. Rassieur Collection

It is risky to generalize about the shared character-istics of such distinct artistic personalities as Flight, Power, Andrews, and Tschudi. But all four of the prin-cipal Grosvenor School artists do acknowledge in their images the accelerated pace of modern life. All also suggest by the blank, generic character of their figures the growing anonymity of that life. Flight, Power, and Andrews in particular reflect the period's obsession with speed, speed trials, and speed records. Closely associated personally, Power and Andrews both make extensive use of abstract curves and dizzily repeated rhythmic patterns in order to more emphatically evoke violent motion. Their human figures are often elastically warped, stretched, and distorted by the movements they are caught up in. Power, however, has in his work a vein of satire and irony toward modern urban life that is not shared by Andrews. Andrews was particularly fas-cinated by the energies, exertions, and repetitive pat-terns of physical labor. With her additional exposure to Cubist-inspired teachers such as Fernand Léger and

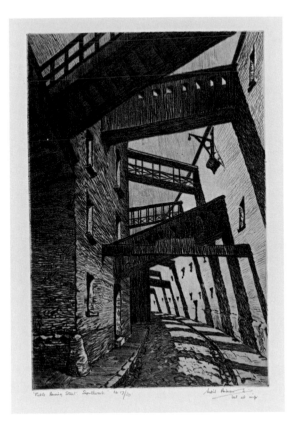

André Lhote, Tschudi stands somewhat apart from her British colleagues. Her favored forms are often more geometric than curvilinear, and her rhythms are gentler and frequently have a jazzy, Art Deco flavor. Flight, the most abstract of the group, suffered a terrible loss of his work (and all of his blocks) when his studio was bombed in 1941.

These artists did, however, share certain Flight-inspired habits regarding the printing and editioning of their work. Stressing the simplicity of the linocut medium, Flight suggested limiting the blocks to three or four, with one color per block (see Andrews's four *Speedway* blocks, cat. nos. 104–107). This approach was in reality not so simple, because additional colors were produced by the skillful overlapping and optical mixing of transparent colors during printing. Though Flight accused the Anglo-Japanese color woodcut artists of being burdened by complicated and laborious printing techniques, Grosvenor School hand printing by hand rubbing from the back of the sheet was in fact

complex, sophisticated, and labor intensive. In spite of the mechanistic imagery of many of the group's prints, Flight disdained press printing as far too mechanical and unfeeling.

The Grosvenor School linocutters generally used a thin, but strong, Japanese paper for printing. Rubbing from the back was performed with a Japanese printing tool called a *baren* (a wooden disk wrapped in bamboo leaves), the back of a spoon, or, for finer nuances, fingers. Skillful manipulation and variations in pressure achieved subtle gradations of color and tone or unusual textures. Flight, especially, exploited the translucency of the Japanese paper, often backing his impressions with colored or painted papers that show through from below and subtly transform the tonality or color of the whole image.

These printmakers usually defined the limits of their linocut images by means of a crisply cut white borderline. This white line served as a guide for the overmatting of the image. In most impressions, random traces of hand printing extend beyond this borderline (see cat. no. 33, where a whole sheet is reproduced). Collectors today — captivated by the artistic process and the concept of the sheet of paper itself as a material object — are often tempted to mat these prints so that the whole sheet is visible. However, such emphasis on the messy edges of the printing and the paper itself tends to flatten out and decompress the stylized spaces and tensions that the artists so carefully created.

Many painstakingly annotated, and very collectible, trial impressions called Experimental Proofs document the evolution of the artists' designs. In a comparison between the Experimental Proof for *Speed Trial* and an impression from the edition (cat. nos. 31–32), one sees how Cyril Power accelerated the speed of, and airflow around, Malcolm Campbell's test car, *Bluebird*. Proposed editions generally ran to fifty or sixty prints, but as they were printed to order, edition numbers were often ideal projected ones rather than fully completed runs. There were also sometimes separate edition runs intended for the United States or Australia. Because a great deal of time often elapsed between printings, and in order that an edition remain reasonably consistent in appearance, the artists kept careful printing notes regarding the sequencing of blocks and colors. Nevertheless, some degree of individual variation from impression to impression was welcomed. The linocutters also conspicuously inscribed each impression by hand, sometimes — especially in the case of Power and Andrews — weaving the signatures, titles, and edition numbers into the image itself. Such practices further contributed to the individual character of prints that were lovingly handcrafted in an era of mechanization and mass production.

The Grosvenor School linocutters, together with Wadsworth, Nevinson, Nash, and the other artists surveyed here, represent a unique and vibrant moment in British modernism. From 1914 to 1939, these printmakers' personal transformations of Futurism and Cubism captured the thrusting, vertiginous, or syncopated rhythms of the modern world, whether in the desolate

no-man's-lands of the Great War or in the accelerated pace of later speed trials, urban transport, or sporting competitions. It is a brave new energized world in which the machine dominates and anonymous figures are swept up in regimented movement, a world of jazzy animation in which velocity is irresistible as well as exhilarating.

This introduction is deeply indebted to Stephen Coppel's definitive publication on the Grosvenor School linocuts, *Linocuts of the Machine Age: Claude Flight and the Grosvenor School* (Hants, England: Scolar Press in association with the National Gallery of Australia, 1995); Richard Cork's various publications on Vorticism, especially *Vorticism and Abstract Art in the First Machine Age*, 2 vols. (Berkeley: University of California Press, 1976); and the British Museum's catalogue of British avant-garde printmakers by Frances Carey, Antony Griffiths, and Stephen Coppel, *Avant-Garde British Printmaking, 1914–1960*, exh. cat. (London: British Museum Publications, 1990).

1. Gino Severini, the Italian Futurist painter's defense of the Futurist vision in response to the negative public reaction to his 1913 one-man show at London's Marlborough Gallery, as published April 11, 1913, in the *Daily Express* newspaper under the headline "Get Inside the Picture: Futurism as the Artist Sees It." Reproduced in Anne Coffin Hanson, *Severini futurista: 1912–1917*, exh. cat. (New Haven, CT: Yale University Press, 1995), 37, fig. 11. Severini here implies that urban imagery is the new Nature.

2. Edward Wadsworth to John Quinn, July 27, 1917, cited in Barbara Wadsworth, *Edward Wadsworth: A Painter's Life* (Wilton, England: Michael Russell, 1989), 73.

3. Nevinson's teacher in lithography was Ernest Jackson, who advocated lithography as an expressive original art medium as opposed to its then more common reputation as a commercial reproductive medium. See J. G. P. Delaney, "F. Ernest Jackson: Draughtsman and Lithographer," *Apollo*, May 1987, 338–43.

4. Paralleling this obsession with speed and movement are contemporary developments in film and photography, including the newsreel and stop-action photography. Russian filmmaker Dziga Vertov's poetic film montage exploring the dynamism of human and mechanical movement in urban environments, *Man with a Movie Camera*, dates from 1929.

5. Claude Flight, *Lino-Cuts: A Hand-Book of Linoleum-Cut Colour Printing* (London: J. Lane, The Bodley Head, 1927), 12.

6. Coppel, *Linocuts of the Machine Age*, 19.

CATALOGUE

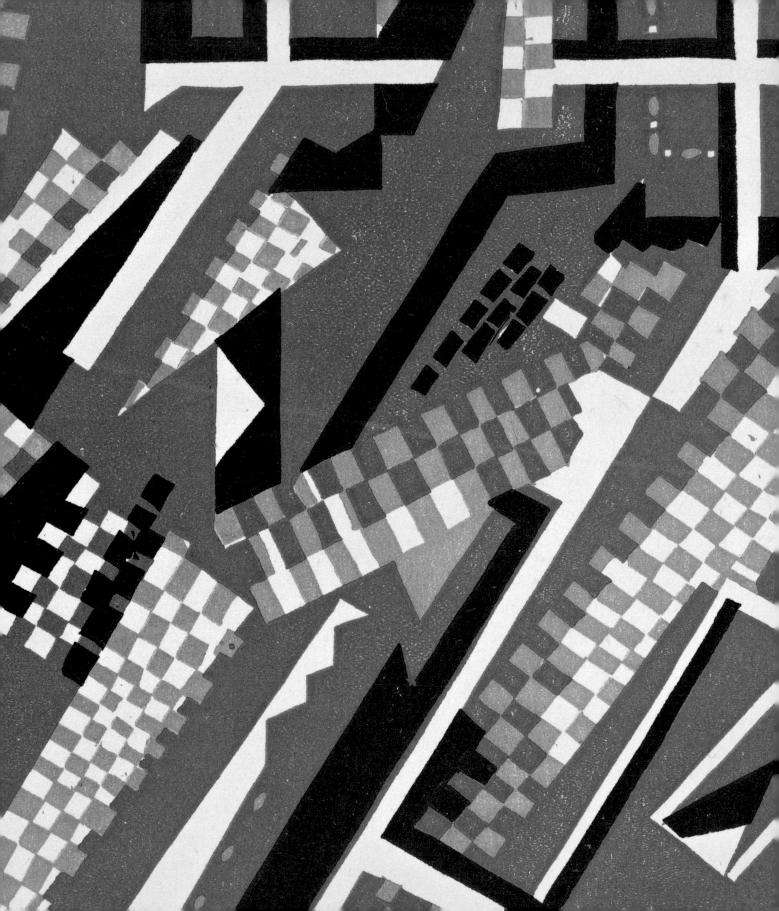

VORTICISM AND ABSTRACTION

Just one month before the outbreak of World War I, an international group of rebel artists and poets residing in London signed a provocative manifesto blasting Victorian art and culture and promoting a British brand of modernism, which they called Vorticism. The manifesto appeared in the first edition of their aptly named magazine *BLAST* and set out to distinguish their aesthetic and theoretical goals from those of the Italian Futurists who had attempted to establish an outpost in the English city. Led by the charismatic painter Wyndham Lewis and encompassing the paintings, drawings, prints, and sculptures of Edward Wadsworth, Henri Gaudier-Brzeska, Jacob Epstein, and David Bomberg, Vorticism established itself as the first truly avant-garde movement in Britain. The group fervently asserted its independence not only from Futurism but from Cubism and Expressionism as well. Rather than simply follow in the footsteps of the Continental movements, as their predecessor Roger Fry and his circle

had with Post-Impressionism, the Vorticists led the charge for an advanced English art that would radically break from and outstrip the leading movements of the day.

Vorticism erupted on the scene during a watershed moment in the history of art. By 1913, artists such as Kandinsky, Léger, Mondrian, and Malevich had largely abandoned the remaining traces of representation and forged a path toward pure abstraction. The Vorticists recognized Kandinsky's importance by including a translation of and commentary on selected passages from his groundbreaking book *On the Spiritual in Art* in the first edition of *BLAST*. While his emphasis on the universal significance of geometric forms and pure color surely influenced their shift toward nonrepresentation, they remained committed to the modern machine as the basis of overthrowing "the doctrines of a narrow and pedantic Realism."[1] They appropriated the ready-made mechanical forms found in the factories and

shipyards of England's industrial centers and created an austere visual vocabulary distinct from the Futurists' celebratory depictions of speed and movement.

The purest expression of Vorticist printmaking is evident in Wadsworth's rare woodcuts. While it is unknown just how many prints he made during the period immediately preceding and during the war, only about forty woodcuts survive, many of which exist in several color variations. His woodcuts are characterized by an uncompromising precision, impersonal touch, and hard-edged imagery. The son of a Yorkshire mill owner, Wadsworth possessed a keen visual understanding of industrial forms and convincingly captured their abstract rhythms in his prints. The boldly graphic character of *Illustration (Typhoon)* (cat. no. 10), one of his most ambitious images, is typical of his larger woodcuts. Inspired by a passage in Joseph Conrad's 1902 seafaring novel of the same name, it suggests the majestic interior of a steamship's engine room. Wadsworth was familiar with the innards of such vessels and was faithful to Conrad's vivid description, conveying a sense of architectonic space through a series of contrasting diagonals that recall soaring iron walls and grated walkways.

By contrast, in the diminutive print *The Open Window* (cat. nos. 7–8), Wadsworth conceived a more intimate, perhaps domestic space. He stripped away any realistic details that would reference the room's interior or the city outside, leaving behind only the barest suggestion of a grid-like window frame. The grid serves to anchor the pulsating city, which has been distilled into a simplified design of flattened geometric forms and checkered boxes. A theme explored by both Robert Delaunay and Umberto Boccioni, the open window signified the diminishing boundaries between the fast-paced, external world and the domestic sphere. Wadsworth devoted a significant amount of time to this image, printing no less than six brilliant color variations, each one, perhaps, evoking the light at a different time of day.

Interior (cat. no. 6) exemplifies the daringly abstract spirit typical of Wadsworth's smallest prints. No larger than a postcard, it is part of a distinct group of five woodcuts that the artist designed while serving as a sublieutenant for the Royal Naval Volunteer Reserve on the Greek island of Lemnos. The modest image is constructed of shifting geometric forms that recede and project into space much like the proto-Cubist works of Picasso and Braque. Unlike their paintings of provincial villages, however, nothing in Wadsworth's composition is descriptive. *Interior*'s Cubist structure suggests architectural form and space, but it is abstract in the extreme. Similarly, in *Brown Drama* (cat. no. 9), Wadsworth removed any vestiges of representation. He used hard-edged shapes to build a machine-like device that references no known machine, effectively creating a new invention, or "Vorticist substitute,"[2] for the real thing.

Although the Vorticists often eliminated figures from their work, Wadsworth implied human activity in *Street Singers* (cat. no. 2). The three standing androids — part man, part machine — are close cousins of Jacob

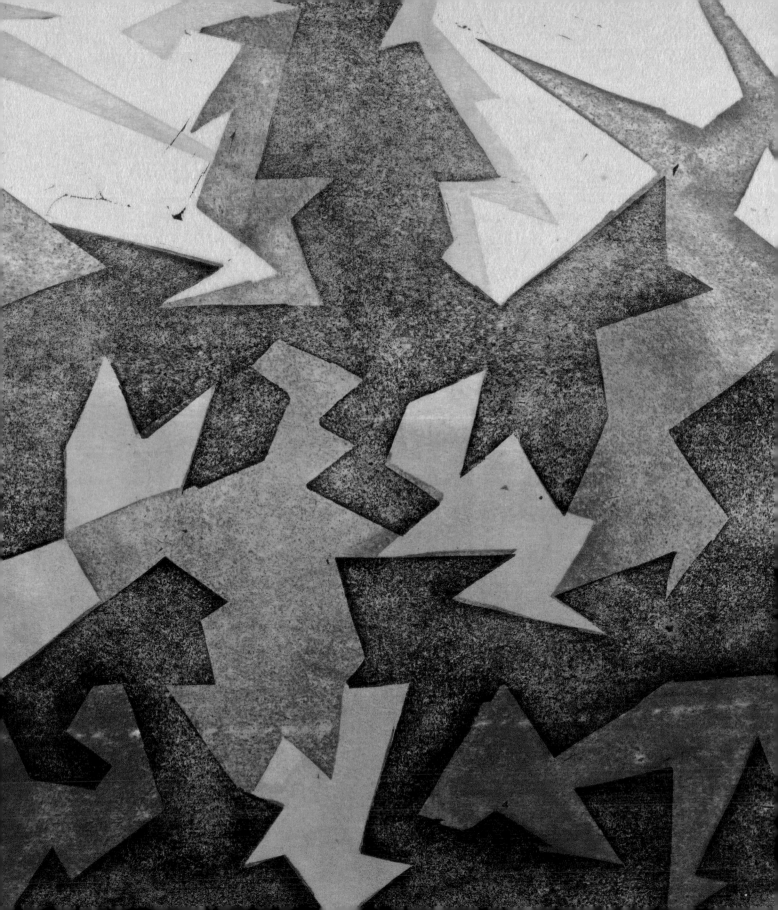

Epstein's notorious sculpture *Rock Drill* and are equally ambiguous. A central element of Vorticism's practice, multiplicity of meaning is a component in David Bomberg's illustrations for *Russian Ballet* (cat. nos. 4–5), as well. His stick-like automatons, simultaneously readable as human figures and abstract forms, stand in for Serge Diaghilev's famous dancers. Closely associated with Vorticism but not a signatory to its manifesto, Bomberg, like many rebel artists, including Lewis, was preoccupied with the idea of capturing movement in nonrepresentational form. Three of the six richly colored lithographs in *Russian Ballet* are the culmination of several dancer drawings that he executed before the war. The remaining three prints incorporate strong Vorticist diagonals and articulate a defined space rather than express movement.

Henri Gaudier-Brzeska, recognized for his virile and anti-sentimental sculptures, was one of Vorticism's most committed, though sadly short-lived, participants. He briefly experimented with intaglio processes but made only a single linocut, *Wrestlers* (cat. no. 1), in the studio of Horace Brodzky, a skilled printmaker and close friend. A spectator at London's wrestling club, Gaudier-Brzeska seized the athletes' push-pull movements through a series of elegantly interlocking planes in this linocut and in a 1914 bas-relief sculpture on which it is based (fig. 4, p. 21). He was a natural carver and, ironically, surpassed Brodzky's achievements with linocut on his first try. His fluid handling of form and content far exceeded his colleague's more literal and conventional depictions.

By 1917, E. McKnight Kauffer successfully synthesized the mechanized vocabulary of Vorticism with popular graphic design. An American expatriate who moved to England in 1914, Kauffer became the preeminent graphic designer of the postwar period, garnering several major commissions, including one to create posters for the London Underground Electric Railways in 1915. The serrated edges and geometric patterns of the flying birds in his woodcut *Flight* (cat. no. 13) evoke machines of war rather than a harmless flock. Kauffer toned down the somewhat threatening nature of his design in a second version of the print, which he used in "Soaring to Success," a poster commission for the *Daily Herald*.

Claude Flight embraced a more humanistic approach to abstraction in his color linocuts. Although he gleaned elements of his style from Futurism and Vorticism, he refused to identify with a particular movement. He strove, instead, to create a popular modern aesthetic based on the ideals of "simplicity, unity, and harmony."[3] Executed eleven years after Wadsworth's *Street Singers,* Flight's linocut of the same name (cat. no. 3) replaces his impersonal automatons with simplified human figures singing in a public square. Flight visualized their resounding voices with a swirl of sound waves and primary colors. In *Dirt Track Racing* (cat. no. 14), one of his most abstract images, an orderly arrangement of fragmented shapes and complementary colors visually articulates the dynamism of the racetrack, while the half-round forms at the center of the composition recall the racers' helmets.

Cyril Power, Flight's Grosvenor School colleague, also employed complementary colors to activate the surface of *Revolution* (cat. no. 15). In keeping with the title, his zigzag shapes, much like Bomberg's stick figures, express the essence of abstract, chaotic movement and perhaps allude to the highly charged political events of the day, including the rise of the Nazi Party in Germany and Stalin's great purges in the Soviet Union. Power clearly referenced Britain's earlier modernists in *The Vortex* (cat. no. 16). He illustrated the spiral funnel of energy from which the Vorticists derived their name, but his vibrant linocut distorts their true conception of themselves. Unlike the Futurist's desire to express the whirlwind of modern life, the true Vorticist was, as Lewis claimed, "at his maximum point of energy when stillest."[4] Rather than exist on the frenzied edges of the vortex, the Vorticists located themselves at its quiet center, from which, they believed, all vital ideas flowed. Power's colorful depiction, printed almost sixteen years after Vorticism's heyday, virtually caricatures the name of the earlier movement.

Vorticism's demise began shortly after Britain entered the war, with the untimely deaths of Gaudier-Brzeska and the influential critic T. E. Hulme. The brutalities of modern warfare left many members rejecting their once-held beliefs in its virtues and questioning their glorification of its machinery and weapons. The war not only sparked the end of Vorticism — a final exhibition of the group's work was held in New York in 1917 — but also largely stunted the radical path toward abstraction forged by the European avant-garde. In its aftermath, many of the most progressive artists returned to a more representational or humanistic approach to their subjects, in effect opening the door for the Grosvenor School's images of modern life.
— SR

1. Wyndham Lewis et al., "Manifesto II," *BLAST No. 1* (June 1914): 39.

2. Richard Cork, *Vorticism and Abstract Art in the First Machine Age,* 2 vols. (Berkeley: University of California Press, 1976), 1:330.

3. Flight, interviewed in "Golders Green Artist's Life as 'Caveman,'" *Golders Green Gazette* (London), June 3, 1927. Excerpts of Flight's interview are reprinted in Stephen Coppel, *Linocuts of the Machine Age* (Hants, England: Scolar Press in association with the National Gallery of Australia, 1995), 17.

4. Wyndham Lewis, "Our Vortex," *BLAST No. 1* (June 1914): 148.

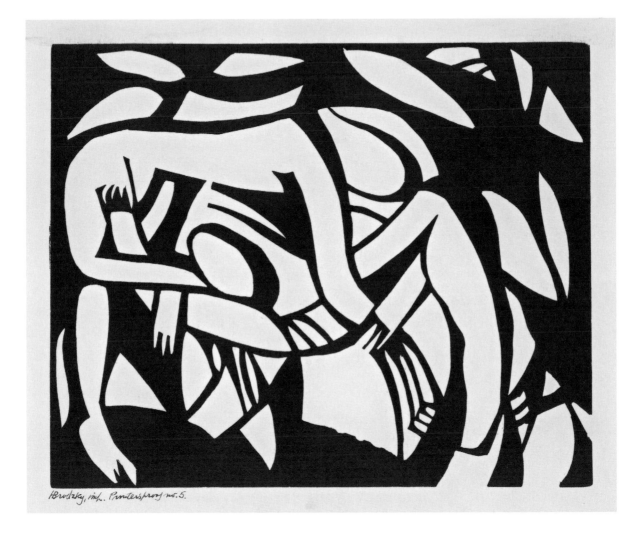

1 HENRI GAUDIER-BRZESKA **WRESTLERS** ABOUT 1914, LINOCUT, PRINTED POSTHUMOUSLY BY HORACE BRODZKY

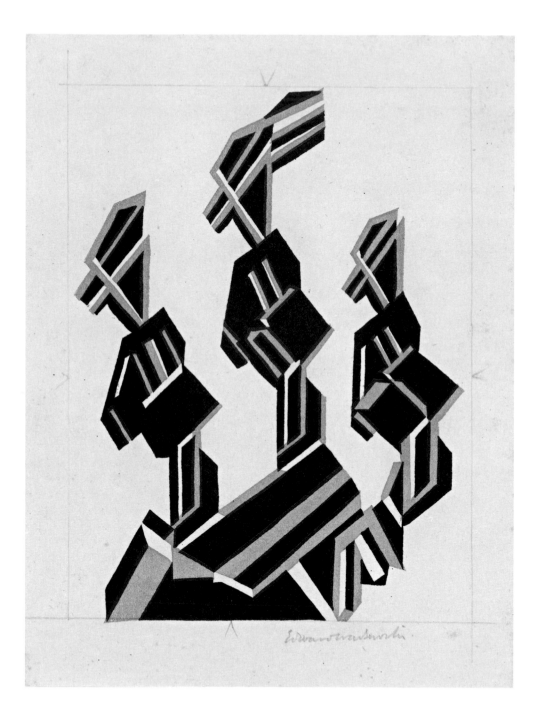

2 EDWARD WADSWORTH **STREET SINGERS** ABOUT 1914, WOODCUT

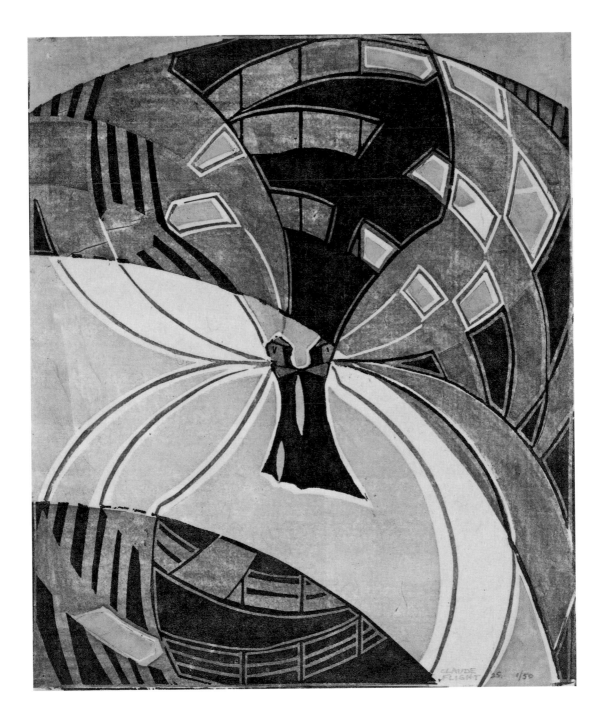

3 CLAUDE FLIGHT **STREET SINGERS** 1925, COLOR LINOCUT

Fluttering white hands beat —
compel. Reason concedes.

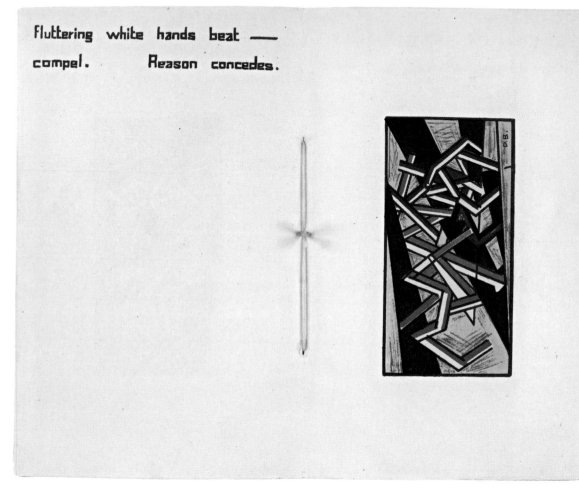

5A DAVID BOMBERG **RUSSIAN BALLET** 1919, COLOR LITHOGRAPHS, UNBOUND PROOF PAGE

5B DAVID BOMBERG **RUSSIAN BALLET** 1919, COLOR LITHOGRAPHS, UNBOUND PROOF PAGE

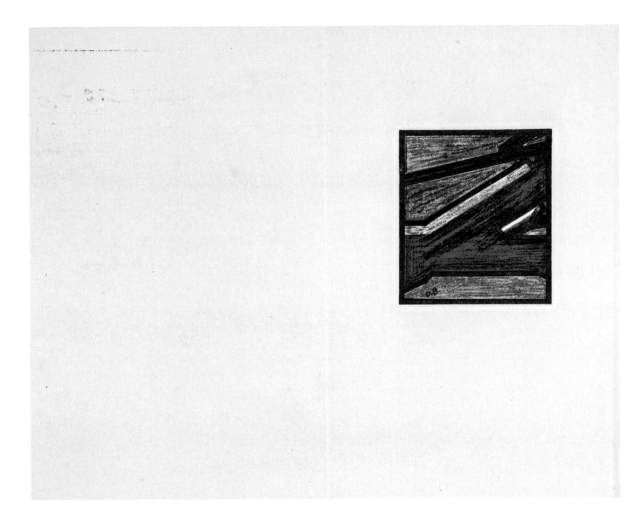

5C DAVID BOMBERG **RUSSIAN BALLET** 1919, COLOR LITHOGRAPH, UNBOUND PROOF PAGE

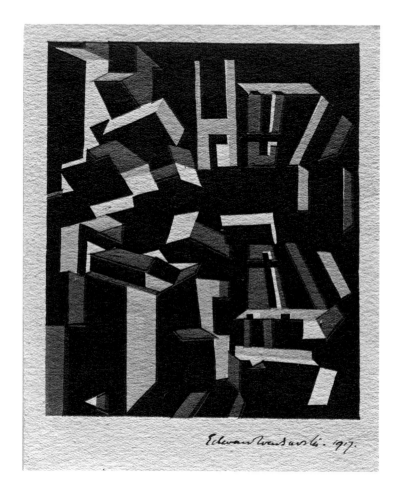

6 EDWARD WADSWORTH **INTERIOR** 1917, WOODCUT

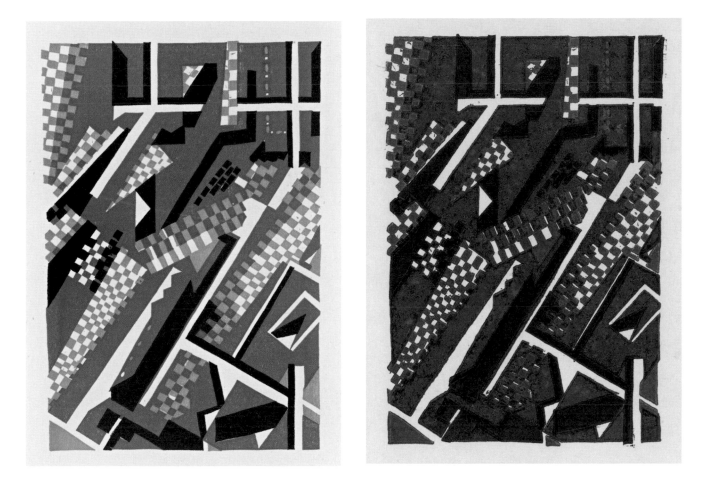

7 EDWARD WADSWORTH **THE OPEN WINDOW** ABOUT 1914, COLOR WOODCUT, GRAY AND BLACK VARIANT

8 EDWARD WADSWORTH **THE OPEN WINDOW** ABOUT 1914, COLOR WOODCUT, BLUE, BROWN, AND BLACK VARIANT

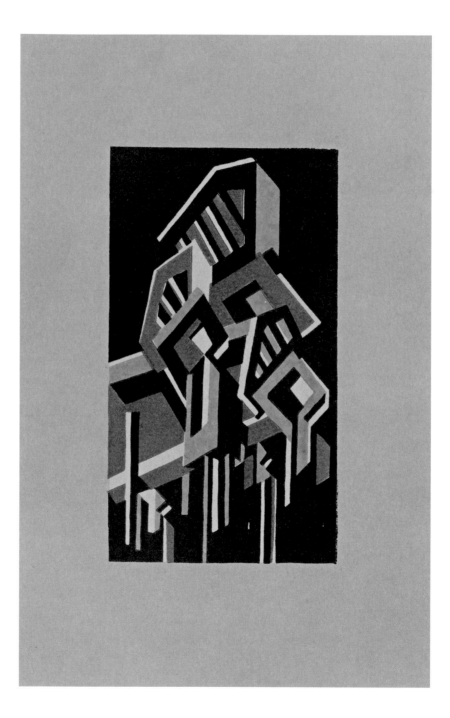

9 EDWARD WADSWORTH **BROWN DRAMA** 1914–17, COLOR WOODCUT

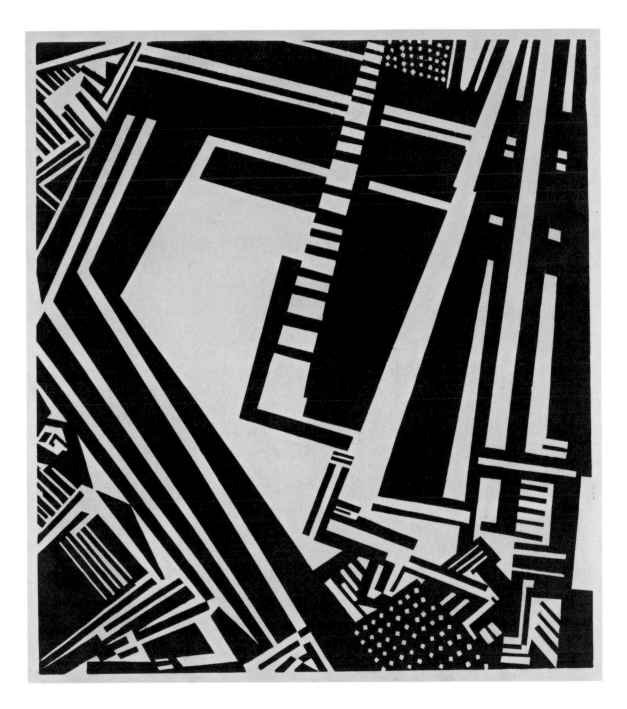

10 EDWARD WADSWORTH **ILLUSTRATION (TYPHOON)** 1914, WOODCUT

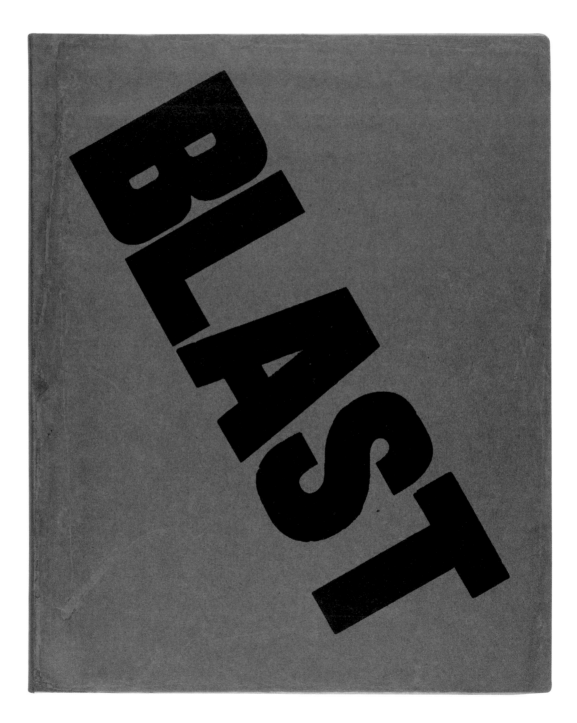

11 COVER OF **BLAST NO. I: REVIEW OF THE GREAT ENGLISH VORTEX** JUNE 20, 1914, EDITED BY WYNDHAM LEWIS

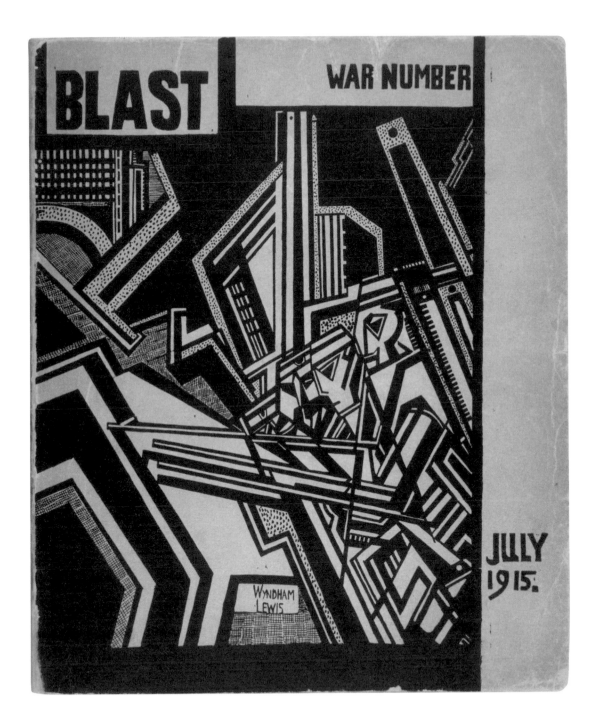

12 COVER OF **BLAST WAR NUMBER: REVIEW OF THE GREAT ENGLISH VORTEX** JULY 1915, EDITED BY WYNDHAM LEWIS

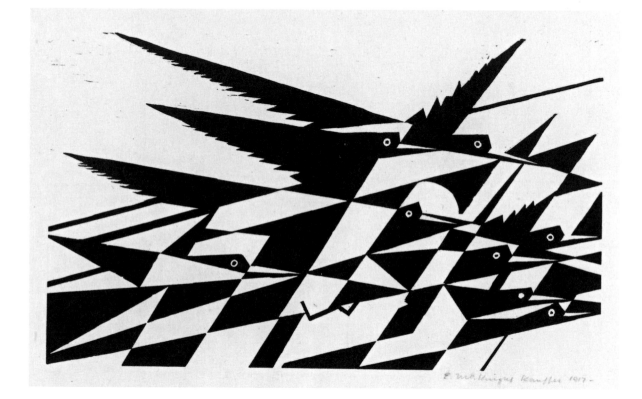

13 E. MCKNIGHT KAUFFER **FLIGHT** 1917, WOODCUT

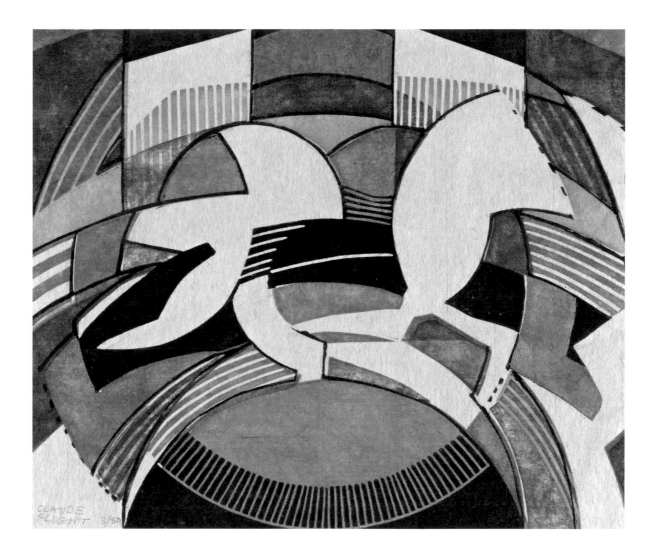

14 CLAUDE FLIGHT **DIRT TRACK RACING** ABOUT 1928, COLOR LINOCUT

15 CYRIL E. POWER **REVOLUTION** ABOUT 1931, COLOR LINOCUT

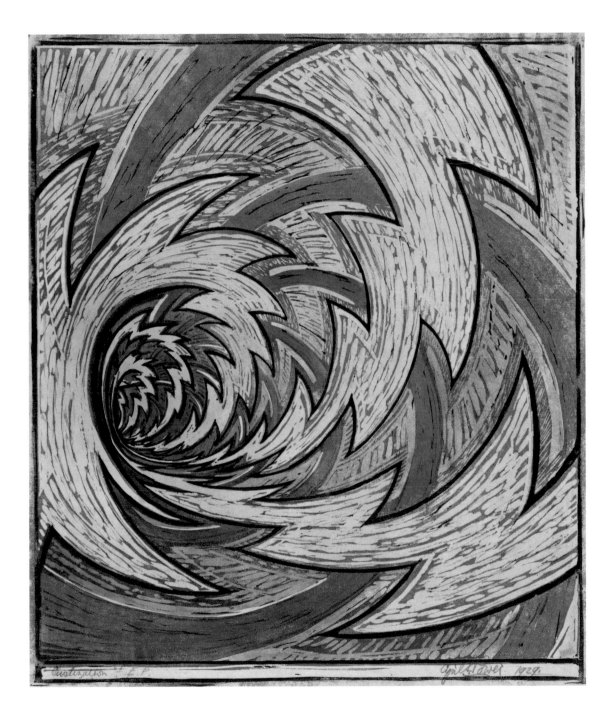

16 CYRIL E. POWER **THE VORTEX** 1929, COLOR LINOCUT

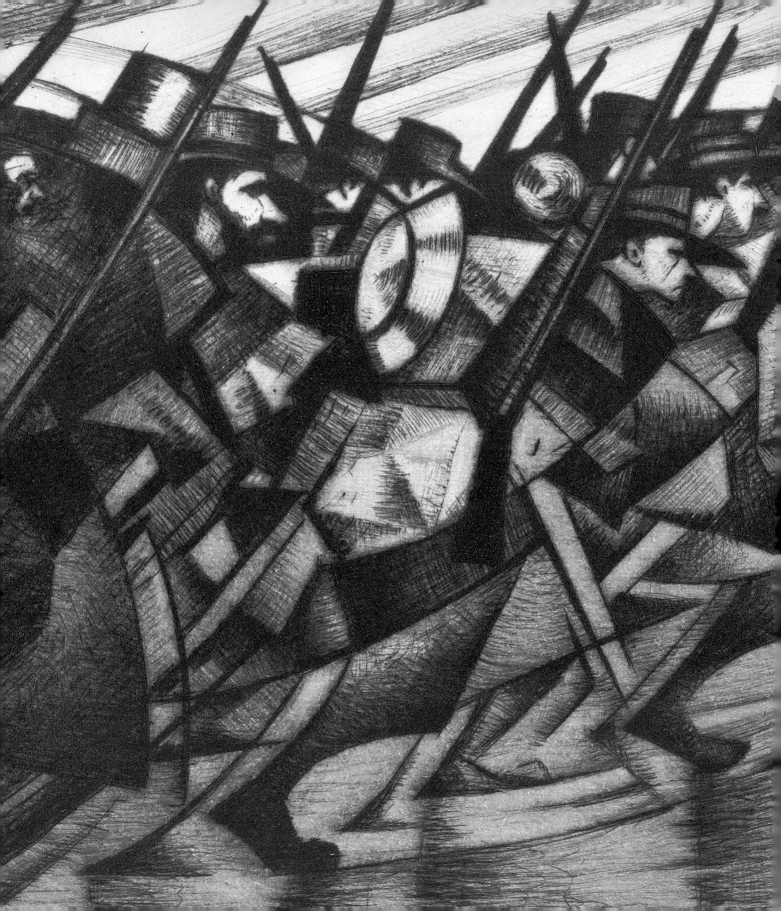

Britain has a long legacy of military art, and World War I generated its own ample share of traditional heroic propaganda. New styles of art and new ways of war, however, led modernist artists to add new types of images to the repertoire. While C. R. W. Nevinson was most versatile with wartime imagery, Paul Nash also made innovative contributions, and Edward Wadsworth created one series of unforgettable woodcuts. Futurism, Vorticism, and Cubism all contributed to Nevinson's drypoints of soldiers on the march. As lithographers, both Nevinson and Nash studied the landscape, which they sometimes portrayed as an anonymous, amorphous abstraction consisting of trenches, mines, shells, and rain. No matter how bleak his war-torn landscapes, Nevinson seems to have found other aspects of modern warfare positively exhilarating, especially the speed, freedom, and perspective of flight. Wadsworth, meanwhile, responded to the international revival of the woodcut that had occurred in the

1890s. In England, artists such as William Nicholson had successfully exploited the medium's ability to produce broad areas of dense, flat blackness. Wadsworth adopted this approach and gave it a newer look with cleaner, simplified contours and stronger contrasts, using white papers for his camouflage-ship images. Nevinson's dynamic angularity and Wadsworth's economical, but visually complex, block prints would lay foundation stones for the linocut artists who emerged in the 1920s and '30s.

In June 1914, Nevinson and the Italian Futurist F. T. Marinetti published their manifesto "Vital English Art," which excoriated English art as hypocritical, timid, and effeminate and sought remedy in "a fearless desire of adventure, a heroic instinct of discovery, a worship of strength and a physical and moral courage — all sturdy virtues of the English race."[1] Three weeks later, the Austro-Hungarian archduke Franz Ferdinand was assassinated, catalyzing the outbreak

of war. Having championed Futurism's aggressive stance, Nevinson may have felt obligated to join the war effort near the front. In October 1914, he signed on with an ambulance unit of the Society of Friends. His brief service as an orderly, driver, and nurse in northern France and Flanders exposed him to the realities of war. Devastated by the suffering of the wounded, he experienced a breakdown and was sent home in less than three months. Back in Britain, Nevinson admitted the inaccuracy of the Futurist view of war as the "only health-giver," while still insisting that Futurism was the only art capable of recording the "ugliness and dullness of modern warfare."[2]

Despite his bluster, Nevinson simplified the kaleidoscopic confusion of his early Futurist style for his wartime compositions. Using the fragmented, faceted forms of Cubism and the repetition and layering of Futurism, he produced legible images that seemed cutting-edge to the general public. His 1916 drypoints *Returning to the Trenches* (cat. no. 19) and *Column on the March* (cat. no. 18) are freely based on paintings and drawings that he made in 1914, apparently during his service. The images in the prints reverse the painted ones. They emphasize the relentless determination of countless French soldiers, but the men's determination is grim and their fate uncertain. Prismatic forms and lighting energize *Returning to the Trenches,* while increasing the anonymity of the men. The phalanx bristles with bayoneted rifles as the troops mechanically press forward at a pace that blurs their feet. The soldiers in *Column on the March* are lined up like cartridges on a belt and seem equally expendable. When these and other works appeared in his first one-man show in 1916, critics immediately identified Nevinson as the preeminent British war artist.

Nevinson, ever the macho poseur and publicity hound, brushed off the accolades, saying that he would no longer depict the war and would instead move on to different subjects. Soon, however, humiliated by brief service as an army private working in a London hospital, he used his journalist father's connections to gain appointment as an official war artist. Returning to France in July 1917, Nevinson experienced even more directly life on the front. In a single month, he witnessed firsthand the operation of big guns, flew on a reconnaissance mission, saw battlefield quagmires that swallowed the wounded by the thousands, and found himself pinned down by heavy German fire when he joined a patrol in the no-man's-land between the opposing lines.

In August, Nevinson was back in London, transforming his experiences into works of art. The results proved perplexing and aggravating to propaganda officers in the Ministry of Information. Several of his paintings are reflected in the lithographs he produced the following year. *The Road from Arras to Bapaume* (cat. no. 17) transforms the bleak landscape into near abstraction, while *Hauling Down an Observation Balloon at Night* (cat. no. 22) similarly abstracts the billowing fabric. In both works, Nevinson completely abandoned Futurist and Cubist conventions. Moreover, he abandoned Futurist ideals. Soldiers appear neither heroic

nor driven by a mission. For Nevinson, war had transformed the Continent into a vast, devastated, faceless wasteland, and his government overseers feared that it appeared hardly worth fighting for.

More favorably received—and more redolent of his Futurist roots—were Nevinson's contributions to *The Great War: Britain's Efforts and Ideals,* a portfolio of prints commissioned by the Ministry of Information and published in 1918. His section, "Building Aircraft," contained six lithographs. *Banking at 4000 Feet* (cat. no. 23) and *Swooping Down on a Taube* (cat. no. 24) suggest the thrill that Nevinson found in his own aerial adventure in France. Aboard a soaring machine, he swoops over all boundaries that define the cultivated landscape. It is as though the aircraft were engineered specifically to fulfill Nevinson's lofty pretensions to superiority. Futurist belief in the beauty of violence resurfaces in his god's-eye view of a hawk-like Allied flier diving toward a stealthy German reconnaissance plane known as a Taube (dove)—the name inspired by the silhouette of its flaring wings and tail. Rays of sunlight fan out across the sky, offering hope of glorious victory.

Ramming Home a Heavy Shell (cat. no. 26) is one of just two woodcuts that Nevinson attempted. While his drypoints and lithographs had avant-garde aspirations, the woodcut taps into a style and technique popular in Britain and France in the 1890s. However, Nevinson breathed fresh air into his image with dynamic perspective, echoed forms, severe cropping, and sharp contrasts.

Paul Nash's wartime landscapes are based on his experiences as an officer and official war artist near the Flemish town of Ypres, the focal point of several horrendous battles. The Germans subjected the town to almost continuous shelling, and it was there that they introduced mustard gas as a weapon, in 1917. The Third Battle of Ypres lasted more than three months and cost more than seven hundred thousand lives. Nash's landscapes refer to specific locations near the railway running southeast of Ypres. Lake Zillebeke (cat. no. 20) and a village of the same name lie about a mile and a half from the town. Numerous cemeteries still bear witness to the carnage that took place there. Trenching, tunneling, and shelling opened the surface of the land, and heavy rains, shown by Nash, transformed the area into treacherous muck. Barren trees punctuate the desolation of the scene. The lake itself, the shimmering focal point, bitterly recalls the lost romance of the rural landscape.

Another mile or so distant is Hill 60, the site of *The Crater, Hill 60* (cat. no. 21), as annotated on some impressions of Nash's lithograph. The hill, a low formation built from soil moved to make way for the train tracks, held such strategic importance that it repeatedly changed hands between Allied and German forces. At the end of the fighting, human remains from both armies lay so densely that trenches were filled in as mass graves. Otherwise, the land was left in its war-battered state. Though now grown over with scrubby grass, the area remains pocked with craters and bunkers. Nash's accurate depiction of the terrain presents

the landscape as both victim and killer, an allegory for the fate of the soldiers mostly absent from his views.

Edward Wadsworth did not see frontline service, but he was involved in one of the most visually striking projects of the war. By 1917, German U-boats were sinking about a hundred British ships each month. To counteract this deadly force, marine painter and poster designer Norman Wilkinson developed camouflage for ships. His designs were so bold and optically disorienting that vessels painted in this manner became known as Dazzle Ships. Wadsworth was sent to Liverpool to help supervise the massive painting project. The powerful, fragmented geometric designs appealed to his Vorticist sensibilities. In 1917 and 1918, he produced a series of woodcuts showing Dazzle Ships in Liverpool's harbor and dry dock (cat. nos. 27–29).

While working in a more representational vein than in his earlier Vorticist art, Wadsworth still pared away detail, emphasizing the graphic impact of the camouflage. Though the actual paint jobs varied in color, including soft blues, grays, and pinks, he reduced the palette to black and white in his prints. Many ships were painted with a crazy-quilt array of shapes and patterns, but Wadsworth limited himself to hypnotic patchworks of stripes. In his dry-dock scenes, tapering perspective lines heighten our awareness of the ships' massive proportions, a sensation confirmed by the Lilliputian men at work on the hulls. Where shown afloat, Wadsworth's Dazzle Ships flatten to two dimensions, lose their distinct edges, and blend into their surroundings. After the war, when the Royal Academy staged a camouflage exhibition, a reviewer for the *Evening Standard* singled out Wadsworth's ship woodcuts as the aesthetic high points of the show.

In the 1930s, C. R. W. Nevinson would recall that, as a youthful student first encountering Cubism in 1911, he had desired "to reach that dignity which can be conveyed pictorially by the abstract rather than the particular."[3] He and the other wartime modernists attained that goal in ways that none of them could have foreseen as younger men. The brutal reality of war convinced wider circles that Britain had entered a new era, and these printmakers offered a fresh visual vocabulary to express a changing culture. — TER

1. F. T. Marinetti and C. R. W. Nevinson, "Vital English Art: A Futurist Manifesto," *The Observer*, June 7, 1914.

2. C. R. W. Nevinson, *The Daily Express*, February 25, 1915, as quoted in J. Black, "A Curious, Cold Intensity," in Richard Ingleby et al., *C. R. W. Nevinson: The Twentieth Century*, exh. cat. (London: Merrell Holberton in association with the Imperial War Museum, 1999), 16.

3. C. R. W. Nevinson, *Paint and Prejudice* (1937; repr., New York: Harcourt, Brace, 1938), 60.

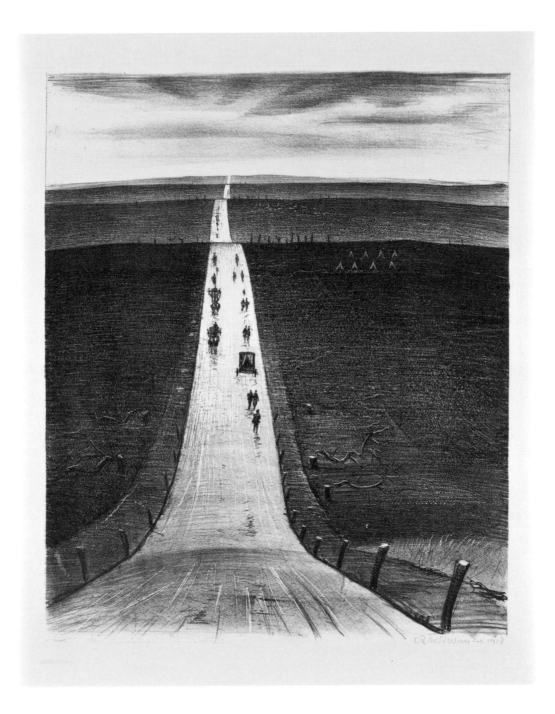

17 C. R. W. NEVINSON **THE ROAD FROM ARRAS TO BAPAUME** 1918, LITHOGRAPH

18 C. R. W. NEVINSON **COLUMN ON THE MARCH** 1916, DRYPOINT

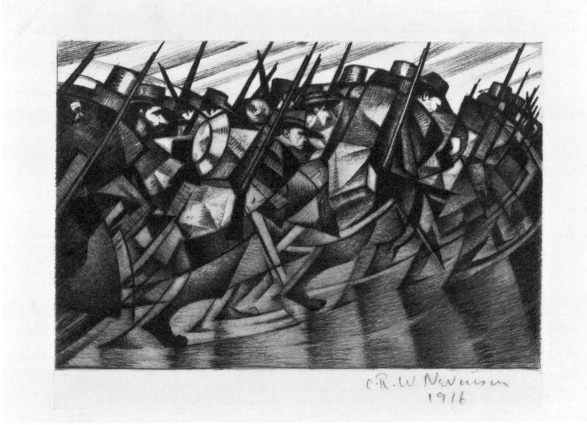

19 C. R. W. NEVINSON **RETURNING TO THE TRENCHES** 1916, ETCHING AND DRYPOINT

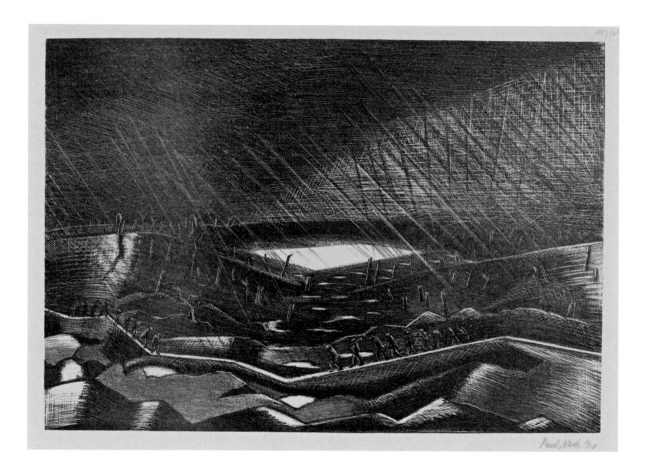

20 PAUL NASH **RAIN, LAKE ZILLEBEKE** 1918, LITHOGRAPH

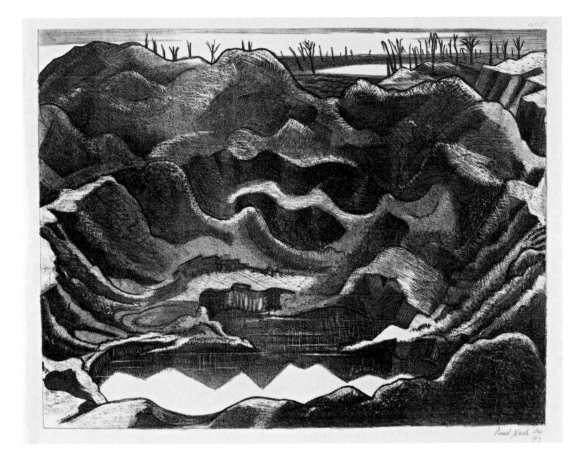

21 PAUL NASH **THE CRATER, HILL 60** 1917, LITHOGRAPH

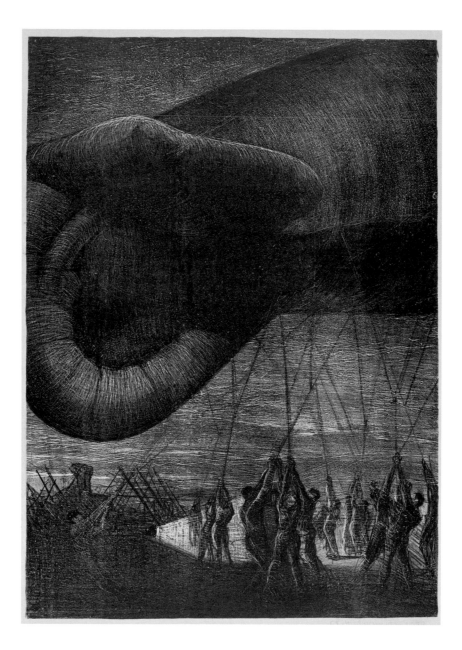

22 C. R. W. NEVINSON **HAULING DOWN AN OBSERVATION BALLOON AT NIGHT** 1918, LITHOGRAPH

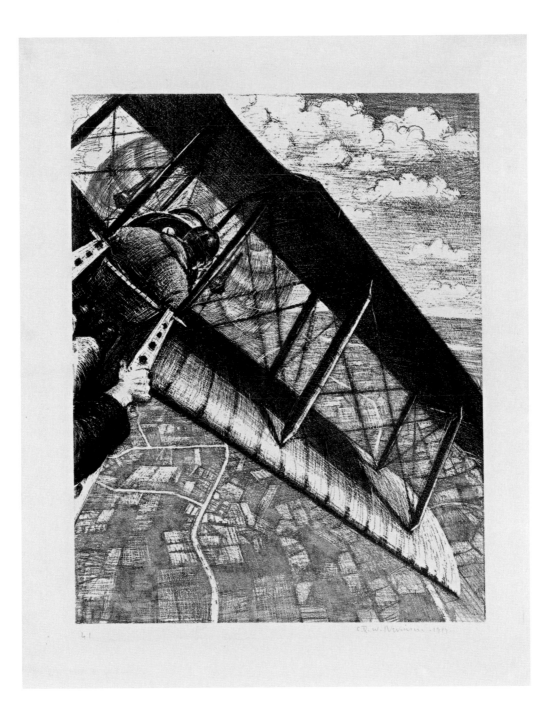

23 C. R. W. NEVINSON **BANKING AT 4000 FEET** 1917, LITHOGRAPH

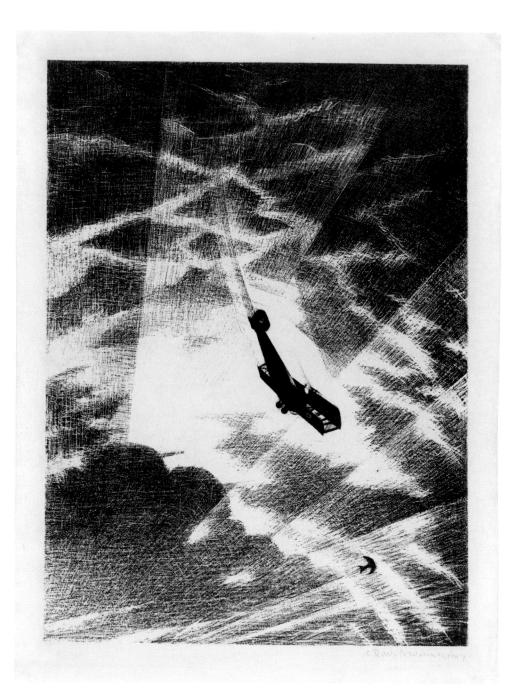

24 C. R. W. NEVINSON **SWOOPING DOWN ON A TAUBE** 1917, LITHOGRAPH

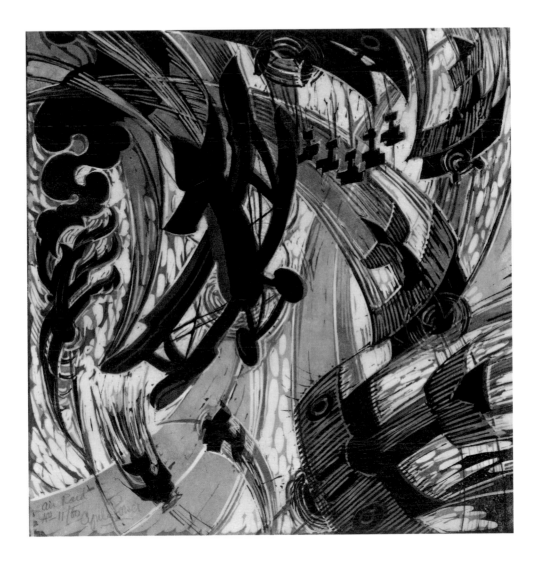

25 CYRIL E. POWER **AIR RAID** ABOUT 1935, COLOR LINOCUT

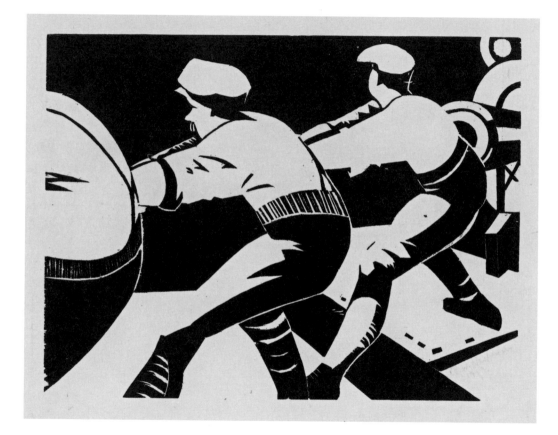

26 C. R. W. NEVINSON **RAMMING HOME A HEAVY SHELL** 1917, WOODCUT

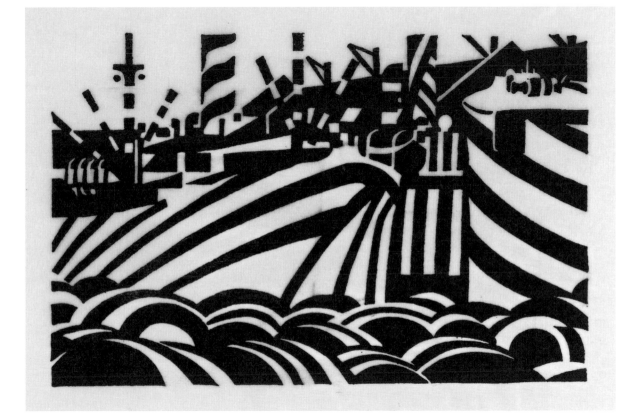

27 EDWARD WADSWORTH **DOCK SCENE** 1917, WOODCUT

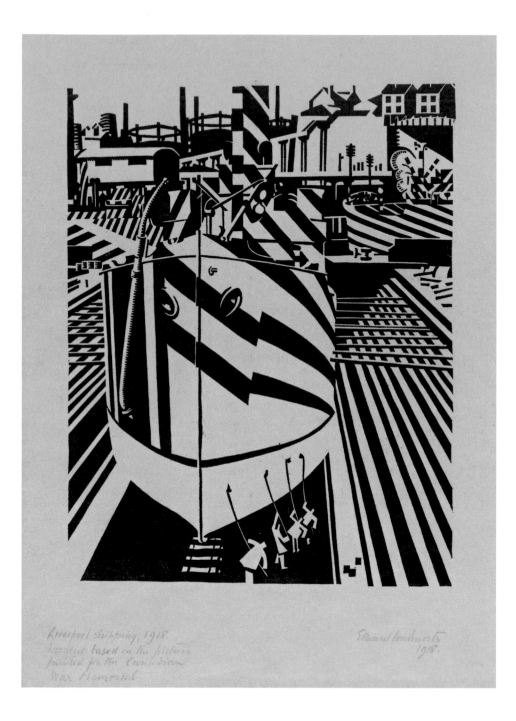

Liverpool shipping, 1918.
woodcut based on the picture
painted for the Canadian
War Memorial.

Edward Wadsworth
1918.

28 EDWARD WADSWORTH **LIVERPOOL SHIPPING** 1918, WOODCUT

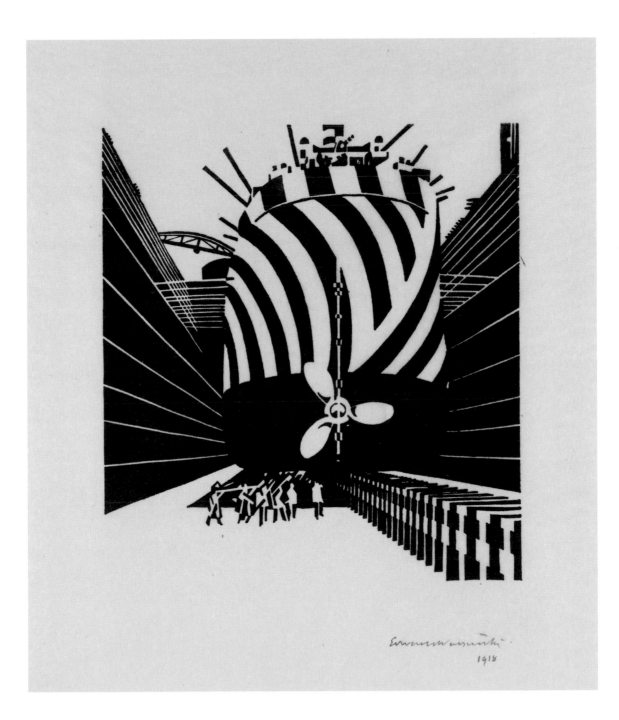

29 EDWARD WADSWORTH **DRYDOCKED FOR SCALING AND PAINTING** 1918, WOODCUT

We declare that the world's splendour has been enriched by a new beauty; the beauty of speed. A racing motor-car, its frame adorned with great pipes, like snakes with explosive breath . . . is more beautiful than the Victory of Samothrace.

F. T. MARINETTI[1]

More than fifteen years after the Futurists' influential 1912 exhibition at London's Sackville Gallery, F. T. Marinetti's impassioned statement resonated with a group of linocut artists associated with the newly formed Grosvenor School of Modern Art. They shared his fascination with speed and sought to capture its essence in their vibrant images of modern life. Claude Flight, a teacher at the school from 1926 to 1930 and the group's unofficial leader, had met Marinetti during one of his early visits to London through the British Futurist C. R. W. Nevinson, yet he never fully subscribed to the Italian movement. Opposed to its political doctrine, Flight claimed, "I am a lone figure, belonging to no school."[2]

While Flight may have disagreed with Futurism's rhetoric, he nevertheless was inspired by its dynamic motifs. In the early 1920s, he started to make bold graphic works in linocut, a novel technique that he tirelessly promoted as a modern medium for a modern age. The linocut was well suited to expressing ideas of speed and movement. Its soft, malleable surface was easy to carve, and in Flight's hands it yielded fluid lines and broad areas of flat color that evoked motion through rhythmic patterns rather than literal representation. The technique also made experimenting with color relatively simple: the artist could easily enhance or impede the sensation of movement by altering the color combinations of the blocks. Flight's enthusiasm for the linocut attracted a number of students to the Grosvenor School. Two of his closest associates, Sybil Andrews and Cyril Power, eagerly pursued the linocut

as their primary medium, illustrating the speed and movement of modern life in a significant group of prints that rivaled, if not surpassed, their teacher's.

Flight's innovative marriage of medium and imagery is exemplified in his linocut *Brooklands* (cat. no. 33). Named for England's legendary racetrack, the print successfully captures the thrill of motorcar racing as three roadsters soar around a track, the lead car just about to speed past the spectator's field of vision and out of the print's frame. A countless number of curving, carved lines, varying in thickness and solidity, create a dynamic pattern of movement. Although Flight used only four colors — red, yellow, and two shades of blue — he ingeniously backed the print's translucent Japanese paper with a separate sheet of speckled silver paper, which is subtly visible on the hoods of the cars, suggesting a metallically glimmering surface. Flight's image, motivated in part by Futurism's admiration for the race car, was also influenced by England's popular enthusiasm for the sport at the time. Founded as a private racing club in 1906, Brooklands had achieved record attendance by the mid-1920s, and its races regularly made the front page of local newspapers.

Power borrowed the subject of *Speed Trial* (cat. no. 32) directly from the headlines. His streamlined linocut chronicles Malcolm Campbell's 1931 record-breaking run at Daytona Beach, Florida, where his celebrated aerodynamic car *Bluebird* reached an unprecedented speed of 246 miles per hour. Power visually conveyed the car's motion by limiting its weight and mass; there are no solid forms or continuous outlines in the composition. Likely taking his cue from Futurist depictions

of the automobile, such as Giacomo Balla's *Abstract Speed,* Power subtly broke down Bluebird's form yet never completely abandoned the image in favor of a more abstract depiction of movement. Unlike Balla's dematerialized image, his elegant pattern of lines, printed in blue and highlighted in white, coalesce in a recognizable picture. Power worked diligently on *Speed Trial,* revising both the composition and the colors in no fewer than sixteen Experimental Proofs (see cat. no. 31) before committing to a final version.

Although the automobile was a central component of Futurism's iconography, it played a somewhat lesser role in the linocuts of the Grosvenor School artists, who found other examples of movement in contemporary life. In *Speedway* (cat. no. 30), Andrews fused man and motorcycle in three repeating forms that move diagonally across the sheet. While the popularity of motorbike dirt-track racing in England in the 1930s influenced her subject — the decade was generally regarded as the sport's golden age — her hard-edged, machine-like figures likely descend from Vorticism's more extreme automatons. *Speedway* was originally conceived as a poster for the London Passenger Transport Board but unfortunately was never produced in poster form.

The fast-moving, mechanized rides of amusement parks also inspired a number of Grosvenor School linocuts. A popular form of adult entertainment in the 1920s, these pleasure havens attracted thrill seekers in search of an escape from the monotony of daily life. Flight, who was eager for his images to appeal to a broad public, took up this subject matter in *Swing-Boats* (cat. no. 34), one of his earliest and most abstract

linocuts. He expressed the ride's dynamic back-and-forth motion by creating a radiating pattern of arced lines, similar to Futurist force lines, and purposefully avoided representational details so as not to distract from the composition's pulsating rhythm. The two standing riders, one arched back and the other leaning forward, mimic the movement of the ride. Ant-like and rendered only in outline, they barely resemble human forms. By simplifying his composition, employing primary colors, and using basic geometric shapes, Flight hoped to get at "the unchangeable and universal, those inherited qualities necessary in a work of art."[3]

Whereas Flight sought to articulate the swingboat's momentum, Power preferred to focus on the human figures that powered it in *The High Swing* (cat. no. 35). Much like a mechanical engine, his figures' synchronized movements — expressed in the schematized concave-convex shapes of their angular bodies — trigger the ride and propel it higher and higher. Complementary colors of orange and blue further contribute to the linocut's vigorous dynamism. Power used a similar color palette in *The Merry-Go-Round* (cat. no. 36) and achieved an equally powerful effect. In his hands, the innocent fun-fair ride is transformed into a demonic funnel of energy, its passengers hurled around in their swings and reduced to zigzag blurs of color. This edgy, highly charged image contrasts with his more lyrical depiction of undulant movement in *The Giant Racer* (cat. no. 37).

Andrews, meanwhile, expressed the rhythmic motion of human figures in such everyday events as a walk through a crowded city park or the evening commute home. In *Hyde Park* (cat. no. 39), she distilled the movement of a bustling crowd into an allover, abstract pattern of overlapping curves and repeating hats. In *Rush Hour* (cat. no. 38), she focused her composition on the hurrying feet of commuters ascending an escalator. The curved, triangular forms of her pared-down escalator recall the elegant armature of Power's roller coaster in *The Giant Racer*, while the orange and blue palette in *Hyde Park* is identical to that of *The Merry-Go-Round*. These visual similarities are not surprising, since Andrews and Power shared a studio from 1930 to 1938, regularly exchanging ideas and printing each other's images.

In their innovative yet accessible images of speed and movement, Andrews, Power, and Flight convincingly visualized Marinetti's embrace of the energetic pace of modern life. They democratized the often-esoteric visual language of Futurism, adapting it to appeal to a broader audience fascinated by the speed of popular contemporary attractions such as amusement parks and motorcar racing. Their total engagement with the linocut process and constant experimentation with printing methods only served to capture the essence of their dynamic subjects. — SR

1. Marinetti, 1909, reprinted in *The Italian Futurist Painters* (London: Sackville Gallery, 1912), 1.

2. Flight, interviewed in "Golders Green Artist's Life as 'Caveman,'" *Golders Green Gazette* (London), June 3, 1927. Excerpts of Flight's interview are reprinted in Stephen Coppel, *Linocuts of the Machine Age* (Hants, England: Scolar Press in association with the National Gallery of Australia, 1995), 17.

3. Flight, quoted in Malcolm C. Salaman, *The Woodcut of To-Day at Home and Abroad*, ed. Geoffrey Holme (London: The Studio, 1927), 54.

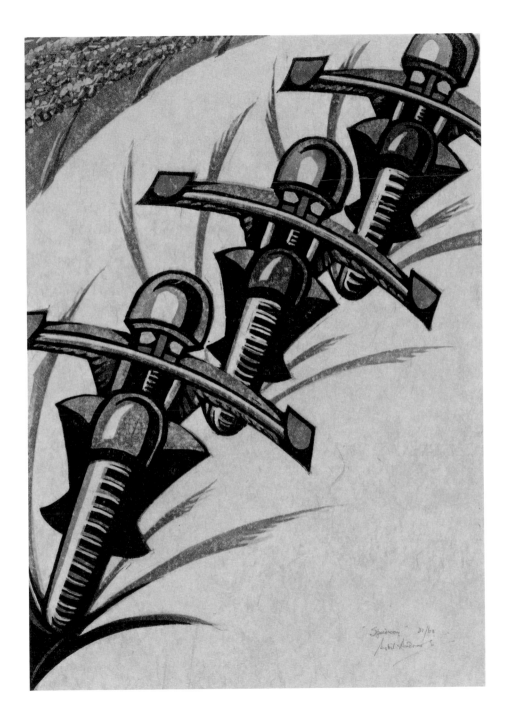

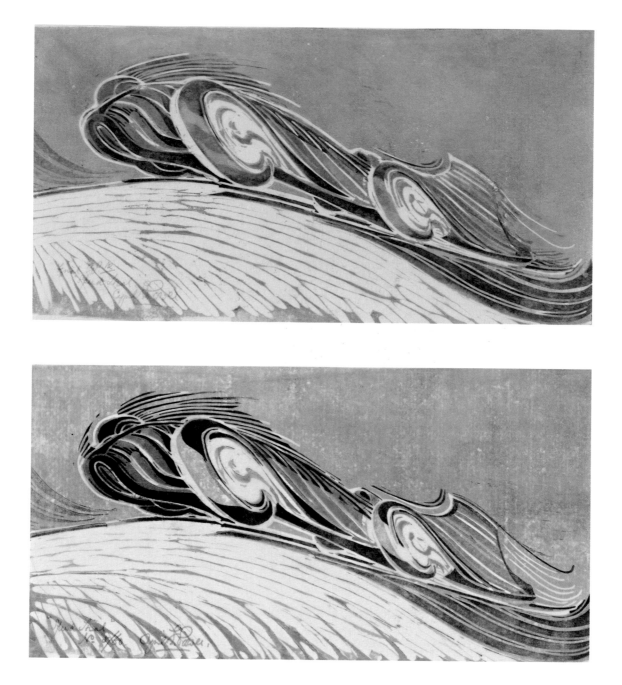

31 CYRIL E. POWER **SPEED TRIAL** 1932, COLOR LINOCUT, EXPERIMENTAL PROOF

32 CYRIL E. POWER **SPEED TRIAL** 1932, COLOR LINOCUT

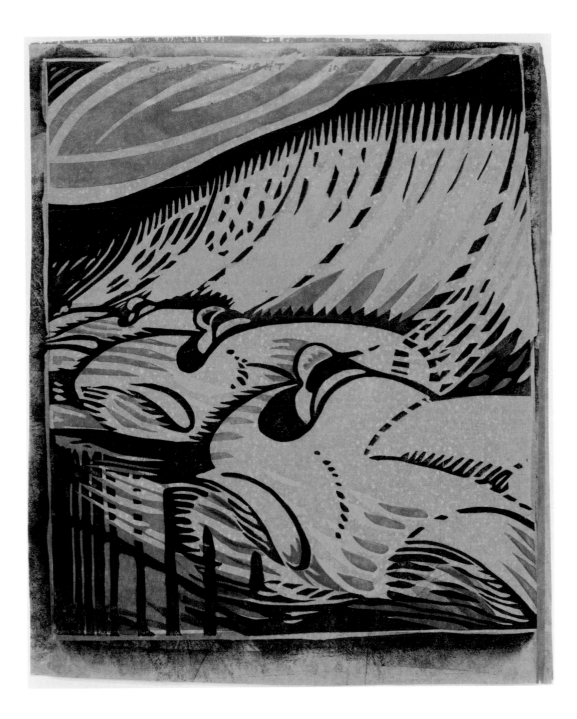

33 CLAUDE FLIGHT **BROOKLANDS** ABOUT 1929, COLOR LINOCUT (SHOWING WHOLE SHEET WITH BORDERLINE)

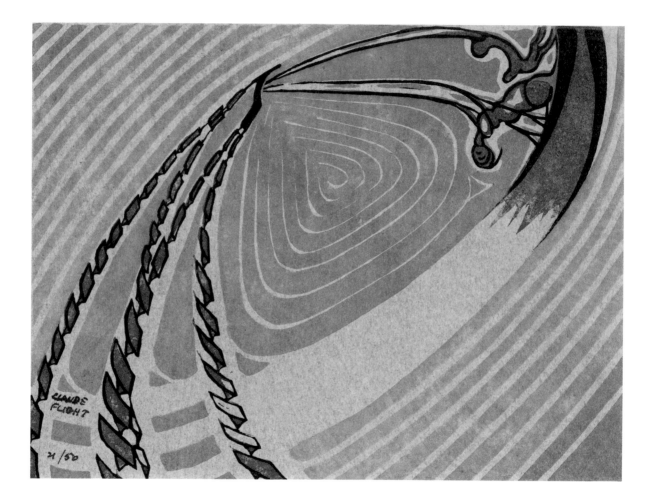

34 CLAUDE FLIGHT **SWING-BOATS** 1921, COLOR LINOCUT

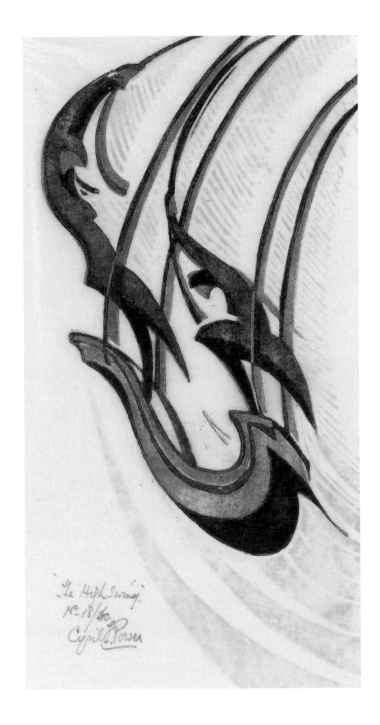

35 CYRIL E. POWER **THE HIGH SWING** ABOUT 1933, COLOR LINOCUT

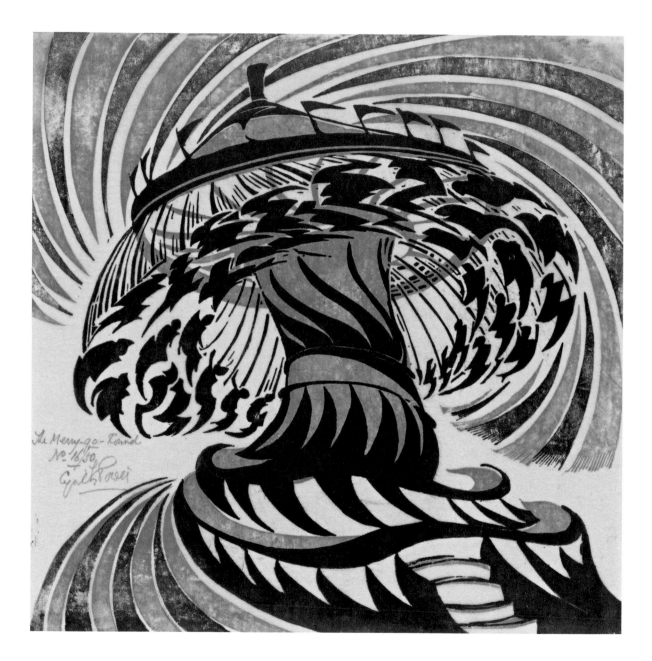

In the print, handwritten: The Merry-go-Round / No 16/50 / Cyril Power

36 CYRIL E. POWER **THE MERRY-GO-ROUND** ABOUT 1929–30, COLOR LINOCUT

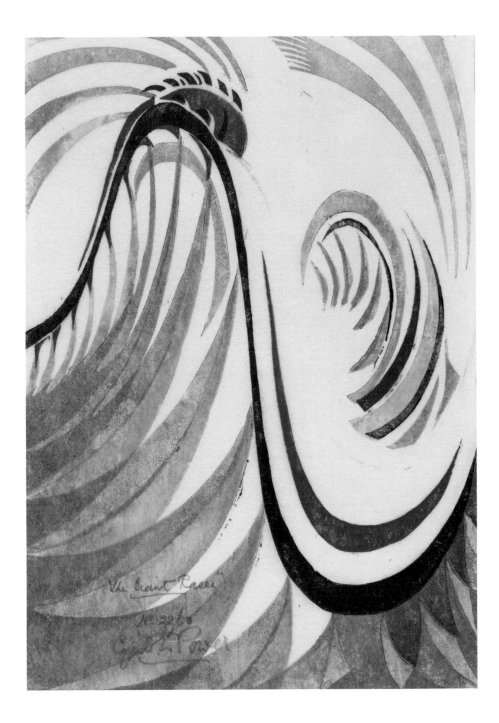

37 CYRIL E. POWER **THE GIANT RACER** ABOUT 1930, COLOR LINOCUT

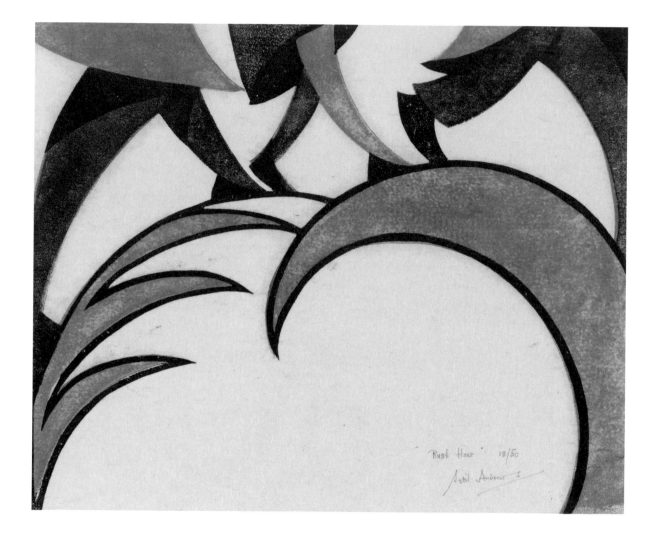

"Rush Hour" 18/50

Sybil Andrews

38 SYBIL ANDREWS **RUSH HOUR** 1930, COLOR LINOCUT

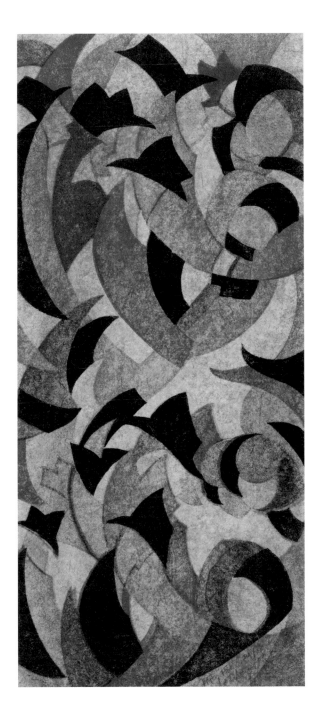

39 SYBIL ANDREWS **HYDE PARK** 1931, COLOR LINOCUT

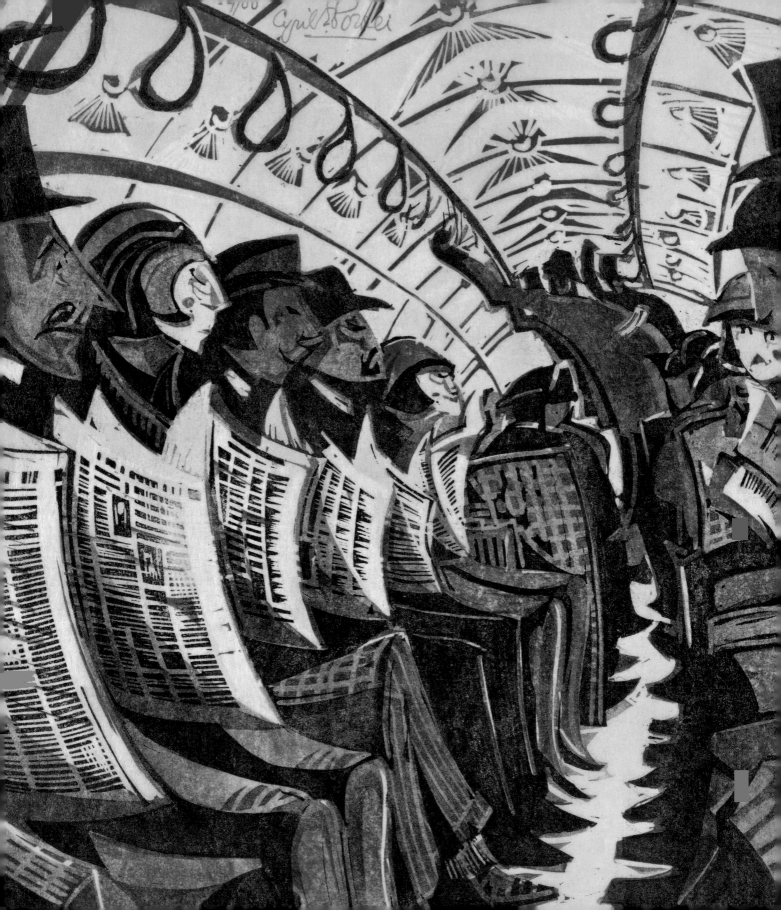

URBAN LIFE / URBAN DYNAMISM

Shortly after C. R. W. Nevinson arrived in New York in 1919 to attend the opening of his one-man show of lithographs at the Keppel Galleries, he announced to the press that America's greatest artistic contribution to the world was its skyscrapers and that "the American idea of art is a well appointed bathroom . . . a plumber their Raphael."[1] His comments echoed those of the French Dadaist Marcel Duchamp, who had infamously claimed two years earlier that "the only works of art America has given are her plumbing and her bridges."[2] Nevertheless, Nevinson, like Duchamp, conceived some of his most important graphic works during his brief trip to New York, undoubtedly inspired by the energy and modernity of the city. While Nevinson portrayed New York as the ultimate modern metropolis, artists of the Grosvenor School — led by Claude Flight, whom Nevinson met in 1912 at Heatherley's School of Fine Art — located the epicenter of modernity in London, creating vibrant linocuts depicting its urban centers, tube stations, and double-decker buses.

Although well known and publicly decorated as a war artist, Nevinson was devoted throughout his career to the dynamism of the city and returned to this theme with renewed vigor at the end of the Great War. "I have thrown over all war work," he declared in 1919. "I hope to concentrate on modern industrialism, or anything connected with human activity."[3] His interest in urban imagery had emerged before the war as a result of his close association with F. T. Marinetti and the Futurists. In his early works, Nevinson, like his Italian counterparts, employed fragmented forms and simultaneous points of view to capture the speed and dynamism of modern life represented by the city's bustling crowds, noisy streets, and often frenzied traffic. After the war, he embraced a newfound naturalism and returned to a conventional, single-point perspective, as did many of his most artistically progressive peers. Despite this new conservatism, his images of the city are among his most successful and fresh. Nevinson found in the gridded streets and geometric architecture of Manhattan a

ready-made modern subject that required little formal intervention. He focused on the Cubo-Futurist aspects of the city, capturing both its pulsating rhythm and its quiet alienation.

Between 1916 and 1931, Nevinson produced close to 150 prints in a variety of media including etching, drypoint, mezzotint, and lithography, executing many of his major graphic works just after his first trip to New York. He made countless sketches during his month-long stay in the city, a number of which he developed into paintings and only sixteen of which he translated into prints. Nevinson worked in the tradition of the painter-etcher. His prints are often closely connected to his paintings and constitute a further exploration of the image in another medium.

Such is the case with the drypoint *New York — An Abstraction* (cat. no. 42). Derived from the painting *The Soul of a Soulless City*, executed one year earlier, *New York — An Abstraction* depicts an isolated stretch of elevated track cutting through the heart of the hard-edged metropolis. The viewer is invited into the composition as a lone passenger in the front car of a train rolling into the city, only to be engulfed and dwarfed by the interlocking geometric forms of its overwhelming architecture. In this claustrophobic composition, with just a sliver of sky visible through the buildings, the imaginary rider is the only human presence. The etching, though diminutive in size, packs a great deal of visual punch. In *Third Avenue under the El-Train* (cat. no. 41), Nevinson once again imparted a powerful dynamism to a small image, this time employing a multiplicity of lines to render an elaborately patterned

shadow on the street that mimics the elevated track's complicated ironwork.

Unlike the confined space of *New York — An Abstraction*, an expansive view of the city's famous skyline is presented in *Looking through the Brooklyn Bridge* (cat. no. 40). Barely visible through the haze across the East River, the monumental buildings along the southern tip of Manhattan appear distant and faint through the bridge's awesome network of suspension cables. Nevinson draws the viewer's eye into the composition with the insistent diagonal of the bridge's wooden walkway yet simultaneously pushes it back with the surface pattern of the cables' crisp lines.

Nevinson celebrated the spectacle of the city in two of his largest lithographs, *The Great White Way* and *Wet Evening, Oxford Street* (cat. nos. 43 and 45). In these nocturnal scenes, he relied on the contrasts of black and white to render dynamic images. He took advantage of the medium's ability to create sumptuous shades of black, especially in his depiction of New York's lively theater district. Here, Nevinson worked from dark to light, laying down broad planes of black ink to establish the basic structure of the composition and then scratching away areas with a scraper to create highlights that define the forms of the buildings and activate the electric signs. The radiating street lights are a reminder of Nevinson's prewar days as a Futurist and recall Giacomo Balla's 1909 painting *Street Light (Electric Light)*. While the city itself takes center stage in *The Great White Way*, the bustling crowd generates the excitement in *Wet Evening, Oxford Street*, one of several prints inspired by Nevinson's native city

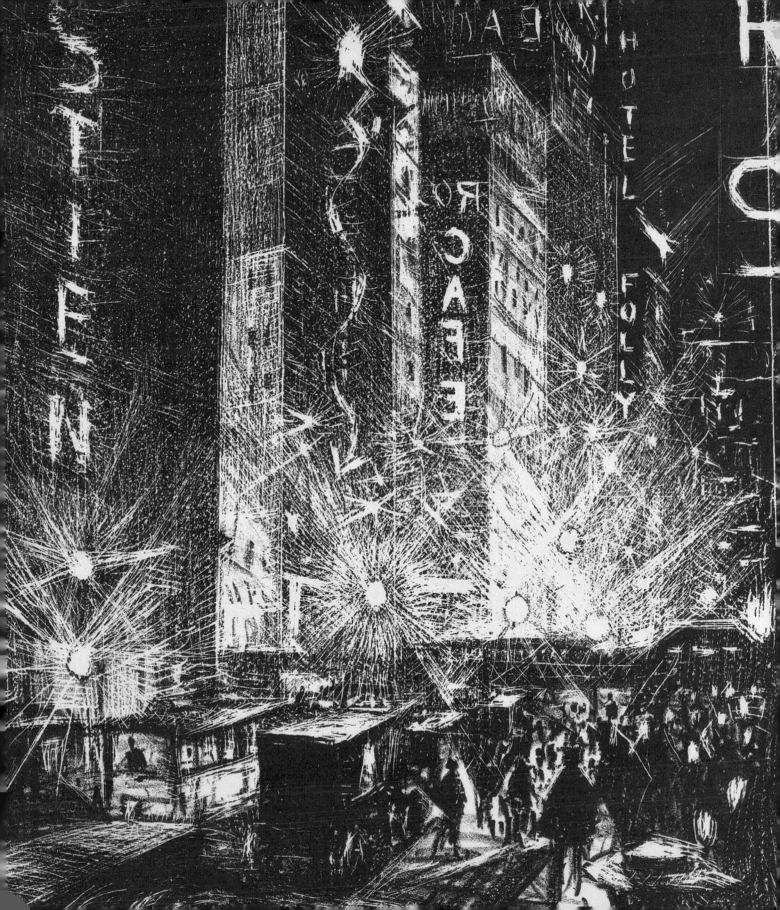

of London. The bobbing heads and repeating umbrellas, illuminated by the shop lights, create a decorative rhythm quite unlike the severe architectonic forms and sooty atmosphere in the more modestly scaled mezzotint *From an Office Window* (cat. no. 44).

The Grosvenor School artists Sybil Andrews and Cyril Power both knew and admired Nevinson's work. In their unpublished 1924 manifesto-like statement "Aims of the Art of To-Day," they recognized the significance of his earlier Futurist-inspired work, declaring: "Look at Nevinson's *Mitrailleuse* [Machine Gun]. To express the revolting horridness and the noisy incessant vibrating, rattle, he has used ugly sharp, angular and square shapes and drabby crude colour which hurt to look at."[4] Power, in particular, picked up on and exaggerated Nevinson's angular forms and expressive use of color to convey a sense of dynamism in his urban images of London. Rather than portray the city's historic buildings or bridges, he focused intentionally on its modern underground system in linocuts such as *The Tube Staircase, The Escalator, Whence & Whither?, The Tube Station* (cat. no. 49), and *The Tube Train.*

Power presents two distinct views of the long mechanical staircases that transport passengers into and out of the tube station in *The Escalator* and *Whence & Whither?* (cat. nos. 50–51). *The Escalator* suggests a sense of anxiety and alienation, pervasive themes in much modern art. Its lone figure, sharply receding staircase, repeating pincer-like arced forms, and somewhat shrill yellow, orange, and green palette create an uneasy tension and vibration similar to Van Gogh's drawing *The Corridor of the Asylum.*[5] Indeed,

Power might have been inspired by this drawing, as it was exhibited twice in London at the Leicester Galleries, in 1923–24 and 1926–27. The abandoned mechanical staircase in *The Escalator* gives way to an endless trail of commuters in *Whence & Whither?* Here, Power represents the riders as faceless figures rendered anonymous by the monotony of the daily commute. As suggested by an earlier title, *The Robottomless Pit, Homo Mechaniens,* recorded on a preparatory study for this print, human beings have become mere robots in the fast-paced world of the machine age.[6]

Power also expressed a sense of modern isolation in his depiction of disengaged passengers in *The Tube Train* (cat. nos. 56–58). Although confined within a tight space, the passengers do not interact with each other or the viewer, preferring, instead, to read their neatly arranged newspapers. Only one young girl with a jack-o'-lantern face, seated on the right side of the train, gazes out at the viewer from behind the sea of subway riders, a scene surely familiar to many urban dwellers. The bright overhead lights, reminiscent of Nevinson's images, illuminate the composition and create a play of light and shade that activates the interior space of the train. Power achieved a similar effect in *The Exam Room* (cat. no. 60). Here, the architecture students display mask-like faces and are seated beneath the glare of lights resembling great staring eyes. While the dramatic lighting and distorted space enhance the tension in the room, the students' faces caricature distinct emotions ranging from nervousness to slyness.

The expressionist qualities of these compositions are offset by the more formal architectural character of

Power's *Tube Staircase* (cat. no. 59). Power was trained as an architect but abandoned the profession in 1922 to pursue a career as an artist. Among his largest prints, *The Tube Staircase* possesses a sense of monumentality and optical dynamism in its striking verticality and pattern of flickering lights and shadows, a prominent feature in many of Power's linocuts. Rather than the machine-like figures that animate *Whence & Whither?*, the serpentine movement of the ascending staircase itself, enhanced by contrasting colors of yellow and blue, breathes life into this otherwise static object, transforming it into a turbine-like industrial form.

Claude Flight's early linocut of a London street scene, *Speed* (cat. no. 46), is more understated than Power's urban images. Rather than employing strong color contrasts or expressive angular or curving shapes, Flight warped the space by using gently undulating forms to suggest rhythm and movement. He achieved the somewhat-muted tonal palette and atmospheric light by experimenting with traditional printing techniques. Instead of printing the dusky blue of the sky and buildings on the front of the sheet, he printed it on the back. The color comes through the thin Asian paper yet appears less intense than the striking red bus, which attracts the viewer's eye as it moves out of the picture's frame.

Both Flight and Power, together with other members of the Grosvenor School, captured the dynamism of urban life with a simplified language of forms and color that serves as a foil to Nevinson's more naturalistic and detailed images in black and white. They were not alone in their interest in the city: the modern metropolis — whether New York or London — provided inspiration to many contemporary artists seeking an alternative to more traditional means of representation. The city's energy and vitality, combined with its new industries, architecture, and infrastructure, affected how the artists saw the world and their role within it. For Nevinson, Flight, and Power, the overwhelming power of the modern city alternately dwarfed its inhabitants, rendered them obsolete, or transformed them into faceless or caricatured beings. Their varied styles and compositions reflect both the awe and the anxiety felt by many urban dwellers and visitors at the time. — SR

1. Nevinson, quoted in Richard Ingleby, "Utterly Tired of Chaos: The Life of C. R. W. Nevinson," in Richard Ingleby et al., *C. R. W. Nevinson: The Twentieth Century*, exh. cat. (London: Merrell Holberton in association with the Imperial War Museum, 1999), 21.

2. Duchamp, "The Richard Mutt Case," *The Blind Man*, no. 2 (May 1917): 5. Facsimile available online from *Tout-fait: The Marcel Duchamp Studies Online Journal,* http://www.toutfait .com/duchamp.jsp?postid=1086.

3. Nevinson, quoted in *Weekly Dispatch*, March 9, 1919. Reprinted in David Cohen, "The Rising City: Urban Themes in the Art and Writings of C. R. W. Nevinson," in Ingleby et al., *C. R. W. Nevinson*, 45.

4. Sybil Andrews and Cyril E. Power, "Aims of the Art of To-Day," unpublished typescript (about 1924), p. 29. Excerpts are reprinted in Stephen Coppel, *Linocuts of the Machine Age* (Hants: Scolar Press in association with the National Gallery of Australia, 1995), 52.

5. For a reproduction, see Colta Ives et al., *Vincent van Gogh: The Drawings* (New York: Metropolitan Museum of Art, 2005), 322–33.

6. See Coppel, *Linocuts of the Machine Age,* 53.

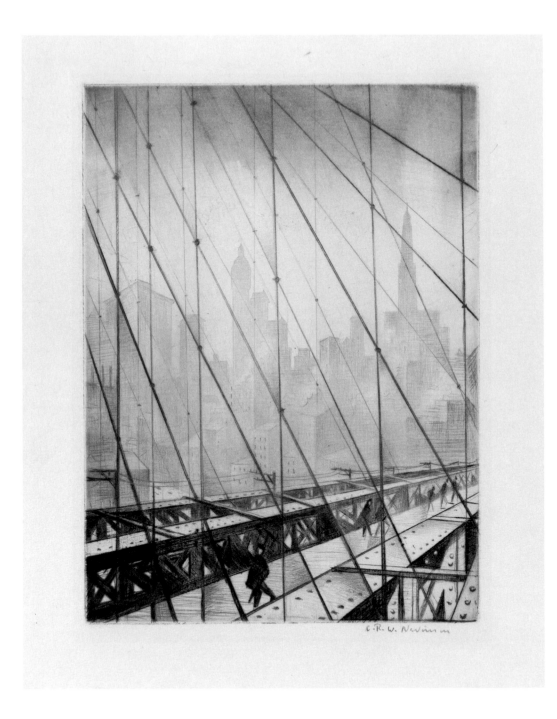

40 C. R. W. NEVINSON **LOOKING THROUGH THE BROOKLYN BRIDGE** 1920–22, DRYPOINT

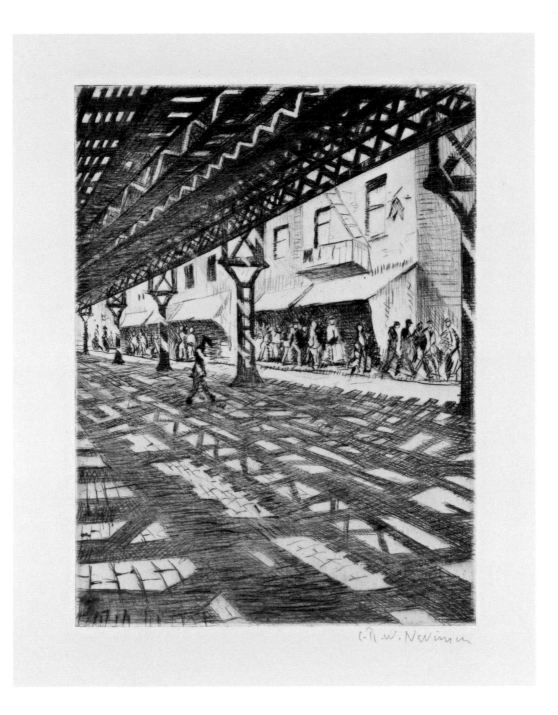

41 C. R. W. NEVINSON **THIRD AVENUE UNDER THE EL-TRAIN** ABOUT 1921, ETCHING AND DRYPOINT

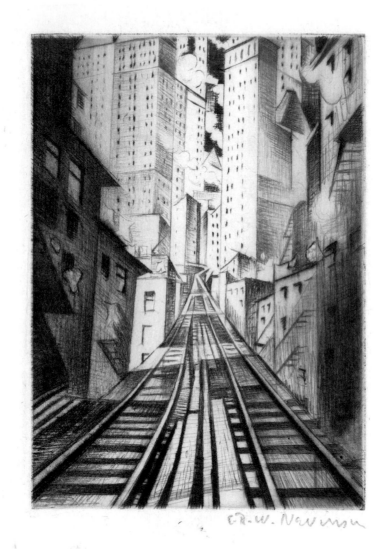

42 C. R. W. NEVINSON **NEW YORK—AN ABSTRACTION** 1921, DRYPOINT

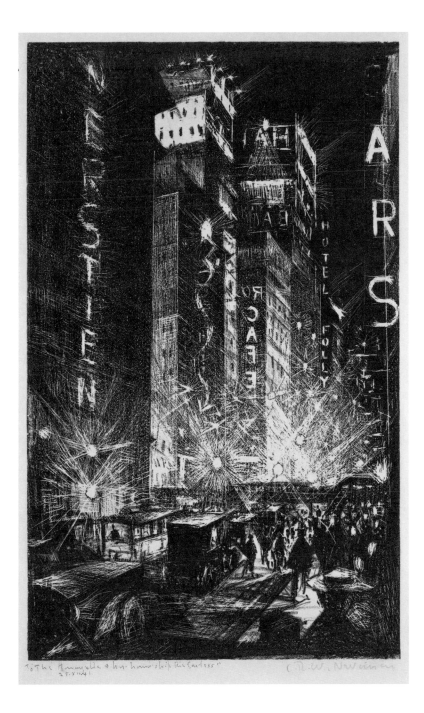

43 C. R. W. NEVINSON **THE GREAT WHITE WAY** 1920–21, LITHOGRAPH

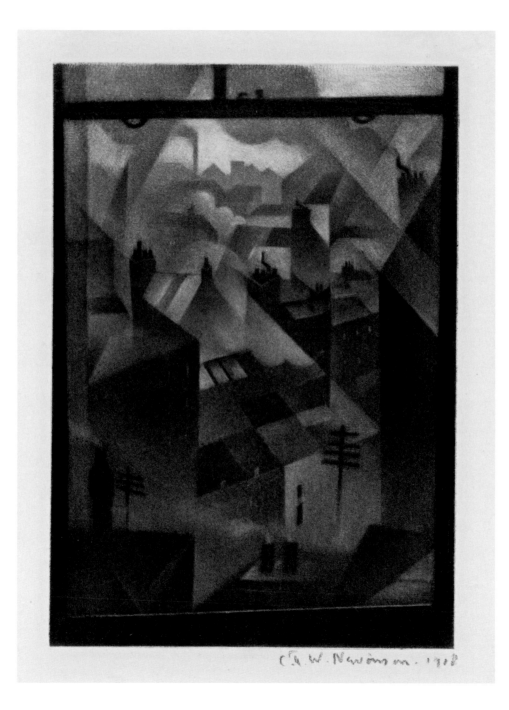

44 C. R. W. NEVINSON **FROM AN OFFICE WINDOW** 1918, MEZZOTINT

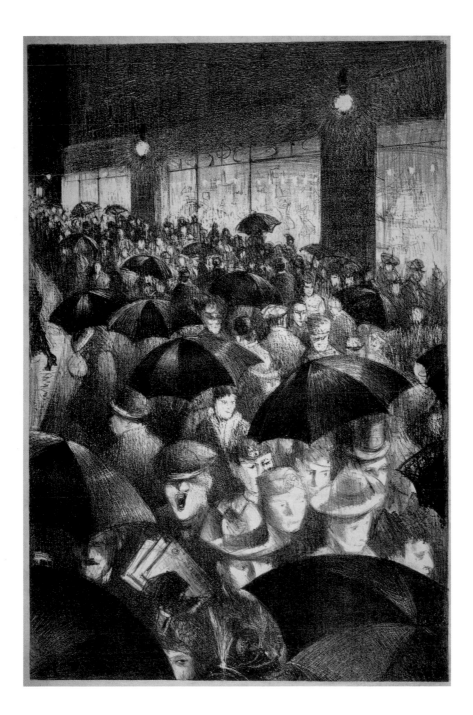

45 C. R. W. NEVINSON **WET EVENING, OXFORD STREET (LES PARAPLUIES)** 1919, LITHOGRAPH

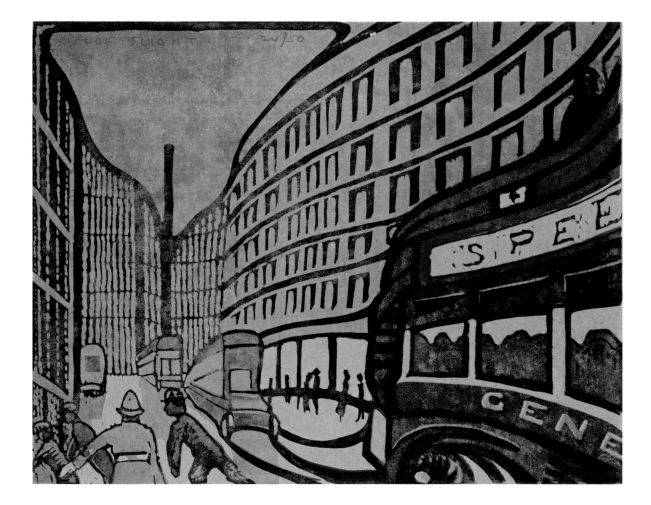

46 CLAUDE FLIGHT **SPEED** 1922, COLOR LINOCUT

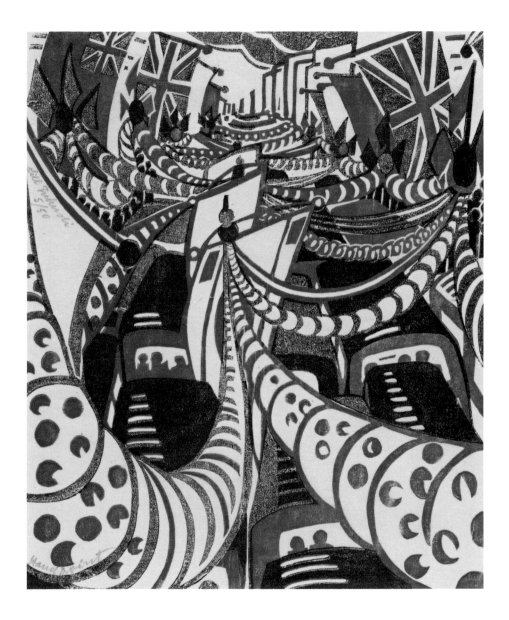

47　LILL TSCHUDI　**STREET DECORATION**　1937, COLOR LINOCUT

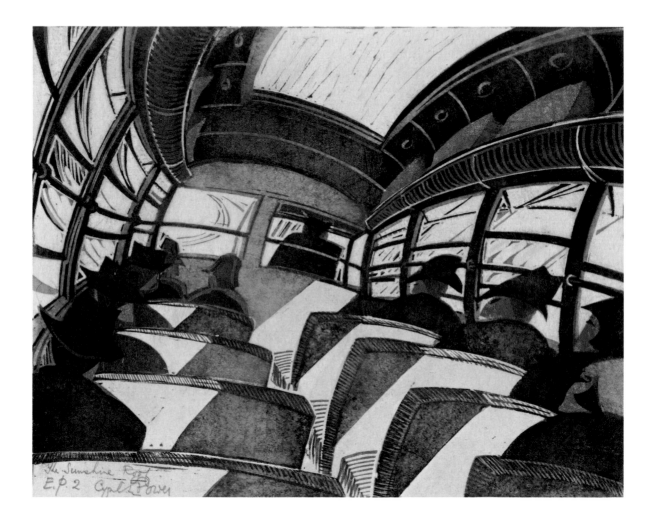

48 CYRIL E. POWER **THE SUNSHINE ROOF** ABOUT 1934, COLOR LINOCUT

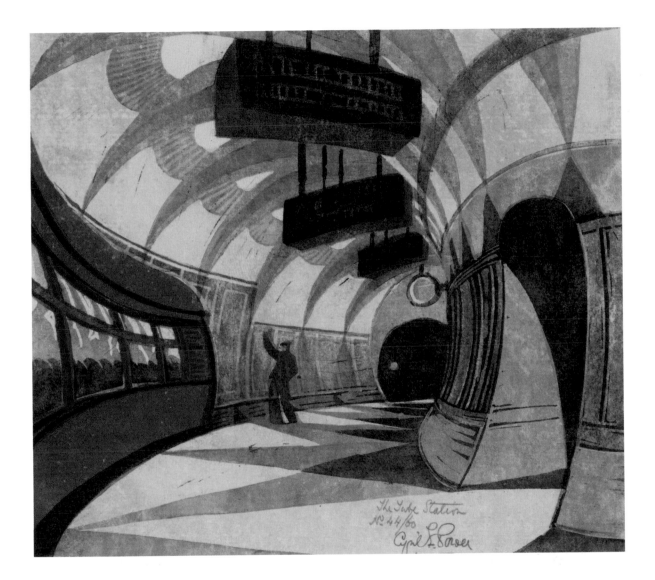

The Tube Station
Nº 44/60
Cyril E. Power

49 CYRIL E. POWER **THE TUBE STATION** ABOUT 1932, COLOR LINOCUT

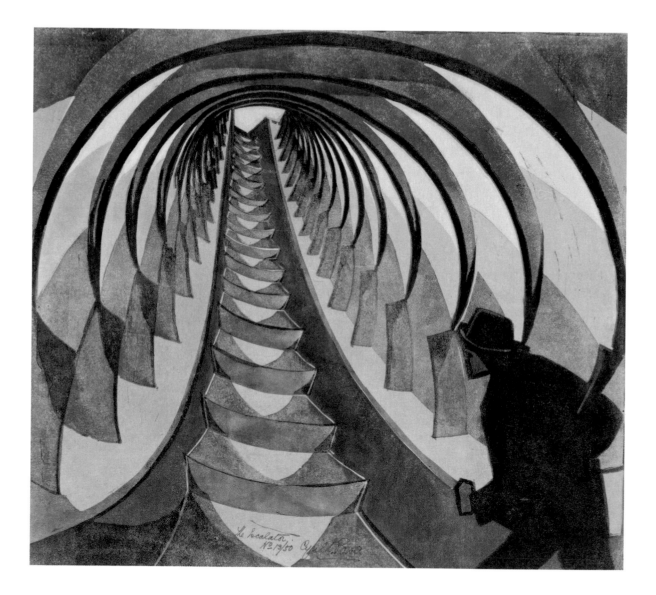

50 CYRIL E. POWER **THE ESCALATOR** ABOUT 1929, COLOR LINOCUT

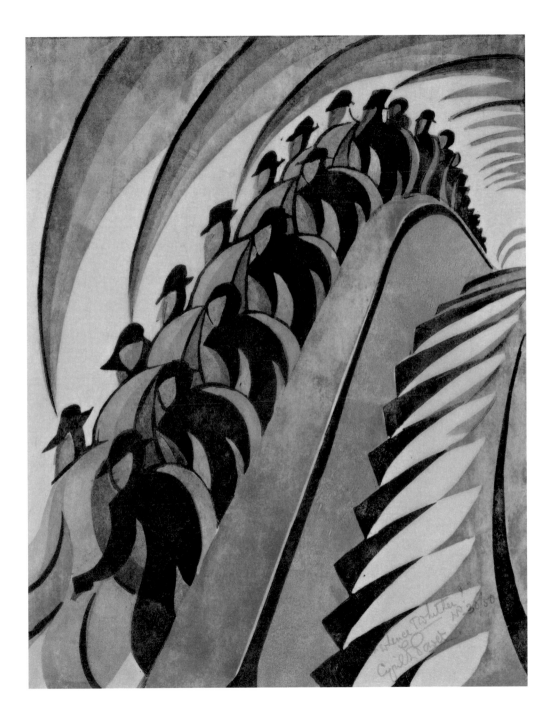

51 CYRIL E. POWER **WHENCE & WHITHER? (THE CASCADE)** ABOUT 1930, COLOR LINOCUT

52 CYRIL E. POWER **LIFTS** ABOUT 1929, COLOR LINOCUT, WORKING PROOF PRINTED IN RED

53 CYRIL E. POWER **LIFTS** ABOUT 1929, COLOR LINOCUT, WORKING PROOF PRINTED IN GREEN

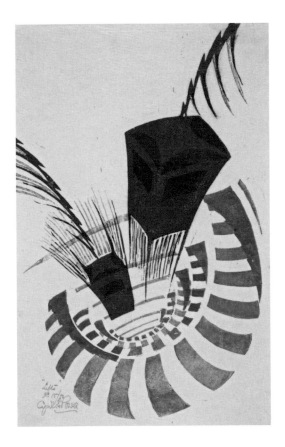

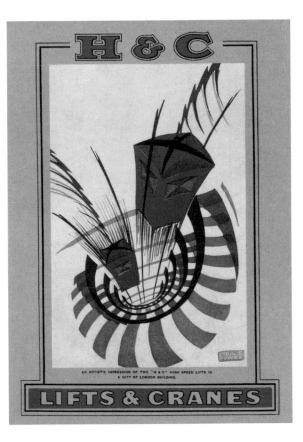

54 CYRIL E. POWER **LIFTS** 1929–30, COLOR LINOCUT, COMPLETED EDITION PRINT PRINTED IN RED, GREEN, AND BLUE

55 CYRIL E. POWER **LIFTS** 1930, PROCESS PRINT FROM LINOCUT

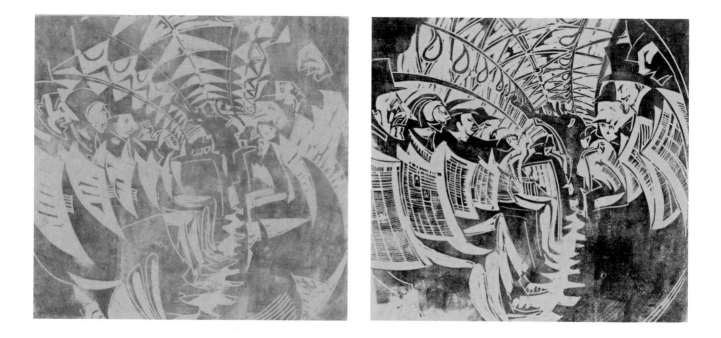

56 CYRIL E. POWER **THE TUBE TRAIN** ABOUT 1934, COLOR LINOCUT, WORKING PROOF PRINTED IN GREEN

57 CYRIL E. POWER **THE TUBE TRAIN** ABOUT 1934, COLOR LINOCUT, WORKING PROOF PRINTED IN BLUE

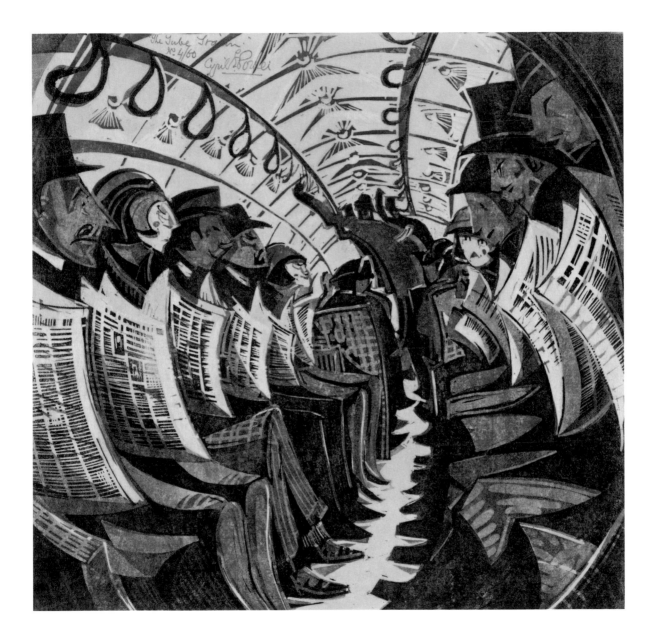

58 CYRIL E. POWER **THE TUBE TRAIN** ABOUT 1934, COLOR LINOCUT, COMPLETED EDITION PRINT

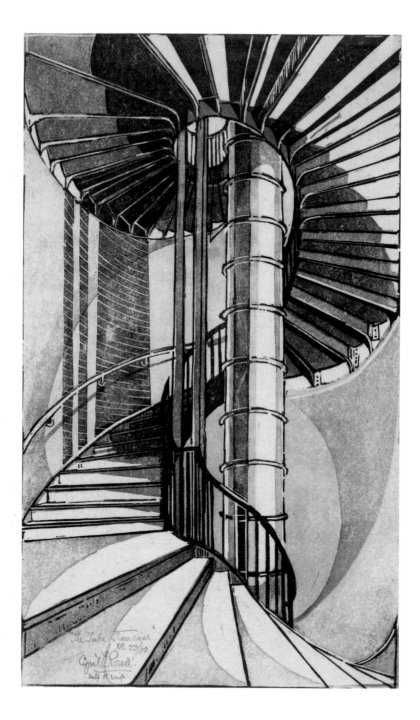

59 CYRIL E. POWER **THE TUBE STAIRCASE** 1929, COLOR LINOCUT

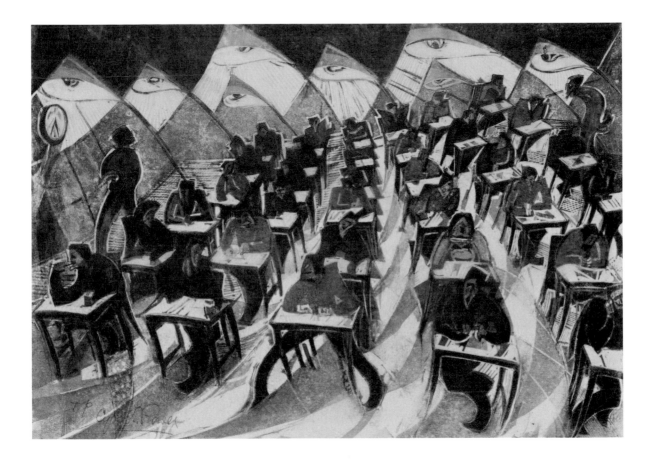

60 CYRIL E. POWER **THE EXAM ROOM** ABOUT 1934, COLOR LINOCUT

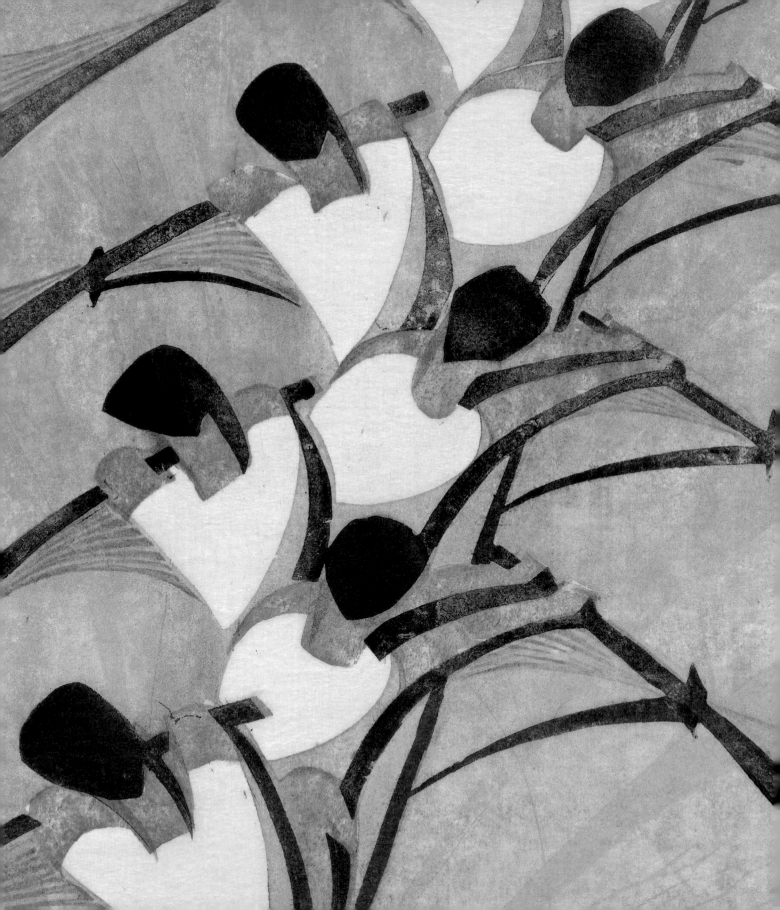

Movement — coordinated, directed, and energetic — made sport an ideal arena for exercising the modernist impulse of the Grosvenor School linocutters. Indeed, Sybil Andrews, Cyril Power, and Lill Tschudi each made several prints of athletic subjects. The uniformity of teammates and competitors, in clothing, physique, and type of movement, reinforced the rhythms that so appealed to the artists. Sport appealed to the public as well. Participatory and spectator sports surged in popularity during the 1920s. The wartime need for able-bodied soldiers and the 1918–19 influenza epidemic had triggered increased interest in physical fitness, health, and hygiene. Utopian idealists saw the human body as a perfectible machine, and fashions favored sleek physiques. The flat forms of linocuts were well suited to presenting the body as machine, and dynamic, sweeping lines set the body in motion.

Angular bodies and boxy heads make the crew team in Andrews's *Bringing in the Boat* (cat. no. 61) appear almost robotic. She heightens the effect by eliminating all individual distinguishing features and turning the rowers' fingerless hands into clamps and hooks. The spirit of unified teamwork expressed in the print echoes the mass demonstrations of synchronized athletic prowess that we now associate with propaganda films of the interwar period. While seemingly straightforward, Andrews's composition contains ambiguities. The vantage point from the top of the steps, yet low to the ground, causes the staircase to appear steep, though each riser also seems wide enough to accommodate a foot of each of two rowers. The zigzag voids between the oarsmen take on a life of their own.

Power, too, took an interest in crew teams. He drew at least ten studies in the process of making *The Eight* (cat. no. 63). Perched on Hammersmith Bridge, not far from his studio, he observed the racing sculls skimming along the Thames during trials for the Head of the River Race. The popularity of the annual March

regatta had been growing rapidly since its inception in 1927. By 1930, seventy-seven crews participated. Executed in pencil, pen, and crayon, one of Power's preparatory drawings for *The Eight* (cat. no. 62) emphasizes the sweeping action of the oars and the bodily strain of the men, who are shown in the late phase of their stroke. The rowers' labor is coordinated by a coxswain who rides in the stern as the boat glides upward on the page, away from our vantage point. We catch a glimpse of the stern of another boat seconds ahead, the passage of time marked by the expansion of the rippling rings made by the touch of the oars on the water. At the upper right, Power marked notes about the color scheme.

By the time of his final design, Power had made many changes. We now see the oarsmen from the back. They travel down the page and are about to pass beneath us. The tightly cropped image eliminates the coxswain, the second boat, and the carefully studied rings in the water. The rowers, not yet straining, are now in the opening phase of their stroke. Beige fields make visible the path through which each oar will sweep. In recasting the image, Power achieved organic unity rivaling the arrangement of seeds and leaves on a plant; yet his heightened tension and compressed forms fully animate the composition.

English football, or soccer, was hugely popular in the 1930s. The Football League established in 1888 had grown to eighty-eight teams. Andrews's players perform a choreographed duet (cat. no. 64). Their sturdily hewn legs are parallel, their shoulders, arms, and

heads nearly mirrored. The round ball is almost lost among the angular forms that appear to project from their surroundings of blank paper.

By contrast, Power's runners whip lithely across a background emblazoned with curving abstract lines of force (cat. no. 66). Perhaps inspired by the lanes of a track or by rising dust, the lines speed the women toward an unseen finish line. Power exhibited this linocut in 1930. The image has been associated with his visits to the Amateur Athletic Association championships held at White City Stadium, near his Hammersmith studio; however, this connection seems to be anachronistic: from 1927 to 1931, that track was planted with grass for greyhound racing. The men's track events were moved there in 1932 and the women's in 1933, probably from Chelsea's Stamford Bridge stadium. Nonetheless, this was an era of great excitement in women's sports. The Women's Amateur Athletic Association had been established in 1922. At the end of the decade, women's world records were tumbling, and in England, Nellie Halstead, Eileen Hiscock, and Gladys Lunn dominated the competition.

After the war, the revealing clothing worn by female athletes had drawn criticism; nonetheless, hemlines rose and necklines dropped, with Coco Chanel's now legendary accidental suntan accelerating the process. Leonard Beaumont's tiny candy-stripe linocut of two women swimming features the snug-fitting, cinch-belted swimsuits that came into style in the later 1920s (cat. no. 65). Beaumont weaves together undulating waves of water, fabric, and flesh, heightening the

sense of motion through transparent water by giving the flesh a degree of transparency as well.

The 1920s and '30s were also the glamour years of champion Norwegian figure skater Sonja Henie. After winning her first World Championship in 1927, at age fifteen, she won nine more in succession, plus the gold medal in three straight Winter Olympics. Along the way, she popularized the short skirt as skating attire. From her childhood, her trainers included a ballet instructor. Henie's fashion sense and her dancer's grace transformed the sport and visibly influenced Cyril Power's linocut of three women whooshing around the ice (cat. no. 67). Skate boots of the period were much suppler than those of today, allowing the women to extend their toes to accentuate the lines of their daringly exposed legs.

Clothing also plays a prominent role in Sybil Andrews's equestrian linocuts. Tight, light-colored pants and smartly tailored dark jackets sharpen the fox hunters' contours (cat. no. 68), while black, red, and orange jerseys boldly set off the jockeys' improbably outstretched arms against the necks of their speeding mounts (cat. no. 69). In both prints, Andrews distorted the landscape to emphasize the motion of the horses.

Among the most dynamic landscapes produced by the Grosvenor School is Tschudi's *Tour de Suisse* (cat. no. 70). Restricted to black and white, her image rivals the graphic impact of Wadsworth's wartime Dazzle Ships (see cat. nos. 27–29). The Swiss bike race, established only in 1933, was still a novelty. Tschudi depicted the cyclists ascending the 6,390-foot elevation of the Klausenpass near her home in Schwanden. Man and machine unite to battle the all-encompassing Alpine terrain, whose switchbacks and precipices completely exclude the sky.

On a more relaxed note, Tschudi's boccia players bowl away the hours (cat. no. 71). The hypnotic circular pattern of the balls contrasts with the understated textures and slack contours of the athletes' clothing. Most of those waiting their turn have loosened their muscles, while the bowler whose turn has come coils himself into a well-calibrated serpentine posture. Tschudi underscores the quiet demeanor of the participants through her dynamic arrangement of curbstones and curving masonry walls.

Taken as a whole, the Grosvenor School sporting images reflect remarkably social and egalitarian tendencies. In an era of sports heroes, the artists insistently maintained their athletes' anonymity. Moreover, we never see the lonely solo athlete; competitors or collaborators are always present. Athleticism, synchronized movement, and participation are given far greater emphasis than the celebrity worship and money that dominate sport in our own time. — TER

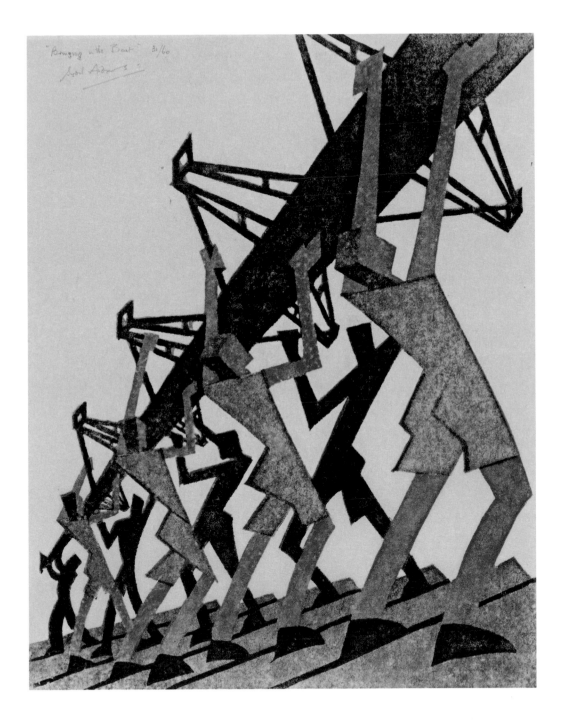

61 SYBIL ANDREWS **BRINGING IN THE BOAT** 1933, COLOR LINOCUT

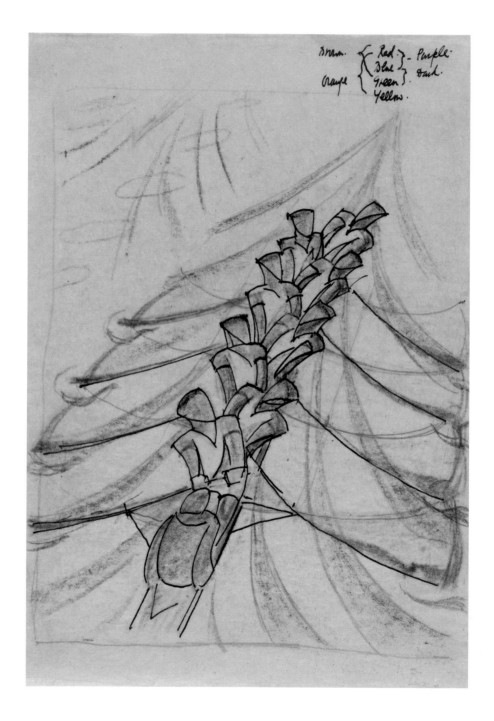

62 CYRIL E. POWER **THE EIGHT** ABOUT 1930,

PREPARATORY DRAWING IN RED, BLUE, GREEN, AND OCHER CRAYONS, BLACK INK, AND PENCIL

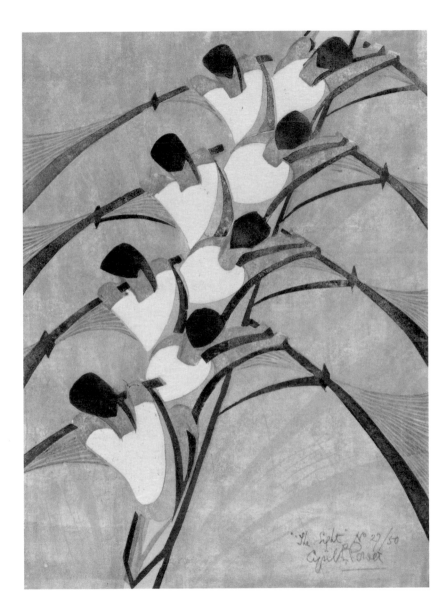

63 CYRIL E. POWER **THE EIGHT** ABOUT 1930, COLOR LINOCUT

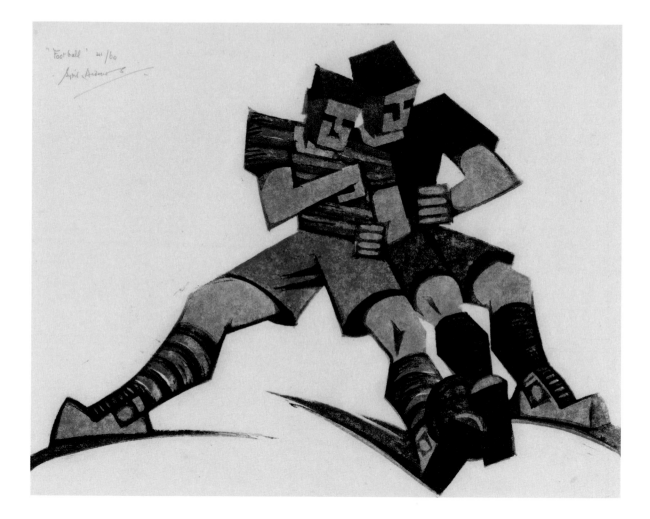

64 SYBIL ANDREWS **FOOTBALL** 1937, COLOR LINOCUT

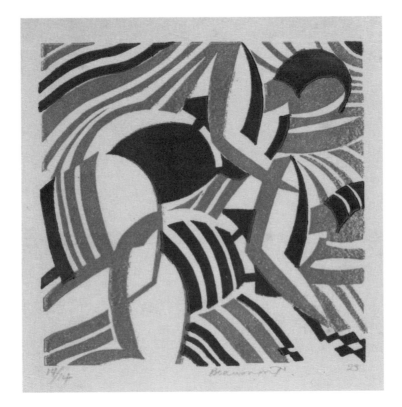

65 LEONARD BEAUMONT **UNTITLED (SWIMMERS)** 1930S, COLOR LINOCUT

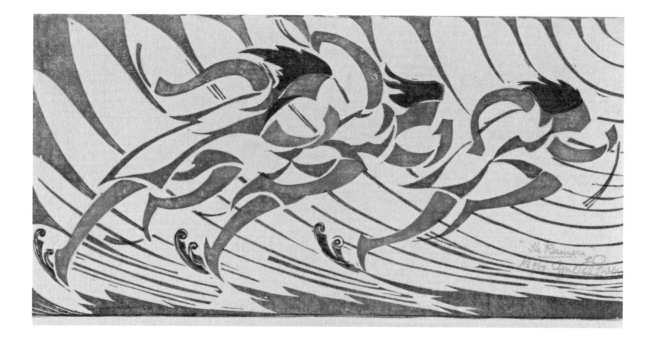

66 CYRIL E. POWER **THE RUNNERS** ABOUT 1930, COLOR LINOCUT

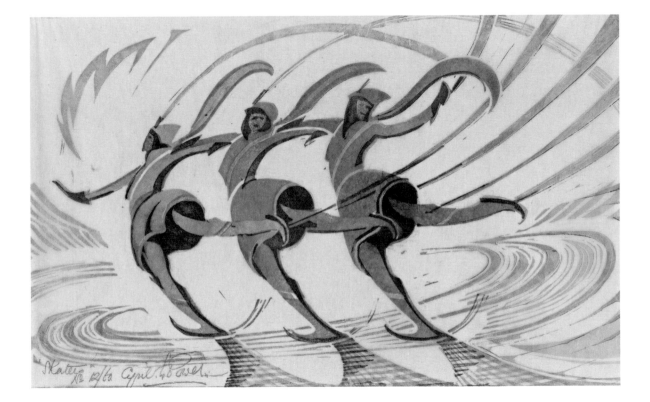

67 CYRIL E. POWER **SKATERS** ABOUT 1932, COLOR LINOCUT

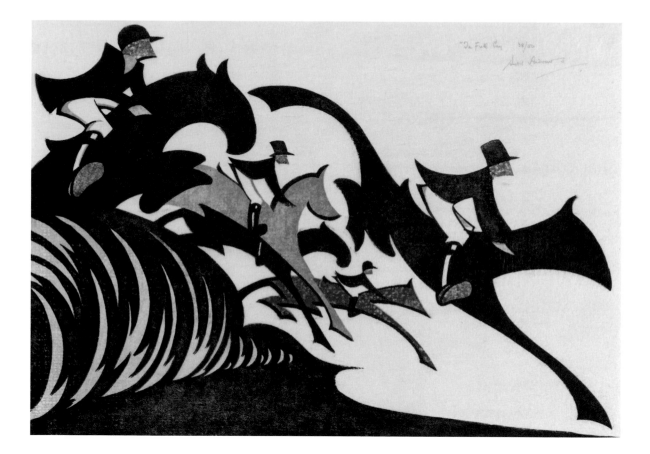

68 SYBIL ANDREWS **IN FULL CRY** 1931, COLOR LINOCUT

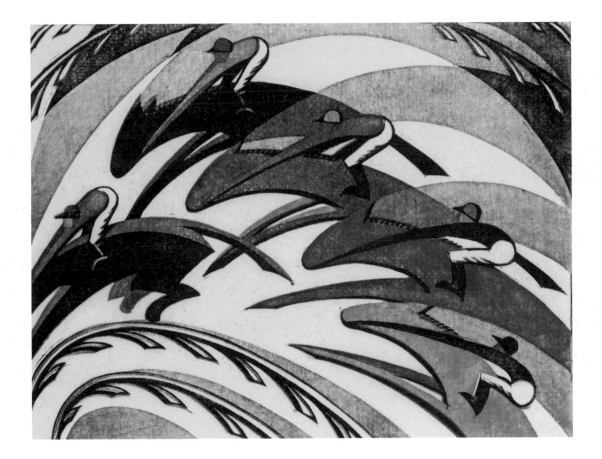

69 SYBIL ANDREWS **RACING** 1934, COLOR LINOCUT

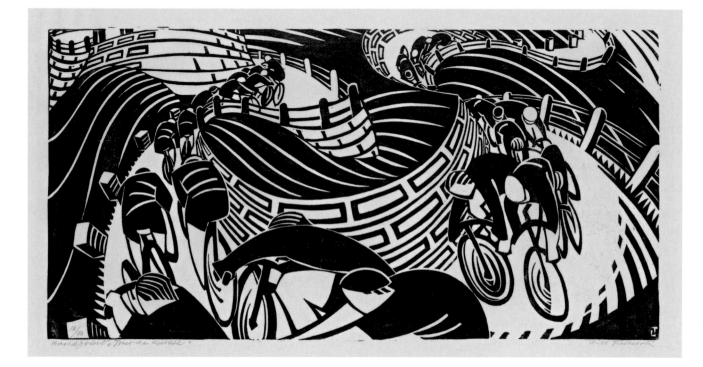

70 LILL TSCHUDI **TOUR DE SUISSE** SEPTEMBER 1935, LINOCUT

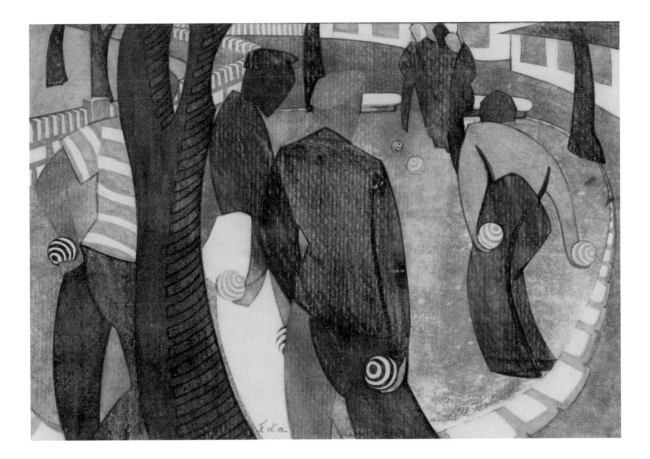

71 LILL TSCHUDI **BOCCIA (JEU DE BOULES)** ABOUT 1934, COLOR LINOCUT

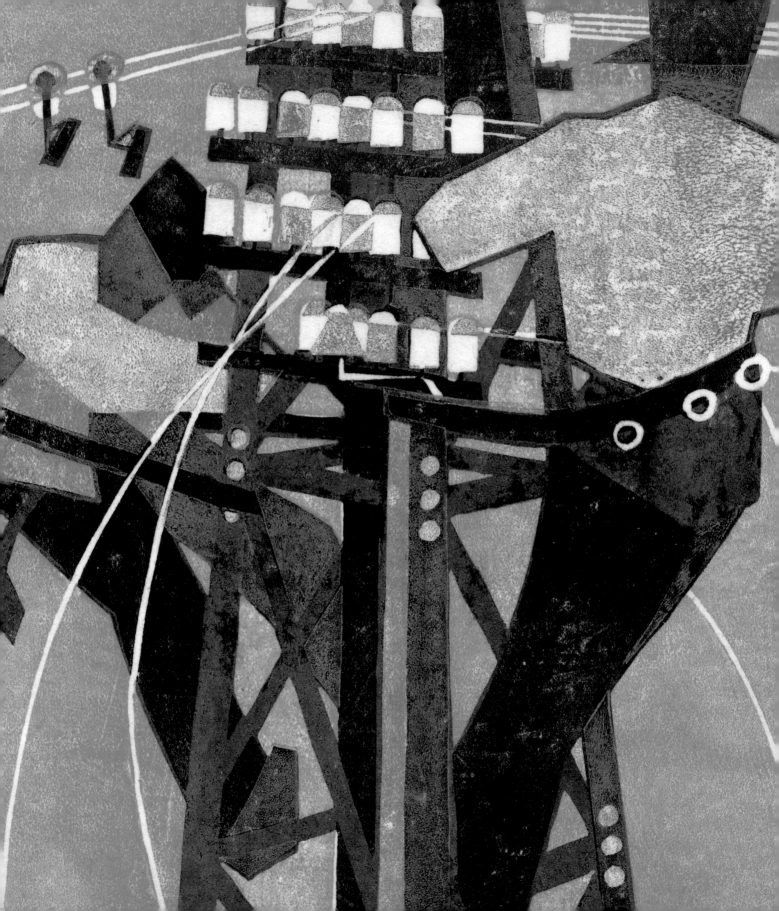

Contemporaries looking at images of workers and factories from the war years through the 1920s and '30s would inevitably have seen them against the backdrop of overwhelming social and economic change. The war swept large segments of the British population into new occupations. Postwar economic conditions further destabilized working life. First, inflation began to consume wages, and then Winston Churchill's 1925 effort to rein in the money supply threw the nation into an economic slump. High unemployment triggered social and political radicalism, strikes, and crackdowns. For the rest of the decade, about a million workers remained unemployed. The shock wave from America's 1929 stock market crash exacerbated the situation. Within a year, joblessness doubled, soaring past 25 percent in some cities. Only when a coalition government of both the Labour and Conservative parties finally allowed the money supply to grow did the dire conditions begin to improve in 1931.

Though the specific economic circumstances in Britain differed from those in the United States, there are parallels in the artistic representation of laborers in the two countries. We might think of the American murals sponsored by various government agencies under the New Deal. Workers are portrayed in positive terms: energetic, strong, and productive. While American prints and photographs trafficked much more frequently in social criticism, British prints tended to resemble America's carefully monitored post office mural program in abstaining from depicting the Depression's devastation. The modernist style of the British printmakers, especially the Grosvenor School linocutters, heightened the anonymity of their laboring figures. Whereas the American muralists sometimes painted their figures with portrait-like individuality, the linocutters subsumed facial features and body language into their program of streamlined stylization. Given the artists' democratic ideals, the anonymity of

their figures may very well have symbolized egalitarian universality.

The war was waged by many who never saw the battlefield. Labor was desperately needed in the factories, ports, and shipyards that supplied materiel to the soldiers. New workers — including some two million women — were also needed to fill other jobs left open by men going off to fight. Propaganda art such as C. R. W. Nevinson's *Loading the Ship* (cat. no. 72) and *Making the Engine* (cat. no. 73) placed home-front productivity on equal ground with combat service. No matter whether the task required brain or brawn, diligence was paramount.

The stevedores in *Loading the Ship* carry massive wooden beams on their backs. The lithograph was preceded by a painting and an etching of the same subject, both of which took in a broader view, including ships and cranes. For his lithograph, Nevinson cropped the image down to the three middle-ground figures. Since the beams extend out of view at both left and right, we imagine an endless procession of materials on the move. The laborers are drawn with a cubistic faceted angularity. Though not quite robotic, they are cogs in a great mechanistic enterprise.

Making the Engine belongs to Nevinson's set of six lithographs entitled "Building Aircraft," which in turn is part of a larger propagandistic portfolio, *The Great War: Britain's Efforts and Ideals*, commissioned by the Ministry of Information and containing the work of eighteen artists. In this Futurist technological paradise, the machinists focus intently on their precision

turning. The whirring drive belts power the image as they do the factory floor. As he worked on his lithographic stone, Nevinson extended his tonal range by scratching and scraping through his crayon drawing. Perhaps less concerned about the subtlety of Nevinson's craft, the Ministry of Information must nevertheless have been pleased by the print's air of intelligent, industrious cooperation.

When the war ended, many artists needed to search for new subject matter. Edward Wadsworth was no exception. The Vorticist returned to the coal-fired industrial landscape of his Yorkshire childhood. Factories inundated by their own smoke, flame, and soot inspired his Black Country paintings and prints (cat. nos. 81–82). Like his wartime Dazzle Ship woodcuts (cat. nos. 27–29), his images of factories pushed representation to the brink of abstraction. Yet their rhythms are less emphatic and their contrasts less stark than those of the ships. Undulating, twisting, and dancing plumes, blown by northern winds, nearly obliterate the factories themselves. Exploring what might be called the Industrial Sublime, Wadsworth imparted varying moods to the anonymous factory-scapes through his choice of colored papers — here, gray and orange.

Among Claude Flight's most talented students, it is notable that the women, Sybil Andrews and Lill Tschudi, found working men a source of inspiration while their male counterpart, Power, did not. The attention to subtleties of natural light evident in Andrews's 1929 linocut of men loading oranges onto a truck (cat. no. 77) distinguishes this work from most other Grosvenor

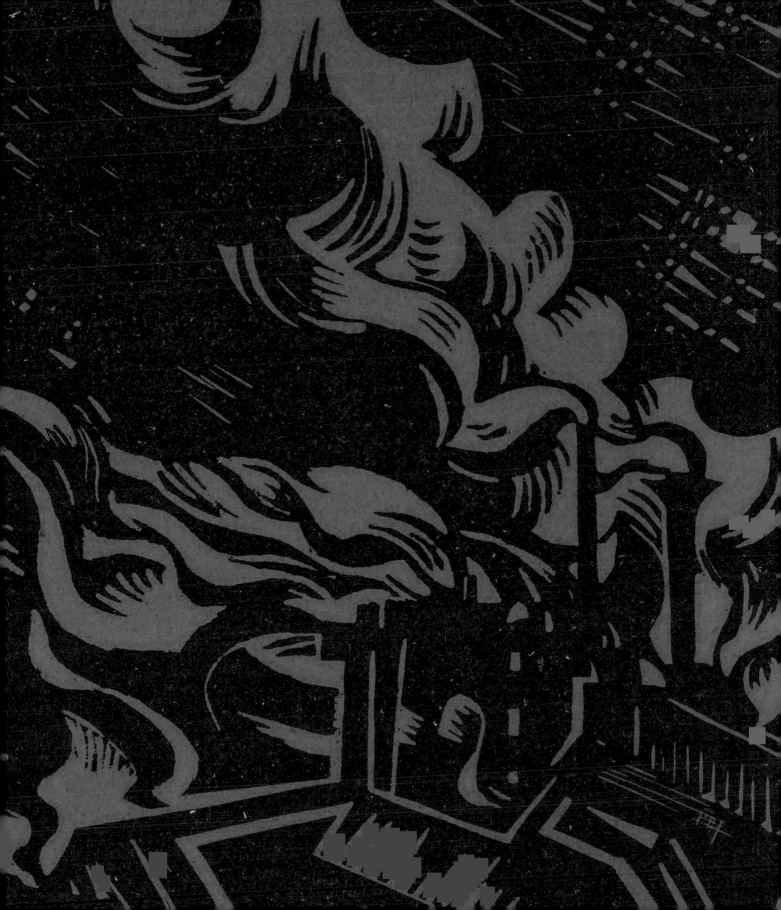

School linocuts. Long shadows tell us that the workers have risen early, and the rhythmic arrangement of the shadows suggests a lively, determined pace. Andrews chose somber, low-key colors and further muted them by using a tone block — an uncut block that laid down a preliminary film of semitransparent ink over which the image was printed. In the soft light of dawn, the men stoop but never stumble beneath the heavy crates.

More typical of Andrews's formula for depicting laborers is her 1930 image of two men cranking a winch (cat. no. 79). The figures are abstracted into forms with sharp, curving contours reminiscent of scythes and sickles. They are less operators of the mechanism than integral parts of it. The sawtooth, pinwheeling aureole leaves no doubt about the vigor they bring to their work.

The blade-like schematic figures are quite recognizable in Andrews's image of cable pullers (cat. no. 80), made the following year. Although Claude Flight proclaimed the linocut a medium free from historical precedent, the artists who practiced the technique did not completely cut themselves off from artistic visual tradition. Here, the workers straining against the cable recall innumerable images of the Raising of the Cross, a traditional episode from cycles illustrating the Passion of Christ. Andrews was familiar with such images, and at the time she depicted the cable pullers, she was starting to make them herself. Beginning in 1931, she made Passion linocuts in each decade through to the 1970s, ultimately producing eighteen such prints, a quarter of her total production.

Another Andrews print, *Sledgehammers*, shows workers at a forge (cat. no. 78). Long a favorite subject of painters for its mysterious nocturnal effects, the forge allows light to emanate from the center of the image. The workers' faces and arms are set aglow by the white-hot iron, which we do not see. Two men pump the bellows and secure the workpiece, while four others wield sledgehammers to strike it in rhythmic succession. Their bodies, arms, and hammers cast dramatic, improbable curving shadows. Again, Andrews uses an explosive background to portray the energy of the workmen, but the pinwheel aureole of *The Winch* here seems to have been shattered by the clanging impact of the hammers.

Lill Tschudi's renditions of men at work are more subdued than those of her British colleagues; she distorted her figures less and relied less on abstract lines to indicate energy and movement. Instead, she allowed the rhythms of their surroundings — both objects and landscapes — to enliven the men's forms. As a result, they seem to be more internally motivated, less controlled by external forces. Tschudi's laborers work cooperatively without appearing caught up in a mechanism the way Andrews's often do.

The linemen in *Fixing the Wires* (cat. no. 74) are surrounded by both taut wires and loose ones in the process of being strung. Tschudi created the wires by engraving fine lines into the surface of her linoleum block, a traditional means of linear representation avoided by her fellow Grosvenor School linocutters. The idea of rhythm — so prevalent among the whole

group of artists — here suggests sheet music, as the insulators act as musical notation on the wire staff. The oblique triangles that mask the left and upper edges, perhaps an abstracted indication of a window frame, charge the image with vertiginous energy.

For any given image, Tschudi could often cite a specific moment of inspiration. *Pasting up Posters* (cat. no. 75) is no exception. She recalled having seen men at work outside a Metro station during her 1933 summer sojourn in Paris, where, for two months each year from 1931 to 1933, she studied life drawing with the Cubist painter André Lhote. Tschudi felt that she particularly benefited from Lhote's ability to make her analyze the construction of her compositions. Such clarity of thought is manifest in *Pasting up Posters*. In its subtle interplay between flat surfaces and three-dimensional spaces, it ranks among the most sophisticated Grosvenor School linocuts. Tschudi added to the calculated appeal of her image by arbitrarily locating the shadows without regard for the natural fall of light. Whereas Andrews and Power often included at least one acid color to electrify their palette, *Pasting up Posters* typifies Tschudi's quieter, more harmonious approach.

While vacationing on the Riviera in 1934, Tschudi came across some sailors scrubbing a sail along the quay. Her linocut of the scene (cat. no. 76) deftly exploits the color of the paper and the varying density of her inks. Her use of dense, dark colors in the sailors' clothing heightens the whiteness of the paper that she allows to show through. The gray ink of the sail and the bucket carrier's hat is thinly applied, allowing a textured linoleum block to mimic the softness of fabric in contrast to the hardness of the surrounding pavement. Simple but effective, Tschudi's cutting of the spray of water creates transparency, allowing the leg of the center sailor's dungarees to show through.

As the 1930s unfolded, Tschudi's approach to images of labor remained consistent: anonymous individuals cooperate to get the job done, using their hands or simple tools. In the sole instance of a complex machine coming into use, the worker is firmly in control. By contrast, Andrews shifted her focus at mid-decade, conceiving of her workers as less machine-like than in her earlier prints. Though more a landscape than a study of labor, *Fall of the Leaf* (cat. no. 100), from 1934, suggests the changes to come. While their forms remain angular, the figures are now engaged in farming activity and, like Tschudi's workers, use their hands and simpler tools rather than cranks and winches. The textures of the land supplant the abstract and man-made surroundings that Andrews's laborers had occupied previously. Given her religious inclinations, we might see her as turning from the hubris of modernist utopianism to place humanity in greater harmony with God's creation. — TER

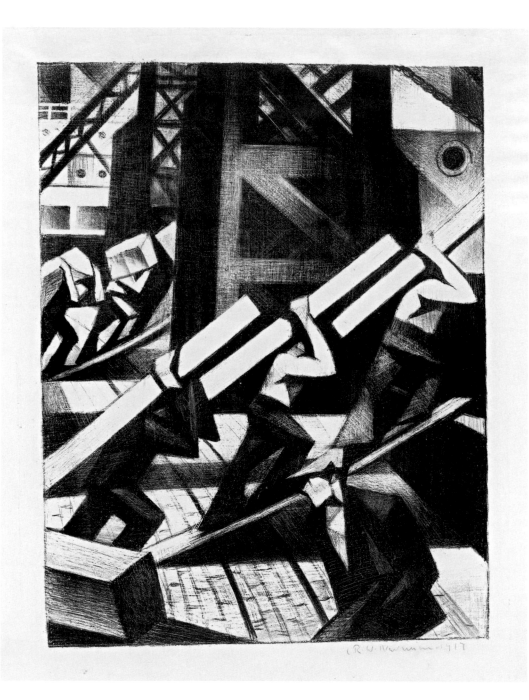

72 C. R. W. NEVINSON **LOADING THE SHIP** 1917, LITHOGRAPH

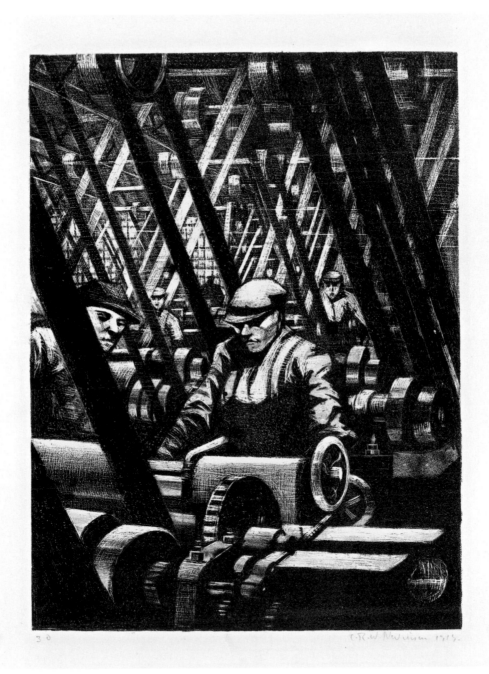

73 C. R. W. NEVINSON **MAKING THE ENGINE** 1917, LITHOGRAPH

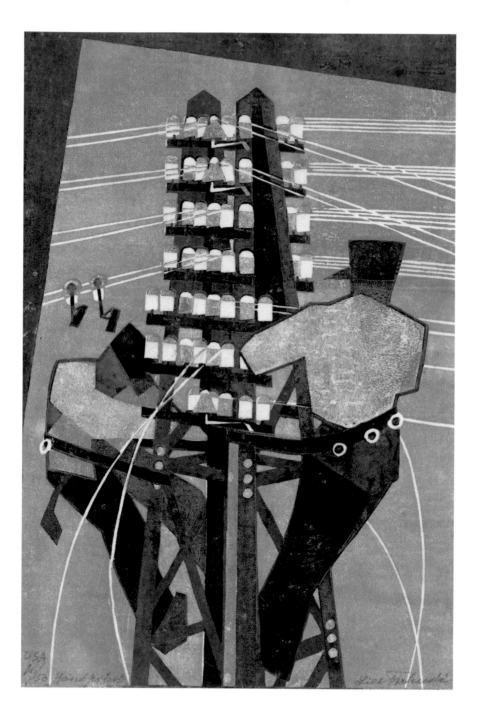

74 LILL TSCHUDI **FIXING THE WIRES** 1932, COLOR LINOCUT

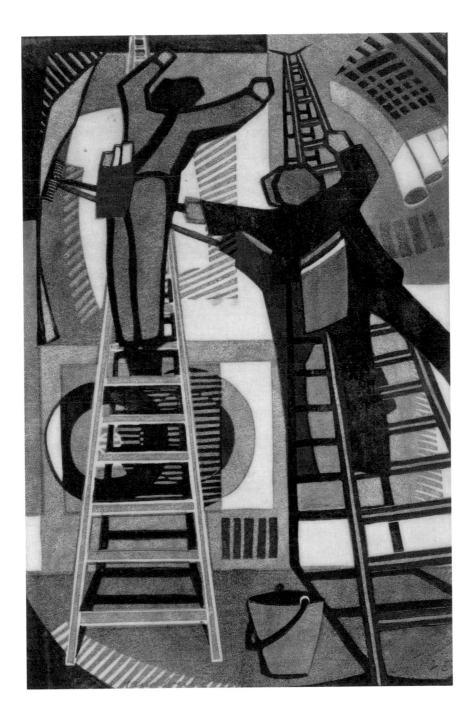

75 LILL TSCHUDI **PASTING UP POSTERS** 1933, COLOR LINOCUT

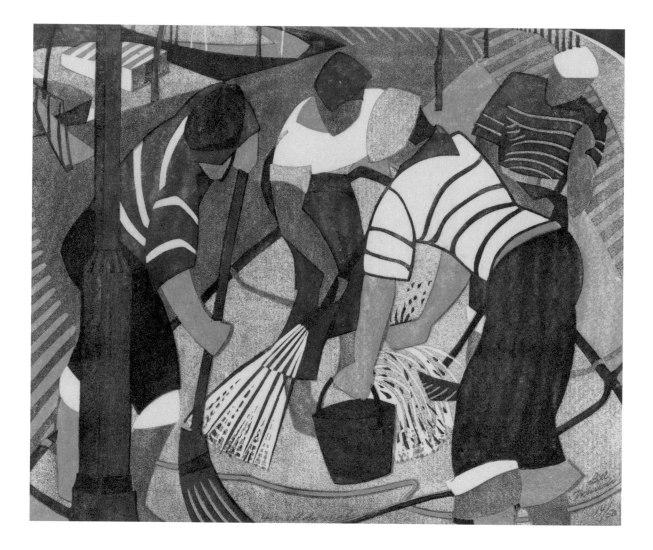

76 LILL TSCHUDI **CLEANING A SAIL** 1934, COLOR LINOCUT

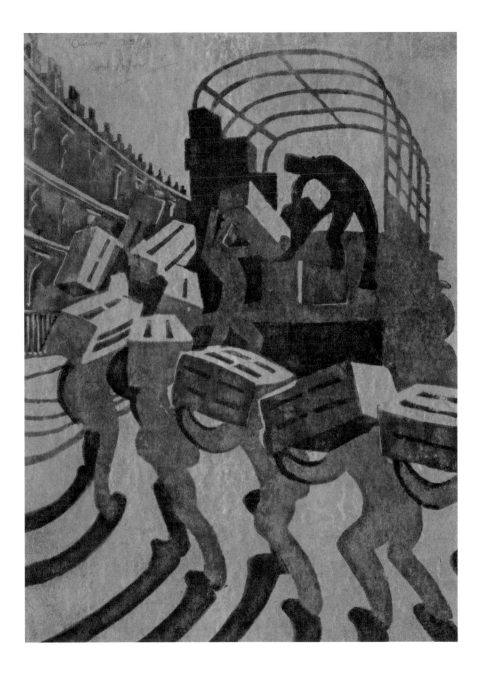

77 SYBIL ANDREWS **ORANGES** 1929, COLOR LINOCUT

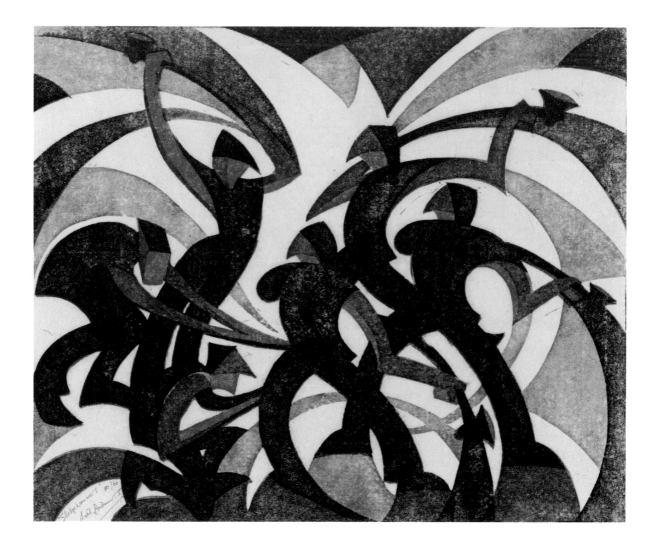

78 SYBIL ANDREWS **SLEDGEHAMMERS** 1933, COLOR LINOCUT

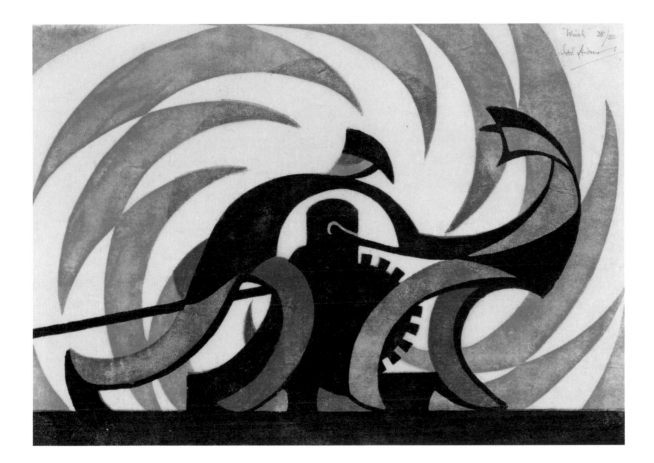

79 SYBIL ANDREWS **THE WINCH** 1930, COLOR LINOCUT

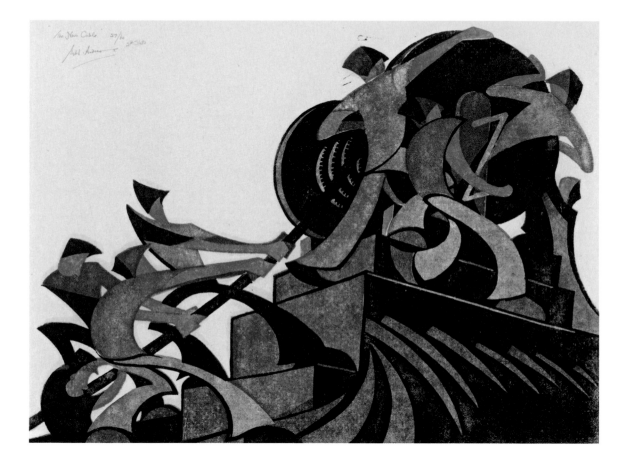

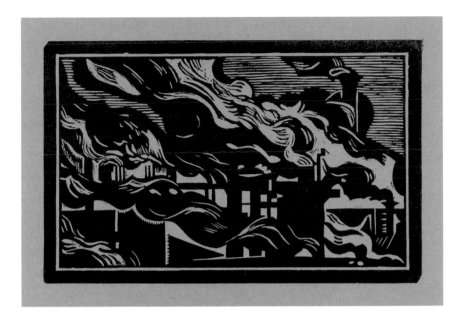

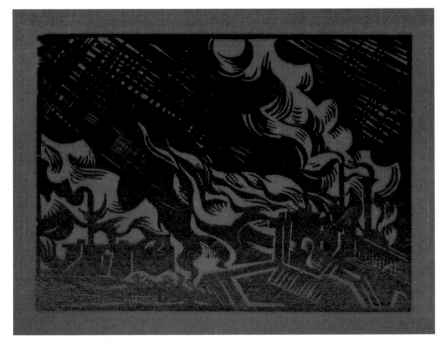

81 EDWARD WADSWORTH **BLAST FURNACES** 1919, WOODCUT

82 EDWARD WADSWORTH **BLACK COUNTRY** 1919, WOODCUT

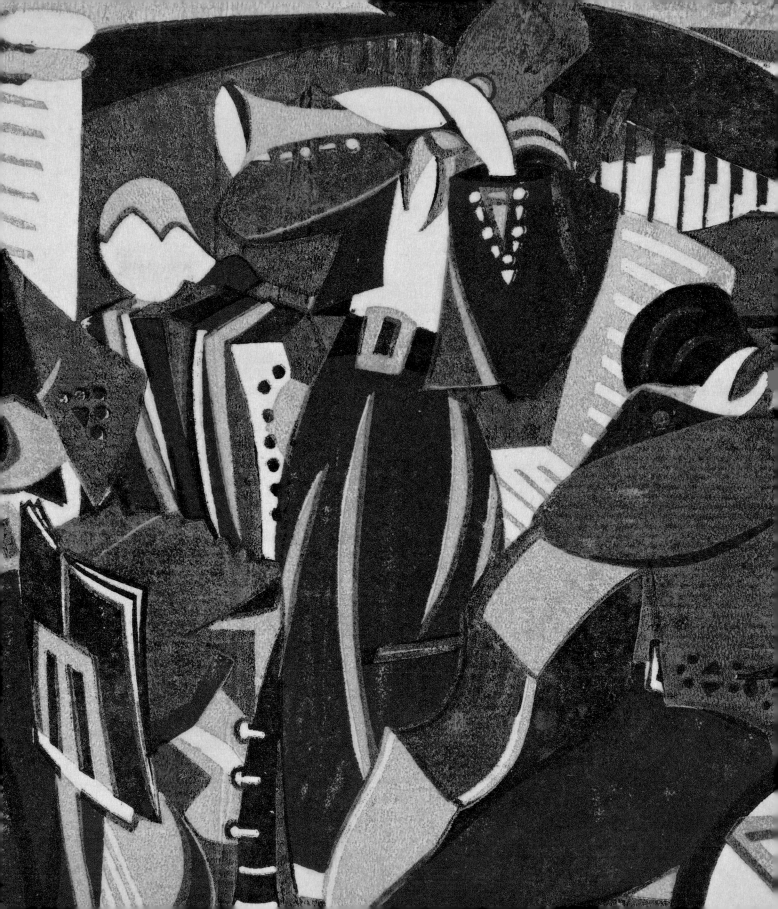

ENTERTAINMENT AND LEISURE

Despite England's postwar political and financial uncertainties, the pursuit of leisure became a widespread social phenomenon. The wartime upheavals that took men off the farm and women out of the house redistributed the availability of leisure time to broader populations. Entertainers eagerly catered to brows high, middle, and low in concert halls, cabarets, and circus tents. The Grosvenor School linocutters found inspiration in the spectacle and applied to it their own brand of dynamic vision.

Claude Flight's conjuror sends playing cards flying on a boomerang trajectory around the stage (cat. no. 83). Flight often scattered spots of light through his images, causing our eyes to dance over the surface, making us participants in the animation. Beyond the scope of the spotlight, we see what appear to be the magician's props, but as is often the case in Flight's art, which shuttles between abstraction and representation, some elements of the semi-abstract image are difficult to decipher. The artist further destabilizes our perception by coloring parts of the magician's trousers with the same blue as the background. As a result, the performer and his surroundings are flattened and seem perforated like a stencil — the tool often used by Flight when engaged in wall decoration and a favorite motif of the Cubists.

Sybil Andrews barely indicated the playgoers in her theater interior (cat. no. 84), and in her concert hall the audience's heads are reduced to rows of decorative patterning (cat. no. 85). For Andrews, the real interest lay in the architecture. But whose architecture is it? Her points of departure were the "Old Vic," a theater built in 1818 and renovated in 1833 and 1871, and Queen's Hall, a concert venue completed in 1893 and heavily encrusted with Neo-Renaissance ornamentation. In Andrews's hands, the buildings became spare, sleek Art Deco structures of 1929. Unfortunately, German bombs would badly damage both of the actual buildings in the Blitz of 1941.

Queen's Hall was mourned not for the loss of its oft-doubted beauty but for its renowned acoustics. Cyril Power's rendition of the hall's interior from 1935 (cat. no. 86) focuses directly on the orchestra in the full heat of performance, with the whippet-like conductor urging them on. None of the players is at rest, and the curving shadows cast by the violinists seem to point to the reverberating piano as the source of light.

Meanwhile, back at the cabaret, Lill Tschudi's fourteen-member jazz orchestra has taken the stage (cat. no. 87). Impeccably dressed in tuxedos, the band is in action, the mandolin, saxophone, and clarinet having been set aside temporarily while their musicians sing this number. Perhaps the irregular clusters of visual rhymes in Tschudi's cool black-and-white composition are intended as a metaphor for the structure of the music played by the band. The artist required hot colors when the time came for her Cuban rhumba band (cat. no. 88). Containing strains of both Spanish and African sound, rhumba music had circulated since the 1890s, but American drinkers thirsty for rum during Prohibition headed south and came home with a taste for a new version of the music with a much faster, double-time beat. In the late 1920s, Xavier Cugat and his orchestra became the personification of the rhumba, and soon the craze jumped the Atlantic.

The circus also proved attractive to both Tschudi and Power. Comparison of their representations of acrobats highlights differences in their typical approaches to motion and to image making in general (cat. nos. 89 and 92). Tschudi freezes the action of her sturdy geometric figures and suggests movement through abstract disjunctions in lighting and color. Power more frequently employs limber curvilinear forms supplemented by multiple abstract lines of force and movement. Tschudi's work, full of irrational transparencies and arbitrary color, is firmly rooted in the Parisian Cubism of her teachers André Lhote and Fernand Léger, while the frenetic kaleidoscopic movement in Power's art suggests the Futurist origins of Vorticism.

A rare Experimental Proof of Power's *Acrobats* (cat. no. 91) allows us to see his critical eye at work as he refined the image. After experimenting with a contrast of cold cobalt blue and warm, light reddish orange, he switched the tent to chrome yellow, producing a warm-on-warm gradient that opens up the space through which the acrobats fly (cat. no. 92). He further expanded the space by removing scattered lines from the tent's panels. In the proof, the shadows on the performers fade softly at the edges, resulting in an illusion of volume. For the finished print, Power sacrificed this effect in favor of more sharply defined shadows that emphasize contours. He apparently decided that his initial array of motion indicators was too dense for the slight figures, removing several solid areas of red and lightening others by transforming them into clusters of parallel lines. He also seems to have added a third block to print stripes that subdue the reds of the tent pole and emphasize the vertiginous height of the big top.

In the nineteenth century, London's Hampstead Heath became the site of holiday carnivals that continue to this day. In the 1890s, a popular song by comedian

Albert Chevalier gave the area the enduring Cockney-inflected nickname 'Appy 'Ampstead, which Power borrowed for his dizzying linocut of swingboats along the midway (cat. no. 90). When Claude Flight studied a smaller version of the carnival ride a decade earlier, he organized his image with the precise concentric patterns of a fingerprint (see cat. no. 34). In Power's conception, the demonic contraption threatens to spin out of control. The frenetic merrymakers seem to radiate so much dizzying energy that the machine's framework melts away, and Power's sweeping lines of force suggest that some of the gondolas may have flown in full circular motion over the crossbar.

Far less chaotic and more in keeping with the controlled regularity of Art Deco style, Power's linocut of dancers onstage (cat. no. 93) employs insistently repeated forms throughout. Even the area of curtain decorated with a lightning-bolt pattern has a friend in the dark wedge of stage front projecting below. Though a 1920s performance by Serge Diaghilev's Ballets Russes was Power's source of inspiration, he may have updated the architecture, much as Andrews modernized her theater buildings. It may be no coincidence that the Rockettes' first performance in Donald Deskey's Radio City Music Hall was in 1932, about the time that Power made this print.

Repeated forms also play a role in Eileen Mayo's linocut of women lounging in a Turkish bath (cat. no. 94). Though it may not be immediately apparent, there is something uniquely modern about her image. Mayo is said to have made the print after receiving linocutting instruction from Claude Flight over the telephone. Her depiction favors languor over speed, yet her use of zigzags, stripes, dots, and diamonds enlivens the composition with rhythmic Art Deco patterns. Mayo also engages in ambiguity, mixing perspectively constructed space with arbitrary flatness.

Whether or not movement was inherent to the leisure time pursuits they depicted, the Grosvenor School artists frequently energized their compositions through radial arrangements resembling cogs or spokes. This can be seen in the architecture of Andrews's audience halls, the light rays and limbs of Tschudi's acrobats, and the seams of Power's circus tent, as well as in the tutus and scenery of Power's ballet. As a metaphor for the thrill of disorientation, Power let the scheme go haywire in 'Appy 'Ampstead.

Another feature common to all the Grosvenor School prints of entertainers is that, as in the sporting images, the figures are anonymous types rather than identifiable star performers. Apart from a scant handful of portraits, the artists generally dealt with archetypes, conceptual abstractions in keeping with their interest in formal abstraction. — TER

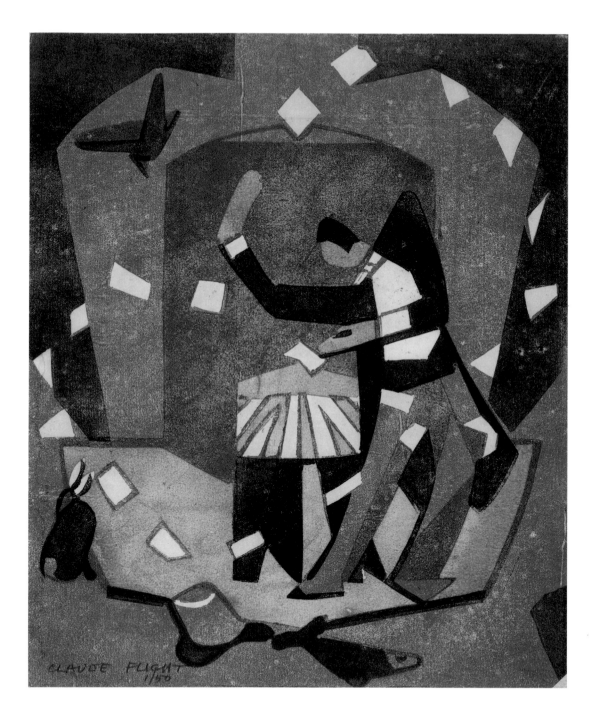

83 CLAUDE FLIGHT **THE CONJURER** ABOUT 1933, COLOR LINOCUT

84　SYBIL ANDREWS　**THEATER**　1929, COLOR LINOCUT

85 SYBIL ANDREWS **CONCERT HALL** 1929, COLOR LINOCUT

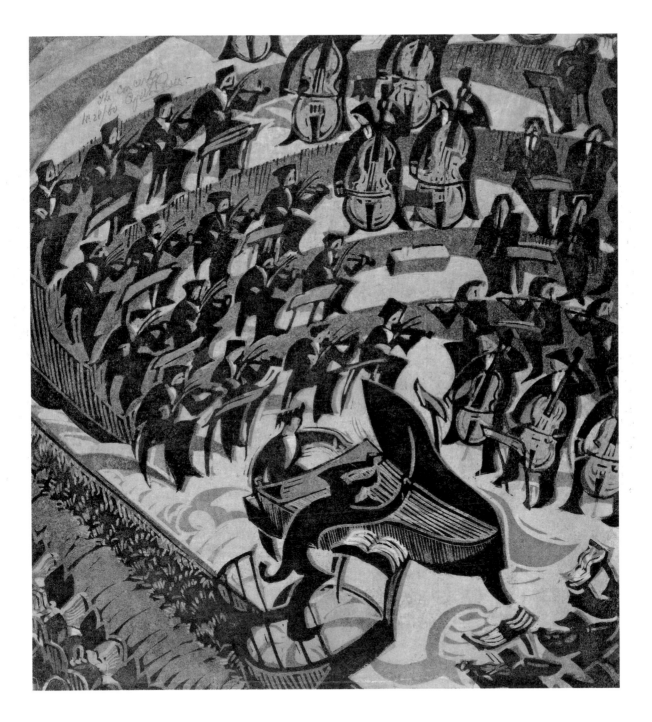

86 CYRIL E. POWER **THE CONCERTO** ABOUT 1935, COLOR LINOCUT

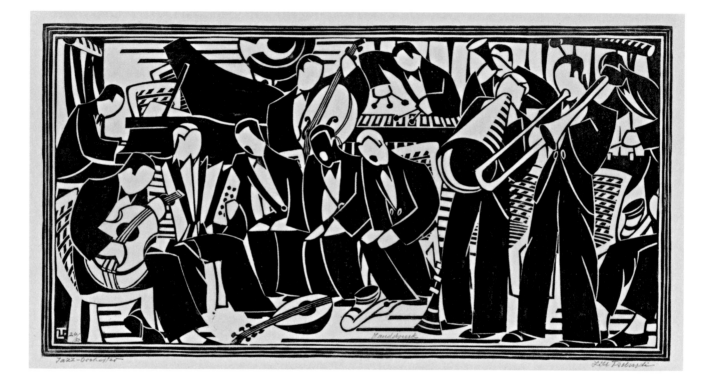

87 LILL TSCHUDI **JAZZ ORCHESTRA** DECEMBER 1935, LINOCUT

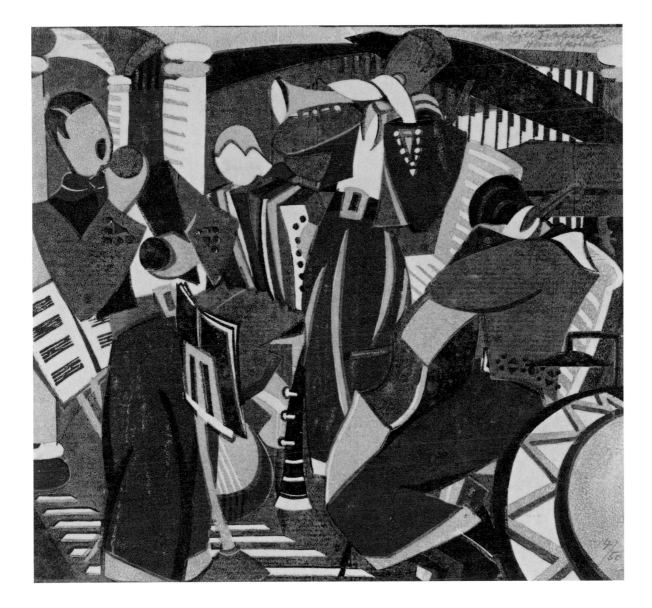

88 LILL TSCHUDI **RHUMBA BAND II** APRIL 1936, COLOR LINOCUT

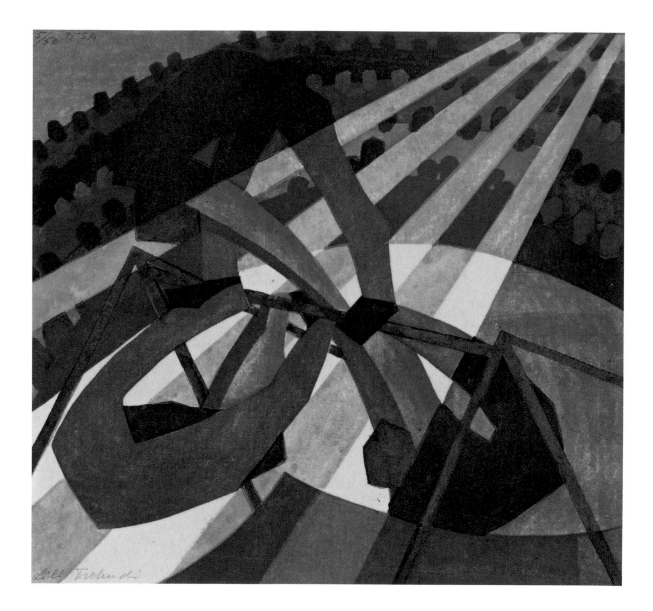

89 LILL TSCHUDI **IN THE CIRCUS** 1932, COLOR LINOCUT

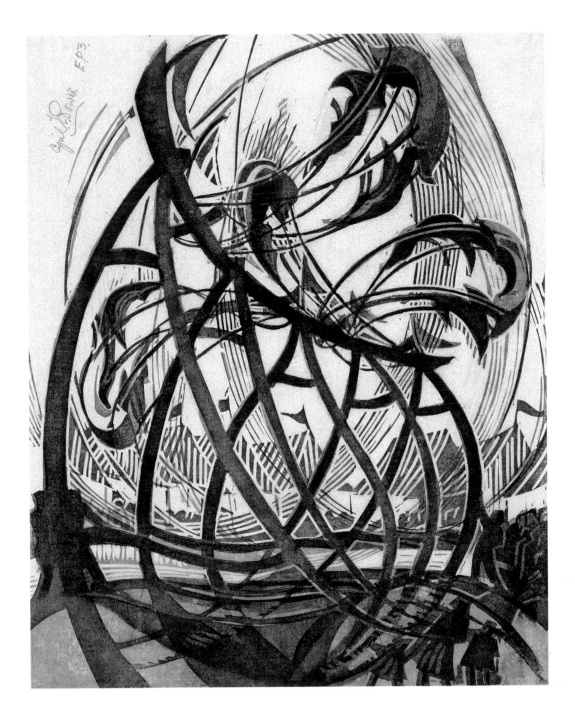

90 CYRIL E. POWER **'APPY 'AMPSTEAD** ABOUT 1933, COLOR LINOCUT

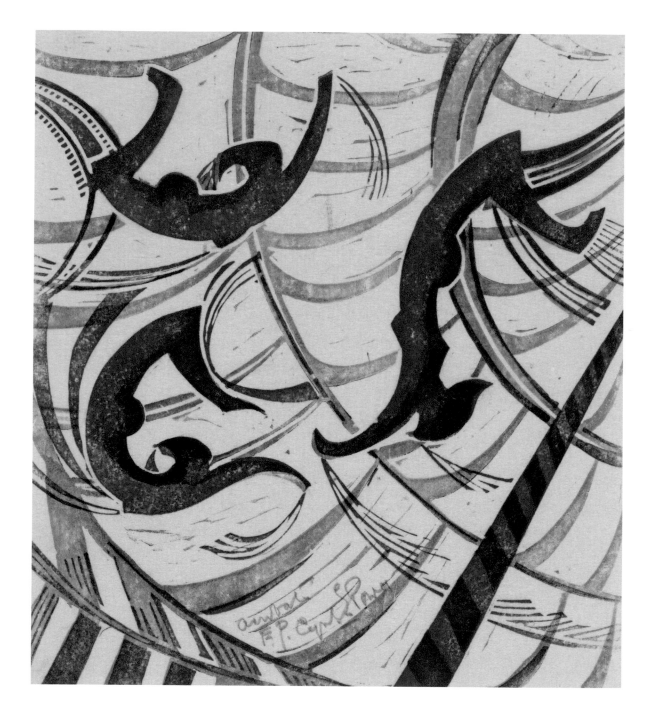

91 CYRIL E. POWER **ACROBATS** ABOUT 1933, COLOR LINOCUT, EXPERIMENTAL PROOF

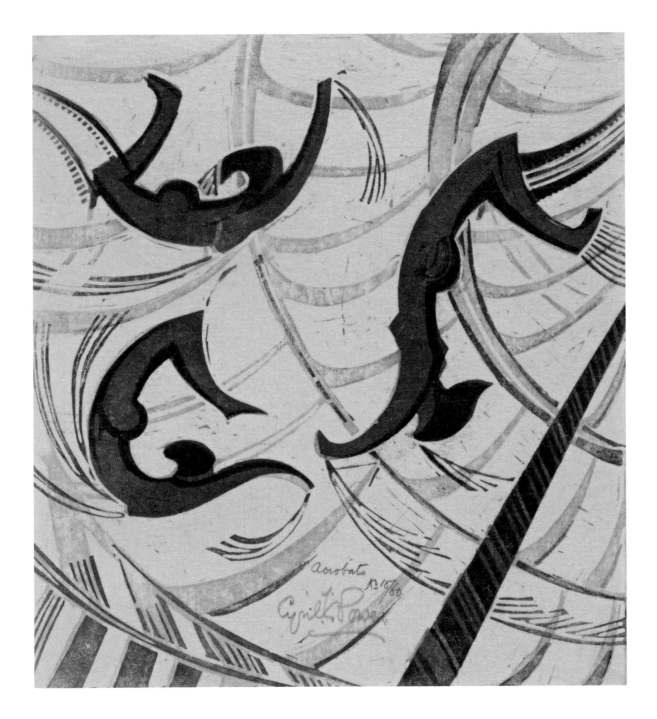

92 CYRIL E. POWER **ACROBATS** ABOUT 1933, COLOR LINOCUT, PRINTED IN RED, OCHER, AND BLUE-GREEN

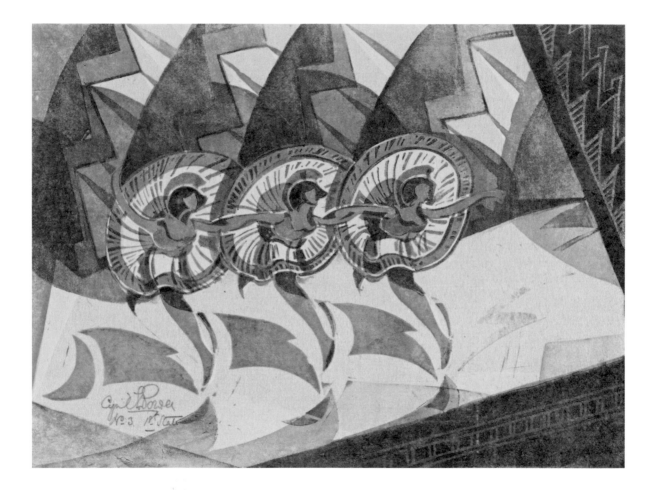

93 CYRIL E. POWER **DIVERTISSEMENT** ABOUT 1932, COLOR LINOCUT

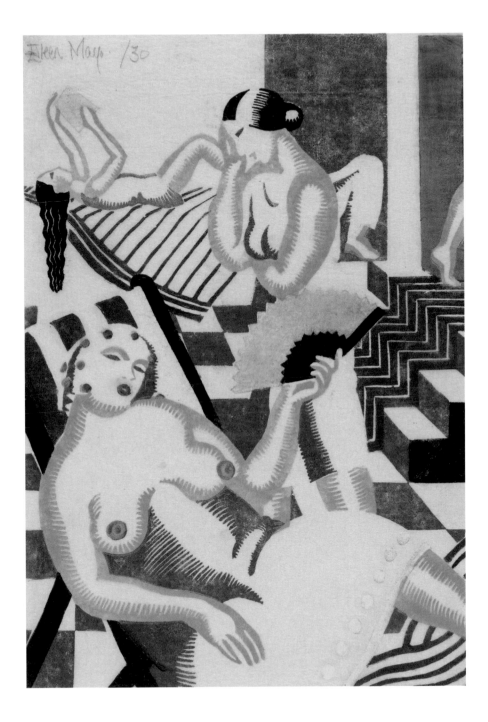

94 EILEEN MAYO **THE TURKISH BATH** 1928, COLOR LINOCUT

Despite many early twentieth-century artists' preference for distinctly modern subjects such as urban views, man-made constructions, and industrial landscapes, traditional subjects dealing with nature and natural forces continued to play a significant role in the work of the most progressive artists of the time. Picasso, Kandinsky, Mondrian, and Malevich, to name only a few, explored both the formal and mystical or metaphysical aspects of the natural world, using abstract visual language that sought to express the essence of their subject. The same is true of the British artists in this catalogue. Sybil Andrews, Claude Flight, and C. R. W. Nevinson, although fervently engaged with the dynamism and vitality of the city, also turned to nature's inherent rhythms and turbulent forces as a source for their images.

Carved from old, discarded linoleum, *Spring* (cat. no. 95) is one of four linocuts Flight made based on the seasons. He utilized fractured geometric forms, curved lines, and flat planes of mottled color to render this symbolic pastoral scene of two embracing figures set against a verdant background. Although the figures' gender is somewhat ambiguous, their rounded shapes and graceful movement evoke female forms, in keeping with traditional feminine associations with spring as a time of fertility and rebirth. "Certain experiences are best expressed in a more abstract way," Flight noted in his 1934 linocut manual.[1] *Spring*, like the other images in the series, attempts to penetrate the surface of the natural world by distilling both human and organic elements into simple patterns of shapes and colors that call to mind the characteristics of the season.

Inspired by Art Deco's stylized lines, the elegant arabesques and curlicued shapes of Andrews's *Bathers* (cat. no. 96) represent the gentle repeating rhythm of swimmers and waves. This impression, although an Experimental Proof, is almost identical to the final edi-

tion in terms of color and design. In both, she employed an extreme economy of means — conflating figure and sea, discarding unnecessary details, and limiting her palette to pale green and red — to achieve her most decoratively abstract image.

Andrews's linocut contrasts with Nevinson's larger, more tumultuous, and naturalistic depiction of the ocean. Printed in reverse after a painting executed the same year, *The Wave* (cat. no. 97) captures the sea's

coiling movement with its swirling, white-capped water. Unlike Andrews's broad planes of flat color, Nevinson's forceful scratches on the surface of the lithographic stone create a textured surface that particularly emphasizes the water's unforgiving momentum and churning power.

While Andrews's *Bathers* exemplifies nature's serene side, *Windmill* and *The Gale* articulate its more potent forces. In *Windmill* (cat. no. 99), the artist relied

on a low vantage point — similar to the wormhole perspective of Power's demonic *Merry-Go-Round* (cat. no. 36) — to render a sense of dramatic action, forcing the viewer to look up at the massive, spinning blades powered by the wind's force. The frenzied energy is highlighted by the circular pattern of blade-like forms that not only mimics but propels the mill's movement. Although Andrews moved to London in 1922, she was not unfamiliar with country life. A native of Bury St. Edmunds, located in the southeast of England, she produced several images of farmers at work in the town's agricultural fields, exemplified by *Fall of the Leaf* (cat. no. 100). The model for her windmill was situated in a small village near her hometown.

Andrews again depicted the wind's power in *The Gale* (cat. no. 98), humorously distorting two windswept pedestrians by giving them block-like feet and elastic bodies. Her animated style and perceptive use of the color blue, which perfectly sets the tone of the image, enlivens a rather ordinary event. As was typical of Andrews, she rejected literal rendering, preferring to use abbreviated, extremely stylized forms to get at the heart of her subject. The simple, bold planes of color in both *The Gale* and *Windmill* differ significantly from the warmer, autumnal tones and textured surface of *Fall of the Leaf*. Here, she ingeniously carved repeated hatch marks in her linoleum blocks to suggest the pattern of leaves in the trees and furrows in the field or, perhaps, to more generally convey the inherent rhythms or cycles of nature.

William Greengrass, a lesser-known Grosvenor School artist whose prints Flight reproduced in both of his linocut manuals, typically made linocuts depicting the speed and movement of athletes. His image of convolvulus, or, more precisely, morning glories (cat. no. 101), displays his decorative approach to nature. Greengrass's allover composition of carefully shaded leaves and flowers, built up with layers of translucent ink, appears to be influenced not only by the Grosvenor School's distinctive use of rhythmic pattern but also by a knowledge of Japanese woodcuts and an interest in textile design.

As with their peers in Continental Europe, the British artists' pursuit of modernism often transcended a strict idea of "modern" subject matter. They depicted traditional subjects inspired by the natural world with an intensity and directness equal to that of their images of contemporary machinery, industry, and lifestyle. Engaged with the specific language of printmaking, and linocut in particular, they sought to capture the underlying rhythms and universal appeal of their chosen subjects by breaking down complex forms and recasting them in boldly novel ways. — SR

1. Claude Flight, *The Art and Craft of Lino Cutting and Printing* (London: B. T. Batsford, 1934), 20.

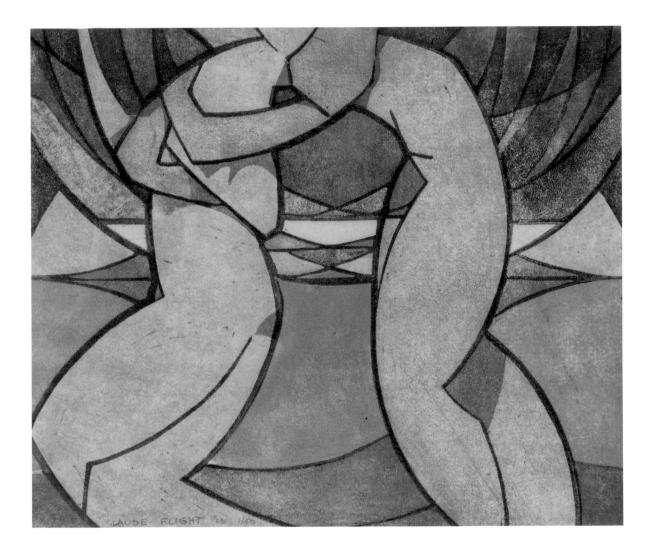

95 CLAUDE FLIGHT **SPRING** 1926, FROM **THE FOUR SEASONS**, COLOR LINOCUT

96 SYBIL ANDREWS **BATHERS** 1930, COLOR LINOCUT

97 C. R. W. NEVINSON **THE WAVE** 1917, LITHOGRAPH, PRINTED IN BLUE

98 SYBIL ANDREWS **THE GALE** 1930, COLOR LINOCUT

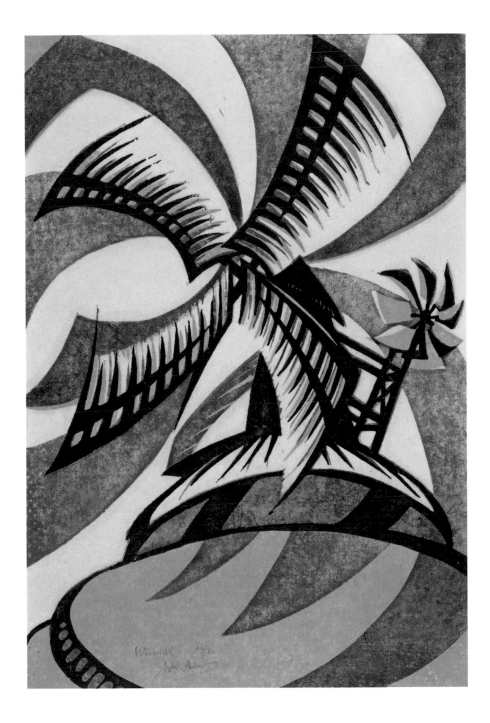

99 SYBIL ANDREWS **WINDMILL** 1933, COLOR LINOCUT

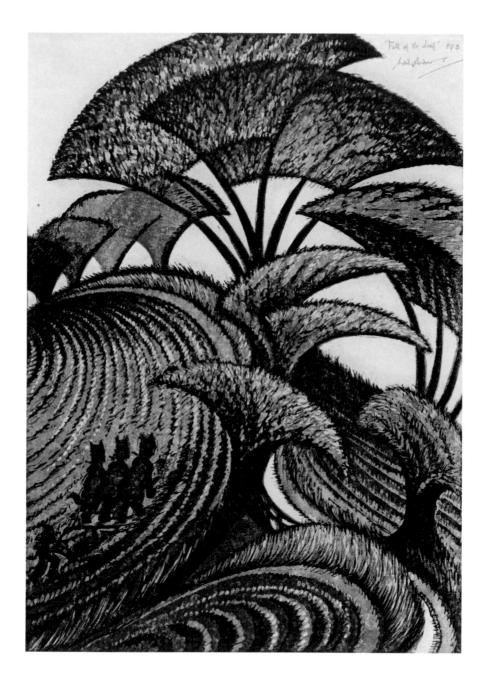

101 WILLIAM GREENGRASS **CONVOLVULUS (MORNING GLORY)** 1937, COLOR LINOCUT

LINOCUT: HISTORY AND TECHNIQUE

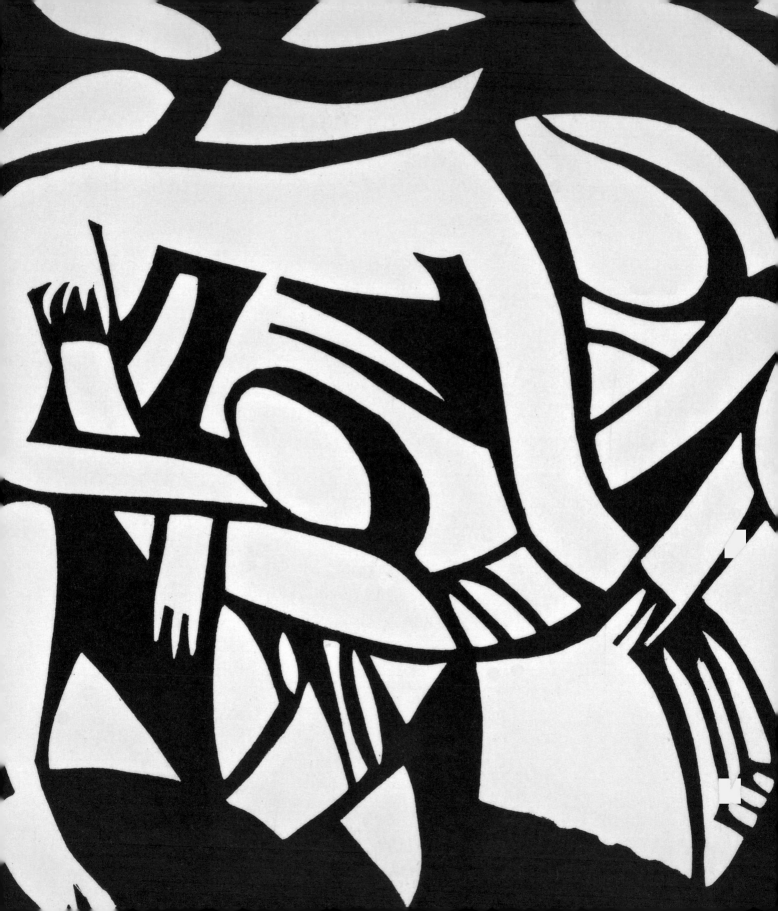

THE HISTORY AND CHARACTERISTICS
OF LINOLEUM BLOCK PRINTS

STEPHANIE M. LUSSIER

Unlike other forms of printmaking that have well-documented technical histories and, in some cases, known inventors, the story of linoleum block printing is brief and discontinuous. Though its origin stems from woodblock printing traditions, the linocut was not recognized for its unique artistic qualities until well into the twentieth century. In fact, lore has it that even established artists such as Wassily Kandinsky labeled their early linocuts as woodcuts. A subtle yet significant deception, this conscious act discloses an awareness of the ambivalent critical reception of the linocut medium in the art world and contributes to the complexity of visually recognizing linocut prints. This essay outlines the short history of linoleum block printing and unveils some of the visual characteristics that distinguish linoleum block prints from other types of prints. The process of discovering and recognizing linocuts reveals the distinctive character of this intriguing print medium and illuminates its refinement by Claude Flight and the other Grosvenor School artists highlighted in this catalogue.

What Is a Linocut?

A linocut, or linoleum block print, is a relief print in which linoleum is used as the printing matrix. To create such a print, an artist uses knives and gouges to cut away the non-image areas of a linoleum block, leaving behind raised image-forming elements.[1] These raised elements are inked and then transferred to paper by applying pressure to the back of the sheet, either by hand or with a press.[2] The pressure on the raised printing surface pushes some of the ink to the edges, forming an irregular ridge of ink along the contour of a line or at the outer edges of the printed design. Printers refer to this easily identifiable feature as "ink squash" (fig. 9).[3] This visual feature distinguishes relief prints,

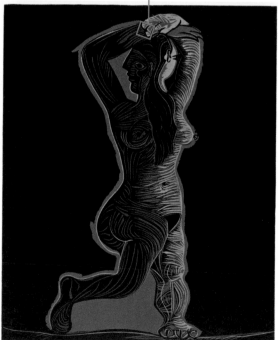

such as woodcut or linocut, from intaglio and plano-graphic prints, such as etchings or lithographs. The back of the paper is sometimes embossed in areas corresponding with the image, depending on the method of printing and the type of paper employed. This physical characteristic is also useful for recognizing relief prints.

The Invention of Linoleum

Linoleum is most commonly known as a household and industrial flooring material. Primarily a mixture of oxidized linseed oil, resins, and cork dust, the material derives its name from the Latin roots *līnum* (flax) and *oleum* (oil). Patented in 1863, linoleum stems from an accidental discovery by the Englishman Frederick Walton, who noticed the elastic properties of a dried linseed-oil film on a paint can.[4]

The first linoleum factory was operating in England by 1864. By 1888, twenty factories throughout Europe and one in America were producing linoleum, reflect-

Figure 9. Detail (top) and overall (left): Pablo Picasso (Spanish, worked in France, 1881–1973), *Large Female Nude*, 1962, reduction linocut, final state, 63.8 x 52.8 cm (25⅛ x 20¹³/₁₆ in.), Museum of Fine Arts, Boston, Lee M. Friedman Fund, Sophie M. Friedman Fund, and Museum purchase with funds from the Print and Drawing Club and donated by the Aaron Foundation, Ruth V. S. Lauer in memory of Julia Wheaton Saines, and Virginia Herrick Deknatel, 2002.48

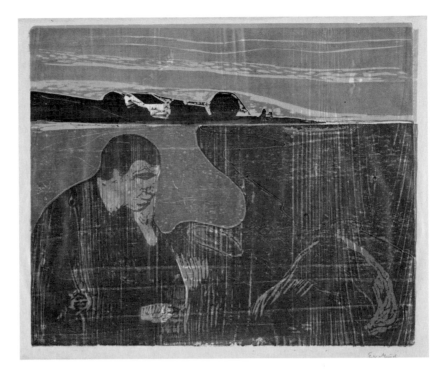

Figure 10. Edvard Munch
(Norwegian, 1863–1944), *Evening
(Melancholy)*, 1896, color woodcut,
37.6 x 45.5 cm (14¹³⁄₁₆ x 17¹⁵⁄₁₆ in.),
Museum of Fine Arts, Boston,
William Francis Warden Fund,
57.356

ing the material's growing popularity. Championed as an inexpensive floor covering with great versatility, linoleum was also very resistant to wear. This made it durable both as flooring and as a printing matrix; later technical and art historical literature notes the material's ability to withstand large print runs without showing signs of wear.[5]

The earliest types of linoleum were monochromatic, colored by the addition of natural earth pigments to the compositional mixture. Technological advancement was rapid, however, and soon a variety of decorative patterns were readily available. In 1892, a popular granite design with a pattern that permeated the entire

depth of the linoleum layer was produced. Homogeneity throughout the material is intrinsic to the linoleum manufacturing process, whereby all raw materials are thoroughly mixed prior to rolling into large sheets on a canvas backing. This uniformity of composition allows an artist to fluently cut a design in linoleum.[6] The "judicious use of linoleum of different textures" mentioned in Claude Flight's linocut printing manuals speaks to the wide variety of surface textures available to the consumer in the 1920s and '30s. This modern convenience was also appealing to the artist, since the texture of the block could be used creatively to affect the appearance of the print.[7]

Linoleum and Printing

Linoleum was reportedly used as a printing matrix in the production of decorative wallpapers in Stettin, Germany, in the late 1890s.[8] Woodblock printing had long been used in wallpaper production, and the transfer of woodblock designs to decorative wall and floor coverings, called oilcloth, was common.[9] Given the growing number of linoleum factories in Germany, similar experimentation with linoleum as a printing matrix in the realm of interior decoration was inevitable, though the acceptance of linocut prints in the art world would prove slower and less certain.

Resistance to linoleum block printing was largely due to the perceived ease of the linocut technique and its already established role in elementary art instruction by the late nineteenth century. Critics unfavorably contrasted the ease and novelty of linoleum block printing with the refined skill and highly demanding craft of traditional wood engraving, which was then considered to be at its peak of perfection. In addition, the international interest in the complex techniques of the Japanese color woodblock masters further encouraged the linocut's reputation as a lesser art form.

Nonetheless, technological advances opened new possibilities for relief printing — including both woodcut and linocut — as a creative medium. One pivotal innovation was the introduction of photomechanical image-reproduction technologies for book illustration. Developed in the 1870s, the photoengraving process supplanted the need for hand-produced printing matrices, paving the way for freer, more individual artistic expression in printmaking media that had previously been confined to this more utilitarian role.[10]

The innovative woodcuts from the 1890s by artists such as Paul Gauguin and Edvard Munch display the earliest use of visible wood grain and the incorporation of gouge marks left behind when carving the block to create new visual effects that directly reflected materials and process in the final printed image (fig. 10). Today, these features seem standard characteristics of modern and contemporary woodcuts and can provide one means of distinguishing between woodcut and linocut prints.

Equally radical were the black-and-white woodcuts produced by Felix Vallotton between 1891 and 1899. In 1892, Vallotton allied himself with the avant-garde principles of Paul Gauguin when he joined the Nabis, a Parisian group of artists interested in flat areas of color, crisp edges, and radically simplified design. Vallotton's prints, like the process prints of Aubrey Beardsley in England, featured stylized compositions with an Art Nouveau rhythm and flat, unmodulated surfaces (fig. 11). This flat, reductive style inspired later artists working in linocut, as well as woodcut.

The first significant use of the linocut medium by fine artists was in early twentieth-century Germany. Experimental artists such as Erich Heckel and Christian Rohlfs sometimes worked concurrently with both linoleum block and woodblock printing techniques. Rohlfs achieved a painterly effect in his relief prints, superimposing printing blocks inked with various

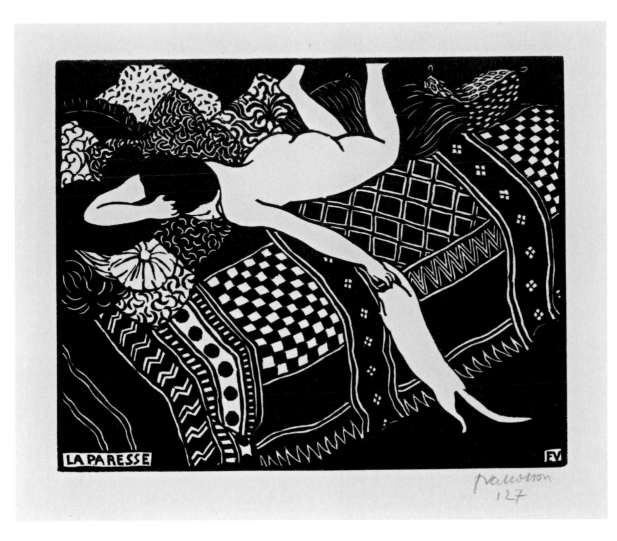

Figure 11. Felix Vallotton (Swiss, active in France, 1865–1925), *La Paresse*, 1896, woodcut, 17.8 x 22.3 cm (7 x 8¾ in.), Museum of Fine Arts, Boston, Lee M. Friedman Fund, 66.832

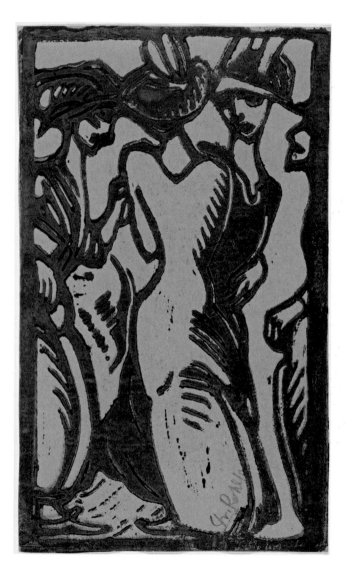

Figure 12. Overall (above) and detail (upper right): Christian Rohlfs (German, 1849–1938), *Three Women,* about 1912, color linocut, 37 x 22 cm (14⁹⁄₁₆ x 8¹¹⁄₁₆ in.), Museum of Fine Arts, Boston, Museum purchase with funds donated by Alan and Marianne Schwartz (Shapero Foundation), 1999.525

colors and heightening the textural qualities of the final print by manipulating the ink consistency.[11] In *Three Women* (fig. 12), a linocut from about 1912, Rohlfs's heavy application of color enhanced the formation of small, often directional patterns of peaked ink created by suction when the paper was lifted away from the printing block. This characteristic may be more pronounced on linocuts than woodcuts, as linoleum is less absorbent than many types of wood. In this particular print, the soft, grainy surface texture of the linoleum was also transferred to the printed image.[12]

For the printmakers of the Mexican Renaissance active from the 1920s through the mid-twentieth century, linoleum played a noteworthy role in the spread of sociopolitical propaganda, particularly in works by El Taller de Gráfica Popular (TGP; The Workshop for Popular Graphic Art). This progressive group felt that art making could not be separated from social responsibility and the dissemination of information. Linoleum,

typically inexpensive and manufactured in large sheets, was well suited to the generation of large-format posters and was regularly employed by members of the TGP when the size of woodblocks or lithographic stones was inadequate. The softness of the material also offered greater production speed and the possibility of hand cutting both image and text on a single block, a feat less easily attained with woodcut.[13]

Pablo Picasso's invention of the linoleum block reduction print is one of the most important innovations in the history of linoleum block printing. Picasso's experimentation with the color linocut began modestly with the production of two small book illustrations in 1939. He returned to the medium in the early 1950s, first producing posters announcing bullfights and art exhibitions before entering a more prolific and inventive period between 1958 and 1959, during which he created more than forty-five color linocut prints from multiple blocks.[14] In the early 1960s, he developed a reduction technique that enabled multicolor printing from a single linoleum block (see fig. 9). Reduction linoleum block printing is a subtractive process in which linoleum is cut away progressively to modify the design between successive printings in different ink colors. The image is usually built up from light to dark, requiring the artist to work in reverse: first carving out highlights, often visible as blank paper, and leaving behind solid forms to be inked and printed; subsequent printing typically progresses toward increasingly dark and more opaque colors. The term "reduction linoleum print" is familiar to aspiring printmakers today, and

Picasso's technique has inspired further exploration by contemporary artists such as Chuck Close.

In the work of Claude Flight and his followers at London's Grosvenor School of Modern Art, a unique movement focused around linoleum block printing in color was finally realized. Consciously rebelling against more conservative approaches to printmaking in Britain, Flight sought to stimulate a unique method of expression for the color linocut. Reminiscent of the German Expressionists' reinvention of the woodcut, the Grosvenor School artists cultivated a linocut technique characterized by bold design, complex layering of color, and an exploration of surface texture unique to their chosen medium and methods of hand printing.

Distinguishing Linocut and Woodcut

Claude Flight strongly advocated the idea that a linocut should be unique in character and easily recognizable, stating, "a lino-cut colour print should not look like an oil or a water-colour painting, it is a print from a soft linoleum block and should not be taken for a wood-cut, a wood engraving, or an etching, it should take its individual place on a wall and be recognized as a lino-cut."[15] Similar sentiments appear in relief-printing manuals throughout the twentieth century, often reflecting the printmaker's attunement with the sculptural act of block carving, the responsiveness or resistance of the material being cut, and ultimately the characteristic qualities imparted to the printed image as a result.

Figure 13. Henri Matisse (French, 1869–1954), illustration for *Pasiphaé, chant de Minos (Les Crétois)*, linocut, 32.5 x 25.3 cm (12¹³⁄₁₆ x 9¹⁵⁄₁₆ in.), edition 31/230, Museum of Fine Arts, Boston, Museum purchase with funds given by a member of the Museum Council Fellows, 2003.109

Nevertheless, distinguishing linocuts from woodcuts can be difficult, even for the informed viewer. This difficulty is evidenced throughout art historical literature, where prints have been labeled erroneously or inconsistently in catalogue entries and critical essays. A significant example is Henri Matisse's seated nude of 1906, now called *The Large Woodcut*. This print was cata-

logued in many collections and published widely as a linocut until the original woodblock was identified.[16]

Some of the confusion regarding the identification of the technique Matisse employed to make his seated nude may have arisen from the artist's known attraction to the immediacy of the linocut medium. Working with linoleum in the mid-1930s, Matisse experimented with a "white line" technique, an approach he returned to in 1944 with his linocut illustrations for Henri de Montherlant's book *Pasiphaé, chant de Minos (Les Crétois)* (fig. 13).[17] This work was celebrated for the elegant balance of white line against black background and for the artist's ability to depict the essentials of form in simplified imagery. The prints demonstrate spontaneity of design, capturing a fluidity consistent with the direct cutting of a linoleum block, which is less resistant than a woodblock. Subtle shifts in line thickness show the material's sensitivity to the slight changes in pressure applied upon the carving tool by the artist's hand. While linoleum may not be chosen to render complex areas of minute detail, it is capable of sustaining a remarkably fine line as part of a continuous, flowing stroke. Matisse advocated the merits of the linocut medium, equating the sensibility of an artist controlling the gouge against the linoleum surface with that of a violinist maneuvering a bow against the strings of a violin; in both sensitive and skillful techniques, the slightest involuntary motion can change the outcome for the worse.[18]

The ease of clearing large areas and cutting in multiple directions, made possible by the softness

and uniform composition of linoleum, is exemplified in the broad design and curved forms achieved by Henri Gaudier-Brzeska in his pioneering *Wrestlers*, of about 1914 (see cat. no. 1). Independent of artistic styles or movements, the material's conduciveness to long, sweeping curves reveals itself in the graceful curls and the nearly uninterrupted stroke that wraps around the hair and face in the image from Matisse's *Pasiphaé*; in the soft, flowing form of the central figure in Rohlfs's *Three Women*; and in the bold spiral of the staircase in Cyril Power's *Tube Staircase* (cat. no. 59).

In contrast, the hardness of a woodblock, even a soft pine plank, makes the act of cutting more laborious. As a result, individual strokes in a woodblock print sometimes display a more chiseled quality. The directional grain of the wood also affects the artist's ability to carve the block, as it is easier to cut "with," or parallel to, the grain direction rather than "against," or perpendicular to, the grain. These characteristics can influence design elements or line quality, sometimes resulting in distinct visual effects. The predominantly vertical composition of Heckel's woodcut *Wounded Veterans* (fig. 14), from about 1914, suggests that the artist oriented the woodblock with the grain running vertically. The series of long, parallel lines in the upper background and the more broadly cleared areas appear strongly vertical, while the slightly curved and horizontal strokes that build up form in the figures are shorter and more abrupt, suggesting cross-grain cutting.

Sometimes, the physical limitations of the woodblock could be overcome by inventive methods. In

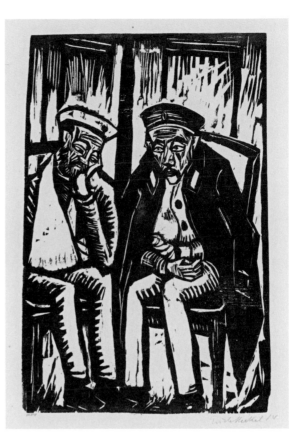

Figure 14. Erich Heckel (German, 1883–1970), *Wounded Veterans*, about 1914, woodcut, 42.3 x 27.9 cm (16⅝ x 11 in.), Museum of Fine Arts, Boston, Bequest of Lee M. Friedman, 58.187

Munch's woodcut *Evening (Melancholy),* of 1896 (see fig. 10), the artist achieved gentle, curved contours similar to those of a linocut by employing a jigsaw technique, avoiding the dominance of the grain that must be countered when hand carving wood. Munch assembled four sawn "puzzle pieces," cut from two separate woodblocks, to create the main forms in the composition,

leaving more angular work and smaller, detailed carving to the woodcut gouge.

Though distinguishing linocut and woodcut remains challenging, it is useful to consider that printmakers are generally selective about the tools and materials they employ for making prints, often choosing materials for their particular working properties or to achieve preferred visual effects. As a result, visual cues in the prints themselves tend to reflect characteristics specific to individual media and methods of printing. Close study of such cues, in combination with an understanding of art historical context, should continue to unravel some of the mysteries of identifying linoleum block prints, realizing Claude Flight's hope that the linocut would reveal itself as a unique and recognizable artistic medium. The documented use of the linocut technique by the aforementioned artists also suggests the possibility of discovering as-yet-undetected linocut prints by their contemporaries, adding to the distinct body of works already known to be executed in this fascinating but often elusive medium.

1. V-, U-, and C-shaped gouges are generally used for carving design elements and clearing broad background areas. Knives are used to trim the linoleum to size and to cut sharp angles.
2. Once the paper is laid upon the inked block, printing is typically carried out by burnishing the back of the paper with a handheld tool, or mechanically with a press. The British artist Michael Rothenstein mentions placing the inked block face-down on the paper and stamping on the back of the linoleum block with one foot. Michael Rothenstein, *Linocuts and Woodcuts: A Complete Block Printing Handbook* (New York: Watson-Guptill, 1964), 52. Hand printing allows selective variation of pressure, giving the printer greater control over textural and tonal qualities in the printed image. Large editions are commonly printed with a press.
3. Bamber Gascoigne, *How to Identify Prints* (New York: Thames and Hudson, 1986), 51a.
4. Oxidation of the linseed oil, induced by exposure to air over time, results in the formation of linoxyn; it is this water-insoluble, highly cross-linked, and polymerized substance that provides the physical characteristics of linoleum. Torsten Ziegler, "Oilcloth, Floor Cloth, Kamptulican, Cork Carpet: Linoleum — The Early Days of the Ideal Floor Covering," in Gerhard Kaldewei, ed., *Linoleum: History, Design, and Architecture,* trans. Ingrid Nina Bell (New York: Distributed Art Publishers, 2000), 32–47. Walton had submitted provisional patents prior to his final one, first in 1860 and again in April 1863. He supposed that oxidized linseed oil (linoxyn) might be a cheaper substitute for India rubber, then used in mass industries such as the waterproofing of fabrics. Myth has it that an unknown tradesman suggested its possible application as a floor covering to replace a then-common floor and wall coating called *kamptulicon,* made of India rubber, gutta-percha, cork dust, and earth pigments. Roland A. Hellmann, "Rise, Fall, and Renaissance of a Floor Covering Classic: The History of Linoleum in Germany," in Kaldewei, ed., *Linoleum: History, Design, and Architecture,* 48–53.
5. One author observes the printing of twenty-five thousand impressions from a block of Battleship linoleum, with the prints showing no signs of wear. Lyle B. Yeaton, *Linoleum Block Printing for the Amateur* (New York: Yeaton Press, 1931), 21. Another emphasizes that linoleum does not break down with pressure or with the printing of multiples; line quality remains consistent throughout an edition. Ernest W.

Watson and Norman Kent, ed., *The Relief Print: Woodcut, Wood Engraving, Linoleum Cut* (New York: Watson-Guptill, 1945), 60, 65.

6. The linoleum manufacturing process is elaborate and time-consuming. First, linseed oil is stirred and exposed to oxygen to form linoxyn; the linoxyn is then mixed with melted resins. This mixture is pulled into long strands and later mixed with fillers and pigments. After heating, the mixture is rolled onto a canvas backing and smoothed. The linoleum is cured for two to four weeks to create firmness prior to cutting into sheets. Hellmann, "Rise, Fall, and Renaissance of a Floor Covering Classic," 48–53.

7. Claude Flight, *Lino-Cuts: A Hand-Book of Linoleum-Cut Colour Printing,* rev. ed. (1927; repr., London: J. Lane, The Bodley Head, 1948), 42.

8. Watson and Kent, *The Relief Print,* 12. The authors do not provide a reference to support this claim.

9. Andrea Tietze, "The Linocut in History and in the Art of the Modern Age," in Kaldewei, ed., *Linoleum: History, Design, and Architecture,* 72.

10. Photoengraving (or photoetching) is a process of *engraving* a metal plate using photographic techniques. A *photosensitive* material, such as gelatin, that is resistant to acids or other etching compounds is applied to a metal plate. The coated plate is then exposed to light through a *photographic* negative or screen, causing it to harden where the negative allows light to pass. The unhardened gelatin or photoresist is then removed in a solvent (usually warm water), exposing the metal in some areas. The exposed areas are dissolved in an acid bath, creating a printing plate that can be inked and printed using relief or intaglio methods.

11. Western printmakers are known to use oil- and water-based printing inks and oil paints for relief printing, sometimes combining them in a single print. It has not been determined which one Rohlfs used in his linocut *Three Women* (fig. 12).

12. Although grain direction is not a factor in linoleum, as it is in wood, the material's pebbly surface texture, often visible in the final print, is sometimes described as "grainy."

13. Lyle W. Williams comments on the dynamic images of the linocuts of Leopoldo Mendez, founding member and director of TGP, whose subjects are enhanced by lines that flow in a single direction. He also notes a surprising tonal gradation in Mendez's works. Unexpected of linocut, this seems linked to Mendez's mastery of tool work and selective use of gouges of a variety of shapes and sizes in a single composition. Williams, "Evolution of a Revolution: A Brief History of Printmaking in Mexico," in John Ittmann, ed., *Mexico and Modern Printmaking: A Revolution in the Graphic Arts, 1920–1950* (Philadelphia: Philadelphia Museum of Art, 2006), 8.

14. R. Stanley Johnson, "An Introductory Essay on the History of Lithography and the Linocut," in *Pablo Picasso: Lithographs and Linocuts, 1945–1964* (Chicago: R. S. Johnson Fine Art, 1998), 17.

15. Flight, *Lino-Cuts,* 11.

16. John Loring, "Notes on a Purity of Means," *Arts Magazine* 49, no. 9 (May 1975): 64–65, is an example of a critical discussion where the print is misidentified. Malcolm Baker and Brenda Richardson, eds., *A Grand Design: The Art of the Victoria and Albert Museum* (New York: Harry Abrams, 1997) contains a catalogue entry on the woodblock: Henri Matisse, *The Large Woodcut.*

17. Henri de Montherlant, *Pasiphaé, chant de Minos (Les Crétois)* (Paris: Martin Fabiani and Pierre Baudier, 1944).

18. Loring, "Notes on a Purity of Means," 65.

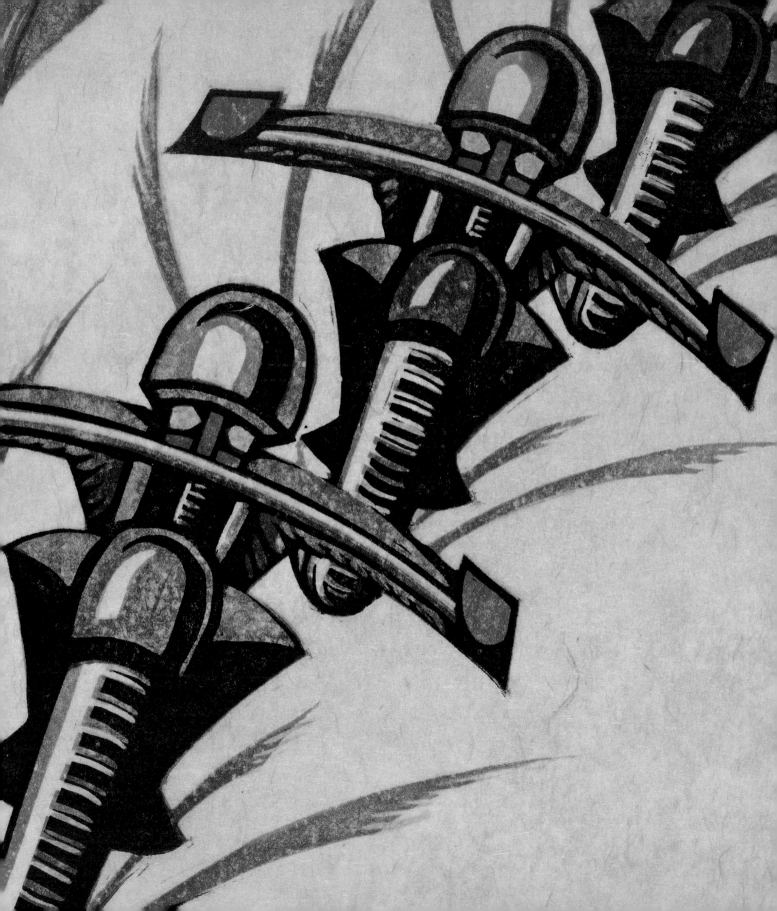

MATERIALS AND TECHNIQUES
OF THE GROSVENOR SCHOOL ARTISTS

RACHEL MUSTALISH

When Claude Flight began teaching at the Grosvenor School of Modern Art in 1926, he became a champion of the linocut. This printmaking technique, first used a few years after the invention of linoleum in the late nineteenth century, was often maligned as amateurish and touted as the perfect medium for children, because it required little skill or expense to create a print. Although the relatively soft linoleum was easier to work than wood or metal, the results achieved by the Grosvenor School artists were far from simplistic, and the variety of effects, textures, and colors in their images necessitated great technical skill, knowledge of materials, and printmaking experience. It was precisely this two-fold nature of the linocut — its simplicity and its sophistication — that Flight found appealing. Free of the technical demands of past techniques, it was the perfect vehicle for modern artistic expression. Linoleum was a new material for a new art; Flight compared his linocuts with radio and films, clear symbols

of the modern era.[1] He published two instruction manuals that taught the linocut technique to beginners and expounded his artistic philosophy (cat. nos. 102–103), and he devised new linocut methods.[2] Together with a group of staff and students at the Grosvenor School, he refined the practice, pushing the boundaries of the materials and techniques to produce the innovative prints featured in this catalogue.

Preparatory Drawings and the Linoleum Block

Preparatory drawings were the first of several steps integral to the creation of these multicolor linocuts. The artists made these drawings, which might begin as pencil sketches and evolve into multicolor drawings in colored pencil or wax crayon, to work out a design and to guide the cutting of the linoleum blocks. As in many other color printing processes, linocuts are typically

printed one color per carved block. Cyril Power used one of his preparatory drawings for *The Eight* (cat. no. 62) to work out the number of blocks required for his design and how to create the tones he desired. His notations explain that the print should be made from four blocks (red, blue, green, and yellow) and that the impressions from the blocks should be layered to create four additional colors: brown, orange, purple, and "dark."[3] An important tenet of Flight's approach was to use a small number of blocks, typically three or four.[4] Printmakers customarily used large numbers of blocks to mimic works in other media, such as watercolor or oil paint, but Flight adamantly believed that linocuts should openly acknowledge the process by which they were made. His streamlined approach to image creation was in keeping with the more minimalist and abstract avant-garde trends of the early twentieth century.

The preparatory drawings acted as a pattern for the carving of the linoleum, with carbon paper often used to transfer the design to the block. Although linoleum is softer than wood, the principles of cutting linoleum are very similar to those used for woodcuts. The artists employed small knives or gouges with shaped tips or blades to scoop out the linoleum, leaving behind the areas that would be coated with ink and printed to create the image. Flight sold a box of tools for cutting linoleum along with his first manual (cat. no. 102); however, always practical and cost-conscious, he also gave instructions on how a good gouge could be made from a sharpened umbrella rib. The tool marks left from carv-

Figure 15. Detail from *Boccia* (cat. no. 71), by Lill Tschudi, showing the stripes created by Tschudi's use of textured linoleum

ing the linoleum could impart a texture to the final print, as is seen in Power's *Vortex* (cat. no. 16), but the Grosvenor School artists usually removed the carved areas sufficiently so as to leave no trace on the impression.

Sybil Andrews's four carved blocks (cat. nos. 104–107) for *Speedway* (cat. no. 30) show the marks of carving, remnants of carbon-paper transfer lines, and printing-ink residue. Their top edges also exhibit the corner and notch system used to position the successive sheets of paper so that the four colors aligned properly in the final image. The surfaces of the blocks indicate that Andrews used linoleum with a small pattern

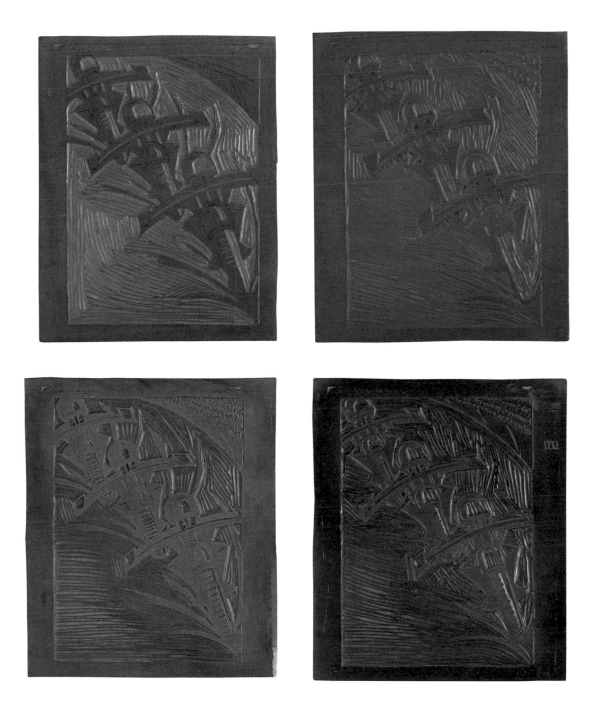

104–107 SYBIL ANDREWS LINOLEUM BLOCKS FOR **SPEEDWAY** 1934

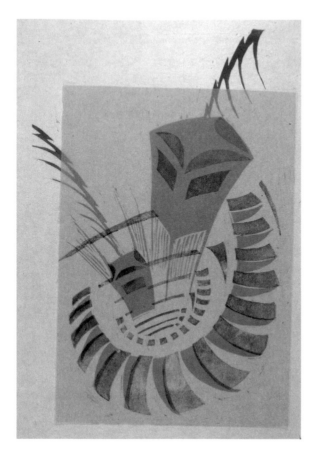

Figure 16. Cyril E. Power, *Lifts*, working proof printed in green (cat. no. 53), laid over Power, *Lifts*, working proof printed in red (cat. no. 52)

proofs were made. These enabled the artists to see what the block they were carving would look like when printed. The artists often printed proofs several times during the cutting and printing processes, allowing them to track the development of the print. Catalogue numbers 52 and 53 show red and green proofs of *Lifts*. Both were printed on cheap, thin paper, so that Power could overlay them while working to see the interaction of the carved shapes and colors (fig. 16). Comparison of the red proof with the final print of *Lifts* (cat. no. 54) reveals that the artist changed the design, removing the red forms from the stairs.

Dissolution of the Key Block

Attention to precision and the printing of proofs were especially important to the Grosvenor School artists, because they usually made their prints without using a key block to help them align all the color elements and to create the conventional dark outline that would define the principal forms of the composition. This significant shift away from traditional color block printing was noted by a London *Times* reporter in a review of Flight's 1931 exhibition.[5] For hundreds of years, the use of a printed outline to define the design was an essential part of color block printing, having perhaps evolved from the practice of hand coloring linear woodcuts and engravings. It was also an essential part of the traditional Japanese woodblock prints that Flight saw as the ancestors of his approach to linocut.[6]

of dots. These dots appear in the final print, aiding in the blending of colors and providing texture. Similar dots appear in Andrews's *In Full Cry* (cat. no. 68) and Power's *Speed Trial* (cat. no. 32). Lill Tschudi at times used patterned linoleum to add texture, as in the men's jackets in *Boccia* (fig. 15).

As each block was cut, trial impressions called

Flight's early prints *Swing-Boats* (1921, cat. no. 34) and *Speed* (1922, cat. no. 46) still relied on a dark outline to create the forms and define the design. However, he moved away from this practice, explaining in his 1927 manual that although beginners in linocut might still need a key block, "the sooner the student in his colour work, learns to consider each block as an arrangement of line and mass, and eliminates the all-line 'key block,' the sooner he will produce work that is true to the use of the medium, which is work that builds up block by block to a perfect whole."[7] This abandoning of the key block became a defining feature of Grosvenor School linocuts.

Figure 17. Detail from *Brooklands* (cat. no. 33), by Claude Flight, showing the metallic-flecked paper to which the print is mounted

The Papers

Although Flight rejected the close imitation of the Japanese print, he did advocate the use of Japanese papers, particularly the very thin, slightly transparent tissue-like sheets. Japanese paper is made of long plant fibers that enable the paper to be thin yet strong. It also has a slight sheen and holds ink on the surface without bleeding, which, combined with its diaphanous quality, produces a vibrant, sensuous surface. These properties have made the paper appealing to Western artists and printmakers beginning with Rembrandt in the 1640s. Flight utilized the paper's transparency in a number of his prints. *Swing-Boats* and *Dirt Track Racing* (cat. no. 14) are two of the many prints he mounted to dark gray paper, thereby reducing the contrast of the

printed areas and the white paper. For *Brooklands* (cat. no. 33), Flight again used very thin paper and mounted the print to a metallic-flecked backing paper (fig. 17). Through the thin paper, the metallic flecks give the cars a subtly speckled look. The paper is attached only at the edges and therefore can move, making the spots appear to change position, just as flecks of light might shimmer across the metallic racecars as they sped down the track. In *Speed,* Flight exploited the transparent nature even further by painting the backing sheet a strong yellow to impart an overall tint to this impression (fig. 18).[8] He also explored the possibilities of the thin paper by printing on both sides of the sheet. The areas printed on the reverse appear on the front as

Figure 18. Detail from *Speed* (cat. no. 46), by Claude Flight, showing an area where the thin Japanese paper has been accidentally folded to reveal the bright-yellow-painted secondary sheet to which Flight mounted the print

Figure 19. Detail from *Speed* (cat. no. 46), by Claude Flight. The strong red on the face is printed on the front of the sheet, whereas the more subtle red on the jacket is a result of red being printed on the reverse.

more subtle tones, as is evident in the central figures (fig. 19). Meanwhile, the printing on the front is vivid and strong, as seen in the large red bus on the right and the strong black outline.

In addition to using a colored backing paper, some Grosvenor School artists chose to tone their sheets prior to printing. This meant that an overall color — either brush-applied watercolor or color printed from a solid, uncarved block or offset from an inking roller — imparted a base color to the entire sheet that the subsequent layers of color would play against. This effect can be seen in several of Andrews's pieces, including *Theater, Concert Hall,* and *Oranges* (cat. nos. 84, 85, and 77).

Printing Ink and Oil Paint

Another aspect of Japanese woodblock prints that Flight rejected was the use of water-based media, whether watercolor or pigment mixed with rice glue.[9] He perceived the use of these media as an attempt to mimic watercolor and considered it to be regrettably imitative of Japanese technique. A feature of the Grosvenor School linocuts is the exclusive use of oil-based media, either printing ink or oil paint. Both are vivid colorants, but, while similar and compatible, they have different textures and appearances. Printing ink is opaque, shiny, thick, and sticky, comes in a limited array of colors, and is difficult to alter in consistency

and hue. Oil paints are vastly more adaptable in terms of thickness and opacity and are easily mixed to create any color imaginable. The Grosvenor School artists used both, giving them a variety of materials with which to work. They may have been aware that, when printed in multiple layers, oil paint can crack while drying and potentially separate from the surface, and that using printing ink for some of the layers could prevent these problems.

Color Experiments

The artists chose their colors with great care and attention to hue, transparency, opacity, and viscosity. Comparing two states of Cyril Power's *Acrobats* illustrates how different colors can affect the appearance of the forms. The EP, or Experimental Proof, impression (cat. no. 91) was printed from two blocks: a cobalt blue and a red. The blue on red creates an effect of shadow at the edges of the figures. In an impression printed in ocher, red, and blue-green (viridian), the effect is quite different (cat. no. 92), as the blue-green block creates a crisp outline on the red acrobats instead of a soft shadow. Additionally, the ocher optically recedes, changing the relationship of the acrobats with the background.

Most of the Grosvenor School artists made color tests before deciding on the colors for an edition. Andrews and Power kept notes on the creation of their prints and obsessively documented their color choices in their print books.[10] They kept paint swatches and

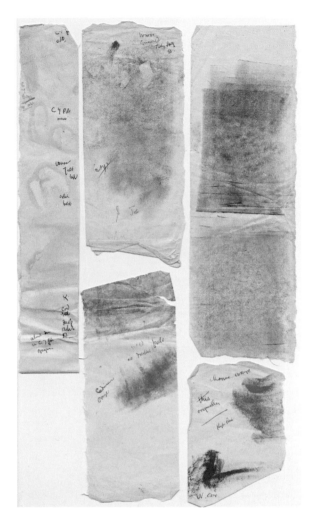

Figure 20. Color trials from Sybil Andrews's *Print Book I*, p. 38, Glenbow Museum, Calgary, Canada, m-8411-138-p. 38

small trial impressions showing their color experiments (fig. 20), and for some of their images they also recorded information on the number and order of blocks used, the paper chosen, the brand of oil paint or

ink used,[11] the printing procedure, what they thought of the results, and the distribution of the prints.

Andrews's color selection and thought process with regard to which color should be used with which block (indicated by the numbers below) can be seen in her description of the print *Theatre*:

> Jap[anese] tissue
> Tone paper — Chinese Orange touched
> up with Perm[anent] Crimson
> only a spot of Crimson
> 1) Viridian
> 2) ~~Prussian~~ Chinese Blue
> better [?]
> 3) ~~Black~~ Print again in Prussian
> or leave out (3) Block entirely[12]

Manipulation of the Colors

Flight also described the process of inking the block, the method of transferring the ink or oil paint to the carved linoleum. A quantity of ink or paint was placed on a sheet of glass, thinned to the desired viscosity, and then worked with a brayer, or roller, made of gelatin. Although brayers could also be made of rubber, Flight recommended gelatin because of the "speed and ease" with which it could lay an appropriate and even amount of ink or paint onto the linoleum block.[13] The viscosity and transparency of the ink or paint could be manipulated by thinning it with Vaseline (petroleum jelly) or linseed oil. Flight issued cautions against using too much diluent, because it could bleed into the surrounding paper, causing a halo. This result is visible in many Grosvenor School impressions, including Andrews's *New Cable* (cat. no. 80).[14]

Knowledge of the transparency of different paints or inks was important in determining the order in which the blocks should be printed. In Power's *The Eight* (cat. no. 63), the wake in the water appears as a very bright, acidic yellow-green. This color was achieved by printing the more transparent yellow, only seen in its pure state inside the boat, over a light blue, imparting to it a greenish hue; if the less-transparent blue had been printed over the yellow, the yellow would have been overpowered and the green would not have resulted.

The choice of paper could also affect the appearance of the colors. On white paper, the ink or oil paint could appear very bright and luminous if made slightly transparent. In the red tower of *Lifts* (cat. no. 54), for example, the glowing sheen of the Japanese paper support is visible through the media, making the red (as well as the other colors) extremely vivid.

Printing Techniques

Not only the type of paper, the choice of ink or oil paint, and the sequencing of the blocks determined the final appearance of the print; the techniques used during printing also played a part. The Grosvenor School art-

Figure 21. Printing paper being put onto an inked linoleum block. Points A and B indicate the points of the registration notches cut into the block. Reproduced from Claude Flight, *Lino-Cuts: A Hand-Book of Linoleum-Cut Colour Printing* (London: J. Lane, The Bodley Head, 1927), The Metropolitan Museum of Art, Thomas J. Watson Library.

ists typically placed the paper facedown on the inked block (fig. 21), rubbed the back of the paper to ensure good contact, and then peeled the printed paper away from the linoleum. They used dry paper, not wet or damp paper as with most printing techniques, because the soft, tissue-like Japanese paper did not need to be damp to pick up the nuances of the carved block. The rubbing could be done using a Japanese-style *baren* (a round, flat disk covered with bamboo leaves), a spoon, or the hand and fingers. Lill Tschudi's linocuts are often annotated "handdruck" or "handprint," to ensure that the viewer appreciates that the print was made by the direct hand of the artist and not by a mechanized printing press that could have been associated with more commercial work, standardized press-printed editions, and reproductions.

These artists employed hand printing in order to manipulate each impression by adjusting the pressure according to the requirements of the design. An example of the effect of differential pressure during printing is Power's *Merry-Go-Round* (cat. no. 36), which was made from just two blocks. The center, the depiction of the actual merry-go-round, is an intense solid color; firm pressure was used here. Around the edges, the moving atmosphere was printed in the same colors from the same block but appears lighter and softer; less pressure during printing gave the media a less intense, more textured appearance.

The instructions found in Andrews's *Print Book I* (fig. 22) for printing *Bathers* (cat. no. 96) illustrate the artists' attention to color and pressure on each block and their interaction when printing:

1) Spectrum Red. Very pale but print head dark red to allow for over printing.
2) Viridian very pale.
3) Viridian not too dark - graduated [and] very pale over waves[15]

The prints were made on demand and often over an extended period of time. Noting which techniques worked to create a desired effect helped the artists replicate results and aided in the creation of an edition with some consistency.

Variable printing pressure and layering, the use of

Figure 22. Printing instructions for *Bathers* (cat. no. 96), by Sybil Andrews, as recorded in Andrews's *Print Book I*, p. 13, Glenbow Museum, Calgary, Canada, m-8411-138-p.13. The instructions include the colors chosen for each block, the heaviness of printing, and the distribution of the prints in the edition.

Figure 23. Detail of *The Giant Racer* (cat. no. 37), by Cyril E. Power. Taken through a microscope, this detail shows how the oil paint has formed into branched peaked lines during the printing process.

Figure 24.

Upper left: detail from *The Concerto* (cat. no. 86), by Cyril E. Power, showing the areas intentionally left "in reserve," or unprinted, to depict the brightest highlights of the white music pages.

Lower left: detail from *Boccia* (cat. no. 71), by Lill Tschudi, displaying the variety of textures and the highly "pointillistic" approach she often used.

Upper right: detail from *Swing-Boats* (cat. no. 34), by Claude Flight, illustrating the contrast between the shiny black printing ink and the more matte oil paints.

Lower right: detail from *The Concerto* (cat. no. 86), by Cyril E. Power, demonstrating the variety of textures found in one impression. This detail also shows the raised ridge that can form at the edges of the printed forms when ink or oil paint is pressed to the edge of the linoleum during the printing process, often a telltale sign of a relief print.

textured linoleum, and the dilution of the ink or oil paint all contributed to the range of textural effects that are an important and predominant feature of Grosvenor School linocuts. Depending on how the ink or paint was diluted, applied, and layered, its texture could be slick, smooth, soft, rough, spattered, or pebbled, each imparting a different feel to the final print. One textural effect evident in many of these prints is a series of rippled lines of peaked ink or paint in converging and diverging lines (fig. 23).[16] This phenomenon can be seen in Flight's *Brooklands* in the blue concentric circles of the sky, which contrast with the solid printing of the flames and cars. It is used selectively by Power in his print *The Giant Racer* (cat. no. 37) and overall in Tschudi's *Pasting up Posters* (cat. no. 75). With experience, the artist could control the ink or oil paint and the printing to create this texture.

Layering of textural effects was very useful in lessening the intensity of a single color or allowing for sophisticated effects when printing with multiple colors. The layered colors could optically combine to create a new color; in *Racing* (cat. no. 69), for example, Andrews printed the green, red, orange, and blue blocks so that they overlapped to form a brown horse at the center of the print. More importantly, layering could modulate a tone to create the effect of light and shadow; in Andrews's *Winch* (cat. no. 79), the pants of the workers are green, but the layering of textured color slightly shifts the tone, giving the effect of light and shadow falling differently on each leg. The technique is used over and over again to create shadow,

as seen in Power's linocuts *The Escalator, Whence & Whither?,* and *The Tube Train* (cat. nos. 50, 51, and 58), and to create highlights, as on the jackets of the band players of Tschudi's *Rhumba Band II* (cat. no. 88).

Dynamic Results

Examining details of these prints shows the variety of texture, opacity, and color that could be achieved in an individual impression, ranging from vibrant solid tones of bold graphic color to subtle, blended, near-pointillist effects (fig. 24). This richness of surface not only enlivens the images but also demonstrates the Grosvenor School artists' knowledge and control of their materials. They clearly believed in the long artistic tradition of thoroughly knowing one's medium and honing one's technique. In fact, they developed a new spectrum of techniques, using modern materials and methods to cast off the restraints of the past and free their creative spirit, resulting in a body of work that was wholly of their time — "the experience of to-day in the technique of to-day."[17]

1. Attributed to Claude Flight in "Lino-cuts," *The Times* (London), July 6, 1929, p. 12.

2. Claude Flight, *Lino-Cuts: A Hand-Book of Linoleum-Cut Colour Printing* (London: J. Lane, The Bodley Head, 1927) and *The Art and Craft of Lino Cutting and Printing* (London: B. T. Batsford, 1934).

3. "Dark," the notation Power made for a mixture of green and blue, may mean dark blue.

4. This was a departure from late nineteenth-century commercial lithography, which could use as many as forty stones or blocks to create an image, and from the Japanese woodcut tradition, which could use eight or more blocks.

5. "Lino-cuts," *The Times* (London), March 18, 1931, p. 14.

6. Flight, *Lino-Cuts,* 8.

7. Flight, *Art and Craft of Lino Cutting,* 20.

8. Although the Grosvenor School artists were very specific about the materials they used, they exhibit an element of thrift and reuse. The sheet of paper that provides the backing material for *Speed* was originally used for a drawing of two nudes, which is faintly visible on the verso.

9. Rice glue is actually a rice starch paste that would have been cooked for use by the artist. It is Asian in origin, and although readily available in Europe, it would have retained its association with an Asian artistic tradition.

10. *Print Book I,* 1929–33, Glenbow Museum, Calgary, Canada, m-8411-138, is the first of several books kept by Andrews and Power. It records prints first made between 1929 and 1933; however, Andrews continued to update these books until the 1980s. Lill Tschudi may have carved notes about the colors she used into the margins of her linoleum blocks.

11. Even within the realm of commercially prepared oil paint or printing ink, the type of pigment can change the characteristics of the final product. Not only do the chemical properties of different colors affect the working properties of the media, but so does the method of manufacture, meaning that even the same color can behave differently if made by different manufacturers. For these reasons, the artists studied and experimented with color choices (and brands), which took on a great deal of importance in determining the look of the final print.

12. Andrews, *Print Book I,* p. 8. "Permanent" is a prefix used by the Winsor & Newton company for synthetic pigments. The other names for colors listed were either common names for a type of pigment or a product name given by one of the various commercial colormen who sold products to the Grosvenor School artists. It is curious that Andrews crossed out "Prussian" and wrote in "Chinese Blue," even though they are the same pigment. This may be an example of how the paint varied between manufacturers.

13. Flight, *Art and Craft of Lino Cutting,* 44.

14. The halo around the printed elements may not have been visible when the print was created. Oil and other thinners will commonly leach out into the paper support and darken over time, creating the halo.

15. Andrews, *Print Book I,* p. 13.

16. This effect is sometimes called "viscous trees" or "dendritic ripples" because of its branched appearance. It is a result of the physical phenomenon that occurs when a fluid (the ink or paint) is pressed between two flat surfaces (the linoleum block and the paper) that are then peeled apart — the exact action that occurs during printing.

17. Flight, *Art and Craft of Lino Cutting,* 63.

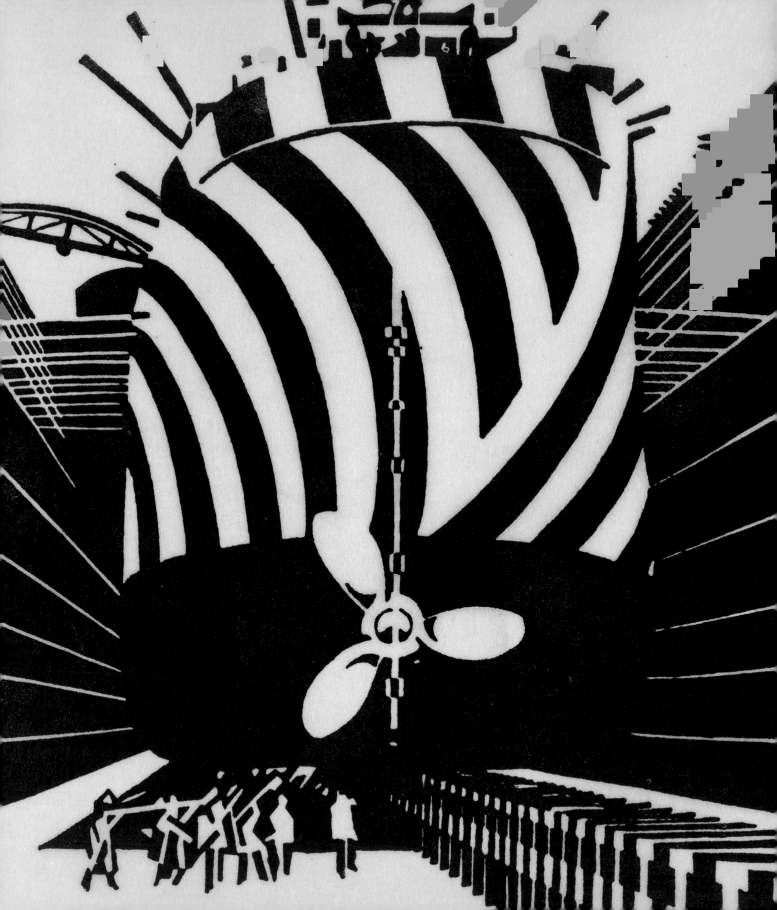

SYBIL ANDREWS
(1898–1992)

After working as an airplane welder during World War I, Sybil Andrews returned home to Bury St. Edmunds, England, where Cyril Power soon became her drawing tutor. Together they left for London in 1922 and enrolled at Heatherley's School of Fine Art, where William Kermode interested Andrews in making woodcuts. From 1925 to 1928, she was secretary to the Grosvenor School of Modern Art. There, she caught Claude Flight's infectious enthusiasm for color linocuts. In 1928, Andrews established a studio in Hammersmith, which she shared with Power from 1930 to 1938. Apart from making linocuts, they also made architectural etchings, designed posters, and studied early music. In 1938, Andrews moved to a village in the south of England. During World War II, she worked in a shipyard, where she met her husband. In 1947, they immigrated to a hardscrabble town on Vancouver Island, Canada, where Andrews achieved recognition that lasted through the 1950s. She fell into obscurity in the 1960s but was rediscovered in the mid-1970s. By the time she ceased to make linocuts in 1988, her production totaled seventy-six works. The Glenbow Museum, Calgary, holds a large archive of her prints and blocks. — TER

LEONARD BEAUMONT
(1891–1986)

The career of Leonard Beaumont is less well known than that of many of his lino-cutting contemporaries. He was born in Sheffield, England, where he initially pursued a career as a journalist. He attended evening classes at the Sheffield School of Art and began making prints in the 1920s, working at first primarily in etching and then in linocut. In the 1930s, he did some work as a book illustrator. A retrospective exhibition of his work was held at the Mappin Art Gallery, Sheffield, in 1983. — TER

DAVID BOMBERG
(1890–1957)

The fifth child of a Polish immigrant in Birmingham, David Bomberg began his printmaking career as an apprentice to a commercial lithographer from 1906 to 1907, while attending evening art classes at the City and Guilds of London Art School. From 1908 to 1910, he studied book production and lithography at the Central School of Arts and Crafts and attended Walter Sickert's evening classes at the Westminster School. In 1911, he entered the Slade School of Fine Art, where his classmates included such talented artists as Stanley Spencer, Paul Nash, and Edward Wadsworth. Bomberg was a founding member of the avant-garde London Group, exhibiting one of his most important prewar paintings, *In the Hold,* at its first official exhibition in March 1914 and holding his first solo show at the Doré Galleries only four months later. In 1915, he exhibited six works in the Doré Galleries' first and only Vorticist exhibition. Although he worked primarily as a painter, Bomberg was well trained in lithography and produced *Russian Ballet,* a masterful booklet of image and text, in 1919, the same year he was demobilized from military service. Following the war, he abandoned abstraction in favor of a more naturalistic style focused on landscape. — SR

CLAUDE FLIGHT
(1881–1955)

Claude Flight practiced various trades — engineer, librarian, farmer, beekeeper —

before enrolling in Heatherley's School of Fine Art in 1912. After World War I, he spent a year studying art in Paris. He also bought a chalk cave along the Seine, which became his lifelong summer retreat. In the 1920s, Flight enjoyed success as a painter and designer. Inspired by the dynamic style of the Italian Futurists and by Vorticism, he sought a medium that could embody the accelerated world of the twentieth century. He settled on the linocut, for it was free of the daunting artistic heritage of the Old Masters and offered the democratic possibility of making contemporary art available at modest prices. Flight produced sixty-seven linocuts from 1919 to about 1939. From 1921 on, his prints hewed to modern style. He championed linocutting during weekly classes at the Grosvenor School of Modern Art from 1926 to 1930, published two books on linocuts (in 1927 and 1934), organized eight annual linocut exhibitions beginning in 1929 at the Redfern Gallery in London, and sent exhibitions to three continents. With the outbreak of World War II, Flight left London, taking along his prints and watercolors. In 1941, his London studio was destroyed, and he lost all of his paintings and printing blocks. He suffered a stroke in 1947 and died in obscurity in 1955. — TER

HENRI GAUDIER-BRZESKA
(1891–1915)

In 1906, the young Frenchman Henri Gaudier-Brzeska received a scholarship to study English in Bristol. After a period of study in Germany in 1909, he returned to England in 1911 and settled in London, where he quickly became one of the leaders of the avant-garde, befriending the influential critic T. E. Hulme and the poet Ezra Pound. He was briefly affiliated with the Omega Workshops, from 1913 to 1914, before joining the short-lived Rebel Art Centre in spring 1914. Later that year, he signed the Vorticist manifesto published in the first edition of *BLAST.* Although Gaudier-Brzeska worked primarily as a sculptor, he briefly experimented with etching and drypoint and made a single linocut, *Wrestlers,* in the studio of Horace Brodzky, an experienced printmaker and close friend. One of Vorticism's staunchest advocates, Gaudier-Brzeska was killed in 1915 while serving with the French army. A memorial exhibition of his work was held at the Leicester Galleries in 1918. — SR

WILLIAM GREENGRASS
(1896–1970)

Unlike most of the artists in this catalogue, Greengrass's primary occupation was not as a visual artist; his full-time job was keeper at the Victoria and Albert Museum in London. He made wood engravings before joining the Grosvenor School of Modern Art in 1930, where he studied with Claude Flight, exhibiting regularly in the latter's linocut exhibitions at the Redfern Gallery. Greengrass's prints also were illustrated in Flight's 1927 and 1934 linocut manuals. Although he is represented in the catalogue with a floral image, his linocuts typically focused on the speed and movement of figures in sport. — SR

E. MCKNIGHT KAUFFER
(1890–1954)

Born in Great Falls, Montana, Edward McKnight Kauffer began painting theater sets as a young man, traveling widely around the United States in that job before attending evening art classes in such varied cities as San Francisco, Chicago, Munich, and Paris. In 1914, he settled in London, where he designed posters for the London Underground Railways, Shell UK Ltd., and the *Daily Herald*, to name just a few. His innovative and popular designs incorporated stylistic elements from modern art movements such as Vorticism and Constructivism and contributed significantly to Britain's poster renaissance. He also illustrated several books by writers such as Herman Melville, Carl Van Vechten, and T. S. Eliot. McKnight Kauffer received an exhibition at the Ashmolean Museum, Oxford, in 1926, a rare honor for a graphic artist, and a retrospective at the Museum of Modern Art, New York, in 1937. — SR

EILEEN MAYO
(1906–1994)

Eileen Mayo entered the Slade School of Fine Art in 1924, but she made the museums and zoos of London her classroom. The following year, she switched to the Central School of Arts and Crafts, where her courses included printmaking. Thereafter, she began to seek commissions as both a printmaker and a graphic designer. In 1928, she enrolled in Claude Flight's linocut class at the Grosvenor School of Modern Art, and the next year, she participated in the historic "First

Exhibition of British Lino-Cuts" at the Redfern Gallery. *The Turkish Bath* (1928) was her first linocut. From the late 1930s through the '40s, her art reflected the devotion of Britain's Neo-Romantic movement to the endangered rural landscape. She regularly exhibited at Redfern until her 1953 divorce prompted a move to Sydney, Australia. In 1962, she moved to New Zealand. — TER

PAUL NASH
(1889–1946)
Paul Nash had little formal training but ably taught himself new techniques throughout his career. Nash's early work was rather conservative, looking back to nineteenth-century conventions, but his artistic vision changed during World War I. Serving as an official war artist from 1917 to 1918, he made emotionally charged pastels and prints depicting landscapes disfigured by bombs and trenches. The six lithographs he produced during that time initiated his activity as a printmaker, which continued until about 1930. During the 1920s, his work became less emotional and more oriented toward problems of modernist form and composition. As modernism grew in popularity toward the end of the decade, Nash gained recognition as a leader. He flirted with both abstraction and Surrealism, finding the latter more suited to his poetic temperament. The vital forces that he sensed within landscapes and individual objects again became evident, as they had been in his earlier, wartime work. With the outbreak of World War II, he again became an official war artist. His late paintings are noted for their personal symbolism. — TER

C. R. W. NEVINSON
(1889–1946)
Christopher Richard Wynne Nevinson studied at the Slade School of Fine Art, but his encounter with the art of the Italian Futurists exhibited at the Sackville Gallery in 1912 set the course for his career. There he met Gino Severini, who would in turn introduce him to avant-garde circles in Paris. Nevinson was attracted to the belligerence of the Futurists, and his own painting became indebted to theirs. His 1914 "Vital English Art: A Futurist Manifesto," a collaboration with Marinetti, outraged Wyndham Lewis and other English artists. Nevinson continued to espouse Futurist militarism until, later that year, firsthand experience of war taught him its true consequences. He immediately turned the dynamic angularity of Futurism to the task of showing the plight of soldiers caught up in horrifying events beyond their control. Nevinson began making prints in 1916, mastering an array of techniques and producing some 150 prints by 1931. After the war, greatly stimulated by visits to New York, he focused his artistic attention on urban life, toward which his often moody images displayed considerable ambivalence. — TER

CYRIL E. POWER
(1872–1951)
Cyril Edward Mary Power pursued a first career in London as an architect and architectural historian. From 1916 to 1918, he oversaw a repair workshop for the Royal Flying Corps. After the war, Power relocated his architectural prac-

tice to Bury St. Edmunds, where he met Sybil Andrews in 1921. The following year, he left his wife to return to London with Andrews, and together they enrolled in Heatherley's School of Fine Art. Beginning in 1925, Power taught architecture and ornament at the Grosvenor School of Modern Art, where he encountered Claude Flight. His participation in the 1929 Redfern Gallery linocut exhibition led to commissions for London Underground posters. He and Andrews collaborated on these under the name "Andrew Power," and Redfern gave them their first major joint showing in 1933. Power and Andrews parted in 1938, and he returned to his wife. From 1925 to about 1937, Power produced forty-five linocuts, the blocks for which were destroyed shortly after his death. He was also prolific in etching and monotype. — TER

LILL TSCHUDI
(1911–2004)
Born in Schwanden, a small textile village in Switzerland sixty miles southeast of Zurich, Lill Tschudi developed an early interest in linocut after seeing an exhibition of the Viennese artist Norbertine Bresslern-Roth's color prints of animals. In 1929, she enrolled at the Grosvenor School of Modern Art and studied with Claude Flight for six months. Although she spent only limited time as his pupil, the two developed a close association that lasted until Flight's death in 1955. From 1931 to 1933, Tschudi lived in Paris and continued her training with the artists André Lhote, Gino Severini, and Fernand Léger. Flight, however, remained her greatest advocate, including her

207

linocuts in his "British Lino-Cut" exhibitions at the Redfern and Ward galleries and reproducing *Fixing the Wires* in his 1934 book *The Art and Craft of Lino Cutting and Printing*. Even after Tschudi returned to Switzerland in 1935, she regularly exchanged work with Flight and occasionally visited him at his studio in London. In 1986, Tschudi was awarded a national print prize in Switzerland for her lifetime achievement, having made 355 prints over the course of her career. — SR

EDWARD WADSWORTH
(1889–1949)

Edward Wadsworth, the son of a textile mill owner in the industrial town of Cleckheaton, Yorkshire, first studied engineering and mechanical drawing in Munich in 1906. Keenly interested in the fine arts, he returned to England in 1907 and attended the Bradford School of Art. In 1909, he won a scholarship to the Slade School of Fine Art, where he met the foremost figures of the rising British avant-garde, including Roger Fry, C. R. W. Nevinson, and David Bomberg. In 1913, Fry included one of Wadsworth's paintings, *Viaduct* (now lost), in the "Second Post-Impressionist Exhibition" and welcomed his participation at the Omega Workshops, where he quickly allied himself with the charismatic painter Wyndham Lewis. After Lewis's bitter split with Fry and Omega in the autumn of 1913, Wadsworth joined him as a founding member of the Rebel Art Centre (which lasted only six months) and a contributor to the Vorticist manifesto in *BLAST No. 1*. From 1916 to 1917, he served for a year as a naval intelligence officer in the Aegean. On his return to England, he supervised camouflage programs for shipping in Bristol and Liverpool.

Wadsworth was the most prolific Vorticist printmaker, first taking up woodcutting while a student in Munich and pursuing the medium with singular focus between 1913 and 1921. He made more than fifty woodcuts during this time, often printing several color variations and using different types of paper to create diverse effects. Although he briefly experimented with lithography and etching from 1919 to 1922, by 1921 his most innovative prints were behind him. Since none of Wadsworth's Vorticist paintings exist today, the prints single-handedly serve as a record of his artistic activity during this watershed period. Wadsworth destroyed his woodcut blocks in a bonfire in early 1927, declaring to his daughter, "They're finished and done with." — SR

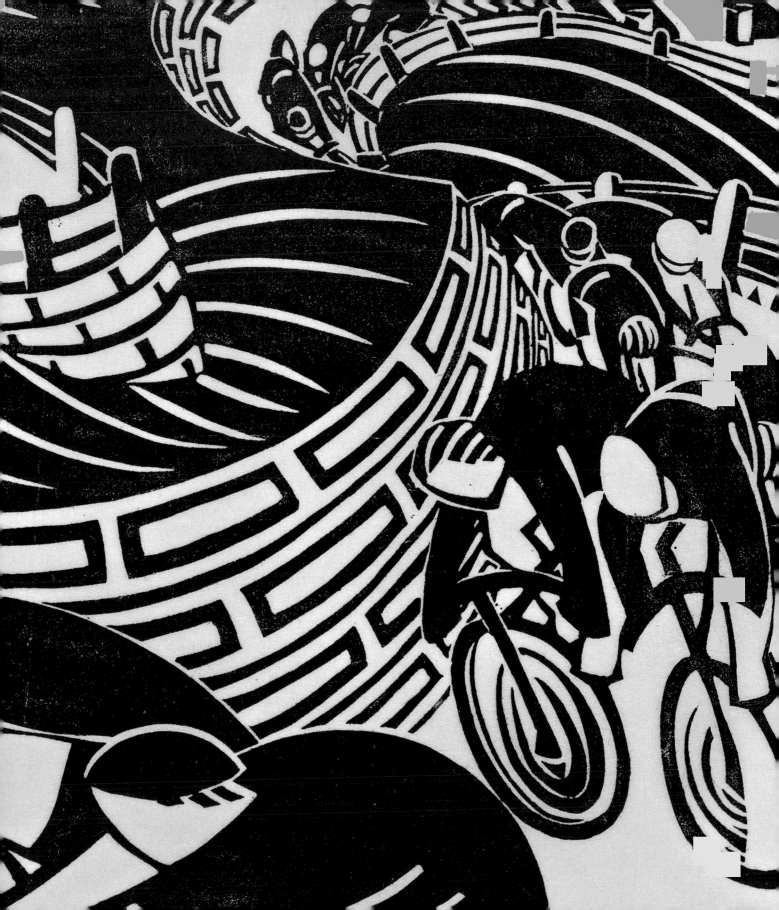

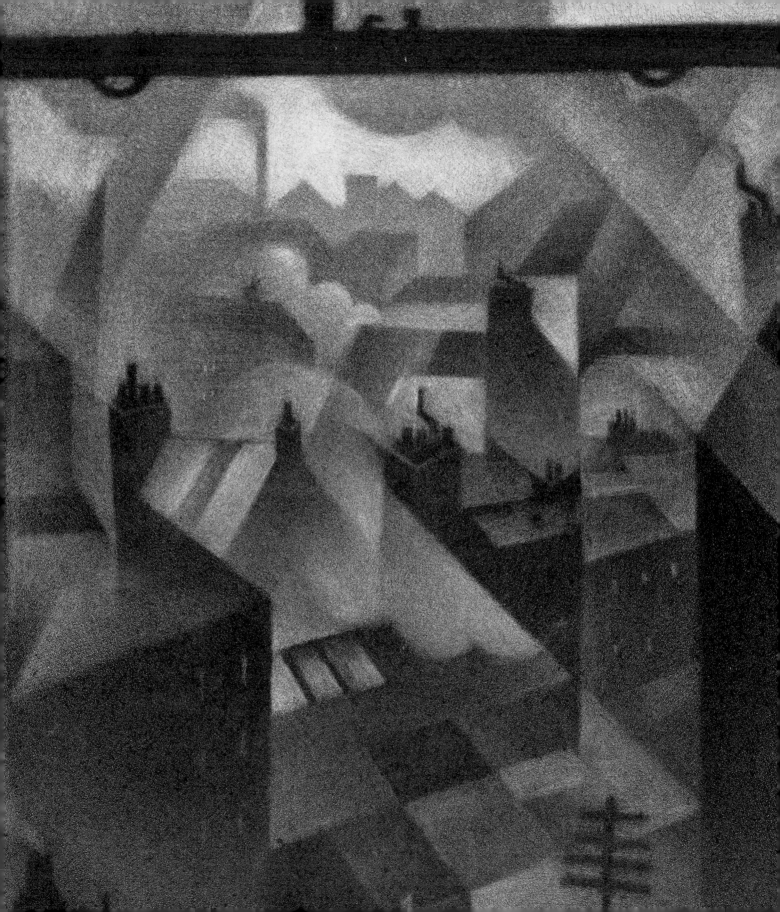

NOTE TO THE READER

The images in the catalogue are arranged in visual sequences according to theme, rather than chronologically. The checklist follows this order. Unless otherwise noted, dimensions are those of the edge or borderline of the image rather than the sheet. For the Grosvenor School linocuts, the edition number represents the intended total edition rather than the number actually printed. If no edition number is given, no information is available. The catalogue raisonné numbers cited in the checklist refer to the following print catalogues:

Coppel: Coppel, Stephen. *Linocuts of the Machine Age: Claude Flight and the Grosvenor School.* Hants, England: Scolar Press in association with the National Gallery of Australia, 1995.

Greenwood: Greenwood, Jeremy. *The Graphic Work of Edward Wadsworth.* With an introduction by Richard Cork. Woodbridge, England: Wood Lea Press, 2002.

Leicester: Leicester Galleries at the Alpine Club Gallery. *Nash and Nevinson in War and Peace: The Graphic Work, 1914–1920.* London: Ernst, Brown, and Phillips, 1977.

Postan: Postan, Alexander. *The Complete Graphic Work of Paul Nash.* London: Secker and Warburg, 1973.

VORTICISM AND ABSTRACTION

1 Henri Gaudier-Brzeska
Wrestlers, about 1914
Linocut, printed posthumously by Horace Brodzky
Thick cream wove paper
22 x 27.5 cm (8½ x 11 in.)
Edition: Printer's proof 5, from a projected posthumous edition of 50
The Metropolitan Museum of Art, New York, The Elisha Whittelsey Collection, The Elisha Whittelsey Fund, 68.676.1

2 Edward Wadsworth
Street Singers, about 1914
Woodcut, with the artist's pencil annotations for close overmatting
Thick cream wove paper
14 x 11 cm (5½ x 4⁵⁄₁₆ in.)
Greenwood W/D 10
Johanna and Leslie Garfield Collection

3 Claude Flight
Street Singers, 1925
Color linocut
Thin cream Asian paper
31.2 x 26.2 cm (12⁵⁄₁₆ x 10⁵⁄₁₆ in.)
Coppel CF 14
Edition: 1/50
The British Museum, London, 1926-2-8-1

4 David Bomberg
Russian Ballet, 1919
Bound booklet with poetic texts and color lithographs
Sheet: 21.6 x 28 cm (8½ x 11 in.)
Published in London by Hendersons
Johanna and Leslie Garfield Collection

5a–c David Bomberg
Russian Ballet, 1919
Color lithographs, unbound proof pages for the illustrated booklet published in London by Hendersons
Sheet: 21.5 x 26.7 cm (8⁷⁄₁₆ x 10½ in.)
Private Collection

6 Edward Wadsworth
Interior, 1917
Woodcut
Thick cream wove paper
10.7 x 7.3 cm (4³⁄₁₆ x 2⁷⁄₈ in.)
Greenwood W/D 25
Johanna and Leslie Garfield Collection

7 Edward Wadsworth
The Open Window, about 1914
Color woodcut, gray and black variant
Thick cream wove paper
16 x 11 cm (6⁵⁄₁₆ x 4³⁄₁₆ in.)
Greenwood W/D 5/I
Museum of Fine Arts, Boston, Lee M. Friedman Fund, 1985.719

8 Edward Wadsworth
The Open Window, about 1914
Color woodcut, blue, brown, and
black variant
Thick tan wove paper
16 x 11 cm (6⁵/₁₆ x 4⁵/₁₆ in.)
Greenwood W/D 5/3
The British Museum, London,
1980-1-26-87

9 Edward Wadsworth
Brown Drama, 1914–17
Color woodcut
Thick gray wove paper
12.5 x 7 cm (4¹⁵/₁₆ x 2¾ in.)
Greenwood W/D 21/2
Private Collection

10 Edward Wadsworth
Illustration (Typhoon), 1914
Woodcut
Medium-thick dark-cream Asian paper
28 x 25.5 cm (11 x 10¹/₁₆ in.)
Inscribed in graphite, lower left:
"'Painted white, they rose high into the
dusk of the skylight, / sloping like a roof:
and the whole lofty space resembled /
the interior of a monument . . . divided
at intervals by / floors of iron grating,
(a mass of gloom) in the / middle,
within the columnar stir of machinery.'
Typhoon: Joseph Conrad"
Greenwood W/D 18
The British Museum, London,
1924-2-9-143

**11 *BLAST No. 1: Review of the Great
English Vortex*, June 20, 1914**
Edited by Wyndham Lewis
Published in New York by John Lane
Yale Center for British Art, Gift of
John Brealey, AP4/B62+/NO.1

**12 *BLAST War Number: Review of
the Great English Vortex*, July 1915**
Edited by Wyndham Lewis
Published in New York by John Lane
Yale Center for British Art, Gift of
John Brealey, AP4/B62+/NO.2

13 E. McKnight Kauffer
Flight, 1917
Woodcut
Medium-thick off-white Asian paper
14 x 23 cm (5½ x 9¹/₁₆ in.)
The British Museum, London,
1939-2-28-8

14 Claude Flight
Dirt Track Racing, about 1928
(Dirt bike racing)
Color linocut
Very thin off-white Asian paper mounted
on dark-gray paper (original dark-gray
backing replaced)
25 x 30.5 cm (9¹³/₁₆ x 12 in.)
Coppel CF 29
Edition: 3/50
Museum of Fine Arts, Boston, Partial
Gift of Johanna and Leslie Garfield,
2005.1101

15 Cyril E. Power
Revolution, about 1931
Color linocut
Very thin light-cream Asian paper
22.5 x 30.5 cm (8⅞ x 12 in.)
Coppel CEP 24
Edition: Number 9 of an unspecified
edition
Johanna and Leslie Garfield Collection

16 Cyril E. Power
The Vortex, 1929
(This impression is inscribed with
the alternate title *Curlization*.)
Color linocut
Very thin light-cream Asian paper
38.6 x 34.5 cm (15³/₁₆ x 13⁹/₁₆ in.)
Coppel CEP 25
Edition: 50
Johanna and Leslie Garfield Collection

WORLD WAR I

17 C. R. W. Nevinson
The Road from Arras to Bapaume, 1918
(Northern France)
Lithograph
Medium-thick cream laid paper
47.3 x 38.7 cm (18⅝ x 15¼ in.)
Leicester 37
The Metropolitan Museum of Art,
New York, Purchase, Reba and Dave
Williams Gift, 1996.577

18 C. R. W. Nevinson
Column on the March, 1916
Drypoint
Thick cream laid paper
16.1 x 22.2 cm (6⁵/₁₆ x 8¾ in.)
Leicester 3
Johanna and Leslie Garfield Collection

19 C. R. W. Nevinson
Returning to the Trenches
(Troops Marching to the Front), 1916
Etching and drypoint
Medium-thick cream laid paper
15 x 20 cm (6 x 8 in.)
Leicester 1

Edition: 75 (inserted in limited edition
of P. G. Konody, *Modern War*, a catalogue
of Nevinson's paintings published
in London by G. Richards in 1917)
The Metropolitan Museum of Art,
New York, Rogers Fund, 1968, 68.510.3

20 Paul Nash
Rain, Lake Zillebeke, 1918
(Zillebeke is a Belgian village near
Ypres.)
Lithograph
Thick off-white wove paper
25.5 x 36.2 cm (10⅛ x 14¼ in.)
Postan L 3
Edition: 7/25 plus
The British Museum, London,
1918-7-4-4

21 Paul Nash
The Crater, Hill 60, 1917
(Ypres Salient, Belgium)
Lithograph
Medium-thick cream laid paper
(Antique DeLuxe)
35.4 x 45.5 cm (13¹⁵⁄₁₆ x 17¹⁵⁄₁₆ in.)
Postan L 1
Edition: 12/25
The British Museum, London,
1918-7-4-6

22 C. R. W. Nevinson
*Hauling Down an Observation Balloon
at Night*, 1918
Lithograph
Medium-thick cream laid paper
51.6 x 36.2 cm (20⁵⁄₁₆ x 14¼ in.)
Leicester 32
The British Museum, London,
1918-2-19-25

23 C. R. W. Nevinson
Banking at 4000 Feet, 1917
(From the set of six, "Building Aircraft,"
Nevinson's contribution to the collective
propaganda portfolio *The Great War:
Britain's Efforts and Ideals*)
Lithograph
Thick light-cream wove paper
40.2 x 31.6 cm (15¹³⁄₁₆ x 12⁷⁄₁₆ in.)
Leicester 23
Edition: 200
Museum of Fine Arts, Boston,
Gift of John T. Spaulding, 37.1265

24 C. R. W. Nevinson
Swooping Down on a Taube, 1917
(From the set of six, "Building Aircraft,"
Nevinson's contribution to the collective
propaganda portfolio *The Great War:
Britain's Efforts and Ideals*. The Taube,
or "Dove," was a German aircraft.)
Lithograph
Thick off-white wove paper
40 x 29.9 cm (15¾ x 11¾ in.)
Leicester 28
Edition: 200
Johanna and Leslie Garfield Collection

25 Cyril E. Power
Air Raid, about 1935
(The artist's memory of World War I
aerial dogfights while serving in the
Royal Flying Corps)
Color linocut
Very thin light-cream Asian paper
30.5 x 39.3 cm (12 x 15½ in.)
Coppel CEP 42
Edition: 11/60
Museum of Fine Arts, Boston, Partial
Gift of Johanna and Leslie Garfield,
2005.1102

26 C. R. W. Nevinson
Ramming Home a Heavy Shell, 1917
Woodcut
Medium-thick cream Asian paper
23 x 30.6 cm (9¹⁄₁₆ x 12¹⁄₁₆ in.)
Leicester 21
Edition: 12
The British Museum, London,
1918-2-19-14

27 Edward Wadsworth
Dock Scene, 1917
(Liverpool)
Woodcut
Very thin light-cream Asian paper
11 x 17.5 cm (4.5 x 7 in.)
Greenwood W/D 36
The Metropolitan Museum of Art,
New York, Mary Martin Fund, 1985.1143

28 Edward Wadsworth
Liverpool Shipping, 1918
Woodcut
Thin off-white Asian paper
25.8 x 19.9 cm (10³⁄₁₆ x 7¹³⁄₁₆ in.)
Greenwood W/D 31
The Metropolitan Museum of Art,
New York, Partial and Promised Gift of
Johanna and Leslie Garfield, 2005.470.12

29 Edward Wadsworth
Drydocked for Scaling and Painting, 1918
(Liverpool)
Woodcut
Very thin off-white Asian paper
22.2 x 20.3 cm (8¾ x 8 in.)
Greenwood W/D 32
Museum of Fine Arts, Boston, Partial
Gift of Johanna and Leslie Garfield,
2005.1107

SPEED AND MOVEMENT

30 Sybil Andrews
Speedway, 1934
(Dirt bike racing, project for a proposed
public transportation poster)
Color linocut
Thin cream Asian paper
32.7 x 23 cm (12⅞ x 9¹⁄₁₆ in.)
Coppel SA 29
Edition: 31/60
Museum of Fine Arts, Boston, Partial
Gift of Johanna and Leslie Garfield,
2005.1099

31 Cyril E. Power
Speed Trial, 1932
(Test driver Malcolm Campbell's
aerodynamically designed racing car
Bluebird)
Color linocut
Very thin off-white Asian paper
19.5 x 37.4 cm (7¹¹⁄₁₆ x 14¾ in.)
Coppel CEP 31
Edition: Specimen, final Experimental
Proof for an edition of 50
Private Collection

32 Cyril E. Power
Speed Trial, 1932
Color linocut
Very thin off-white Asian paper
19.5 x 37.5 cm (7¹¹⁄₁₆ x 14¾ in.)
Coppel CEP 31
Edition: 5/50
Johanna and Leslie Garfield Collection

33 Claude Flight
Brooklands, about 1929
(Brooklands racetrack)
Color linocut
Thin off-white Asian paper mounted
over a metallic and tan backing paper
with silver flecks
30.5 x 25.8 cm (12 x 10³⁄₁₆ in.)
Coppel CF 30
Edition: 10/50
Museum of Fine Arts, Boston, Partial
Gift of Johanna and Leslie Garfield,
2005.1100

34 Claude Flight
Swing-Boats, 1921
Color linocut
Thin off-white Asian paper mounted on
dark-gray paper
22.2 x 28.5 cm (8¾ x 11¼ in.)
Coppel CF 5
Edition: 21/50
The Metropolitan Museum of Art,
New York, Partial and Promised Gift of
Johanna and Leslie Garfield, 2005.470.2

35 Cyril E. Power
The High Swing, about 1933
(Fun Fair, Hampstead Heath)
Color linocut
Very thin off-white Asian paper
29.8 x 15.7 cm (11¾ x 6³⁄₁₆ in.)
Coppel CEP 37
Edition: 18/60
Johanna and Leslie Garfield Collection

36 Cyril E. Power
The Merry-Go-Round, about 1929–30
(Giant swing, Wembley Exhibition
Fun Fair)
Color linocut
Very thin light-cream Asian paper
30.5 x 30.5 cm (12 x 12 in.)
Coppel CEP 16
Edition: 16/50
Johanna and Leslie Garfield Collection

37 Cyril E. Power
The Giant Racer, about 1930
(Roller coaster, Wembley Exhibition
Fun Fair)
Color linocut
Very thin off-white Asian paper
27.8 x 19.1 cm (10¹⁵⁄₁₆ x 7½ in.)
Coppel CEP 15
Edition: 22/50
Johanna and Leslie Garfield Collection

38 Sybil Andrews
Rush Hour, 1930
Color linocut
Medium-thick light-cream Asian paper
20.8 x 25.2 cm (8³⁄₁₆ x 9¹⁵⁄₁₆ in.)
Coppel SA 9
Edition: 18/50
Johanna and Leslie Garfield Collection

39 Sybil Andrews
Hyde Park, 1931
Color linocut
Medium-thick cream Asian paper
33.8 x 15.4 cm (13⁵⁄₁₆ x 6¹⁄₁₆ in.)
Coppel SA 16
Edition: 24/60, from the continued
edition after the blocks were recut
in 1981
Johanna and Leslie Garfield Collection

URBAN LIFE / URBAN DYNAMISM

40 C. R. W. Nevinson
Looking through the Brooklyn Bridge,
1920–22
(New York)
Drypoint
Medium-thick cream wove paper
23.6 x 17.5 cm (9⁵⁄₁₆ x 6⅞ in.)
Leicester 41
Johanna and Leslie Garfield Collection

41 C. R. W. Nevinson
Third Avenue under the El-Train,
about 1921
(New York)
Etching and drypoint
Thick cream laid paper
20.1 x 15 cm (7^{15}/$_{16}$ x 5^{7}/$_{8}$ in.)
Leicester 42
Johanna and Leslie Garfield Collection

42 C. R. W. Nevinson
New York — An Abstraction, 1921
Drypoint
Medium-thick cream laid paper
12.7 x 8.9 cm (5 x 3^{1}/$_{2}$ in.)
Leicester 43
The Metropolitan Museum of Art,
New York, Purchase, Reba and Dave
Williams Gift, 1998.68.2

43 C. R. W. Nevinson
The Great White Way, 1920–21
(New York)
Lithograph
Medium-thick cream laid paper
49.8 x 30.5 cm (19^{5}/$_{8}$ x 12 in.)
Leicester 54
The Metropolitan Museum of Art,
New York, Purchase, Reba and Dave
Williams Gift, 2001.152

44 C. R. W. Nevinson
From an Office Window, 1918
(London)
Mezzotint
Medium-thick cream laid paper
25.2 x 17.6 cm (9^{15}/$_{16}$ x 6^{15}/$_{16}$ in.)
Leicester 76
Museum of Fine Arts, Boston, Gift of
Mr. and Mrs. James N. Rosenberg,
46.564

45 C. R. W. Nevinson
*Wet Evening, Oxford Street
(Les Parapluies),* 1919
(London)
Lithograph
Thick off-white Asian paper
73.6 x 48.3 cm (29 x 19 in.)
Leicester 57
Museum of Fine Arts, Boston,
Lee M. Friedman Fund, 1986.11

46 Claude Flight
Speed, 1922
(Buses, Regent Street)
Color linocut
Medium-thick off-white Asian paper,
mounted over paper tinted with
yellow oil paint
22.7 x 30 cm (8^{5}/$_{16}$ x 11^{13}/$_{16}$ in.)
Coppel CF 7
Edition: 24/50
The Metropolitan Museum of Art,
New York, Partial and Promised Gift of
Johanna and Leslie Garfield, 2005.470.1

47 Lill Tschudi
Street Decoration, 1937
(Silver Jubilee of George V, 1935)
Color linocut
Medium-thick off-white Asian paper
24.1 x 20 cm (9^{1}/$_{2}$ x 7^{7}/$_{8}$ in.)
Coppel LT 57
Edition: 5/50
Johanna and Leslie Garfield Collection

48 Cyril E. Power
The Sunshine Roof, about 1934
Color linocut
Very thin off-white Asian paper
26 x 33 cm (10^{1}/$_{4}$ x 13 in.)
Coppel CEP 39
Edition: Experimental Proof 2 for
an edition of 60
Johanna and Leslie Garfield Collection

49 Cyril E. Power
The Tube Station, about 1932
(Bank tube station)
Color linocut
Very thin light-cream Asian paper
25 x 28.2 cm (9^{13}/$_{16}$ x 11^{1}/$_{8}$ in.)
Coppel CEP 32
Edition: 44/60
The Metropolitan Museum of Art,
New York, Partial and Promised Gift of
Johanna and Leslie Garfield, 2005.470.6

50 Cyril E. Power
The Escalator, about 1929
(Exit, Charing Cross tube station)
Color linocut
Very thin light-cream Asian paper
33.5 x 37.4 cm (13^{13}/$_{16}$ x 14^{3}/$_{4}$ in.)
Coppel CEP 12
Edition: 13/50
Museum of Fine Arts, Boston, Partial
Gift of Johanna and Leslie Garfield,
2005.1105

51 Cyril E. Power
Whence & Whither? (The Cascade),
about 1930
(Tottenham Court Road tube station
escalators)
Color linocut
Very thin light-cream Asian paper
31.2 x 24 cm (12^{5}/$_{16}$ x 9^{7}/$_{16}$ in.)
Coppel CEP 14
Edition: 30/50
Johanna and Leslie Garfield Collection

52 Cyril E. Power
Lifts, about 1929
Color linocut, working proof printed
in red
Thin dark-cream tracing paper
Sheet: 41.3 x 28.6 cm (16¼ x 11¼ in.)
Coppel CEP 13
Johanna and Leslie Garfield Collection

53 Cyril E. Power
Lifts, about 1929
Color linocut, working proof printed
in green
Thin dark-cream tracing paper
Sheet: 31.6 x 22.2 cm (12⁷⁄₁₆ x 8¾ in.)
Coppel CEP 13
Johanna and Leslie Garfield Collection

54 Cyril E. Power
Lifts, 1929–30
Color linocut, completed edition print
printed in red, green, and blue, with
borderline in pencil
Very thin light-cream Asian paper
Sheet: 37 x 23.4 cm (14⁹⁄₁₆ x 9³⁄₁₆ in.)
Coppel CEP 13
Edition: 15/50
Johanna and Leslie Garfield Collection

55 Cyril E. Power
Lifts, 1930
(Advertisement for Hammond Bros. and
Champness Ltd. Elevators, reproduced
in *The Builder,* January 10, 1930)
Process print from linocut
Thin cream wove paper, mounted on
thick buff wove paper
Sheet: 19.5 x 12.6 cm (7¹¹⁄₁₆ x 4¹⁵⁄₁₆ in.)
Coppel CEP 13
Johanna and Leslie Garfield Collection

56 Cyril E. Power
The Tube Train, about 1934
Color linocut, working proof printed
in green
Medium-thick cream Asian paper
31.2 x 32.2 cm (12⁵⁄₁₆ x 12¹¹⁄₁₆ in.)
Coppel CEP 41
Edition: Block III, first state, for an
edition of 60
The Metropolitan Museum of Art,
New York, Partial and Promised Gift of
Johanna and Leslie Garfield, 2005.470.8

57 Cyril E. Power
The Tube Train, about 1934
Color linocut, working proof printed
in blue
Cream tracing paper
31.2 x 32.2 cm (12⁵⁄₁₆ x 12¹¹⁄₁₆ in.)
Coppel CEP 41
Edition: Block IV, first state, for an
edition of 60
The Metropolitan Museum of Art,
New York, Partial and Promised Gift of
Johanna and Leslie Garfield, 2005.470.9

58 Cyril E. Power
The Tube Train, about 1934
Color linocut, completed edition print
Very thin off-white Asian paper
31.2 x 32.2 cm (12⁵⁄₁₆ x 12¹¹⁄₁₆ in.)
Coppel CEP 41
Edition: 4/60
The Metropolitan Museum of Art,
New York, Partial and Promised Gift of
Johanna and Leslie Garfield, 2005.470.7

59 Cyril E. Power
The Tube Staircase, 1929
(Russell Square tube station)
Color linocut
Medium-thick light-cream Asian paper
44 x 25.5 cm (17⁵⁄₁₆ x 10¹⁄₁₆ in.)
Coppel CEP 11
Edition: 23/50
Johanna and Leslie Garfield Collection

60 Cyril E. Power
The Exam Room, about 1934
(Examination, Royal Institute of British
Architects)
Color linocut
Very thin light-cream Asian paper
26.5 x 38.2 cm (10⁷⁄₁₆ x 15¹⁄₁₆ in.)
Coppel CEP 40
Edition: Experimental Proof for an
edition of 60
Johanna and Leslie Garfield Collection

SPORT

61 Sybil Andrews
Bringing in the Boat, 1933
Color linocut
Thin light-cream Asian paper
33 x 25.8 cm (13 x 10³⁄₁₆ in.)
Coppel SA 24
Edition: 31/60
The Metropolitan Museum of Art,
New York, Partial and Promised Gift of
Johanna and Leslie Garfield, 2005.470.3

62 Cyril E. Power
The Eight, about 1930
(Head of the River Race, the Thames)
Preparatory drawing in red, blue, green,
and ocher crayons, black ink, and pencil;
one of at least ten drawings for the
linocut (Coppel CEP 18)
Dark-cream tracing paper
Sheet: 37.6 x 25.5 cm (14¹³⁄₁₆ x 10¹⁄₁₆ in.)
Museum of Fine Arts, Boston, Partial
Gift of Johanna and Leslie Garfield,
2005.1104

63 Cyril E. Power
The Eight, about 1930
(Head of the River Race, the Thames)
Color linocut
Very thin cream Asian paper
31.5 x 23.2 cm (12⅜ x 9⅛ in.)
Coppel CEP 18
Edition: 27/50
Museum of Fine Arts, Boston, Partial
Gift of Johanna and Leslie Garfield,
2005.1103

64 Sybil Andrews
Football, 1937
(Soccer)
Color linocut
Medium-thick cream Asian paper
25 x 31.7 cm (9¹³⁄₁₆ x 12½ in.)
Coppel SA 40
Edition: 41/60
Johanna and Leslie Garfield Collection

65 Leonard Beaumont
Untitled (Swimmers), 1930s
Color linocut
Medium-thick light-cream paper
10 x 10 cm (3¹⁵⁄₁₆ x 3¹⁵⁄₁₆ in.)
Edition: 14/14
Johanna and Leslie Garfield Collection

66 Cyril E. Power
The Runners, about 1930
Color linocut
Very thin light-cream Asian paper
17.4 x 35 cm (6⅞ x 13¾ in.)
Coppel CEP 19
Edition: 9/50
Johanna and Leslie Garfield Collection

67 Cyril E. Power
Skaters, about 1932
Color linocut
Very thin off-white Asian paper
19.9 x 31.8 cm (7³⁄₁₆ x 12½ in.)
Coppel CEP 29
Edition: 12/60
Johanna and Leslie Garfield Collection

68 Sybil Andrews
In Full Cry, 1931
Color linocut
Very thin light-cream Asian paper
29 x 42 cm (11⁷⁄₁₆ x 16⁹⁄₁₆ in.)
Coppel SA 13
Edition: 38/50
Johanna and Leslie Garfield Collection

69 Sybil Andrews
Racing, 1934
Color linocut
Medium-thick cream Asian paper
26 x 34.3 cm (10¼ x 13½ in.)
Coppel SA 32
Edition: 57/60
The Metropolitan Museum of Art,
New York, Partial and Promised Gift of
Johanna and Leslie Garfield, 2005.470.5

70 Lill Tschudi
Tour de Suisse, September 1935
(Alpine bicycle race)
Linocut, originally intended to be printed
on cloth; later printing after decorative
border was removed in 1965
Medium-thick cream Asian paper
25 x 49.9 cm (9¹³⁄₁₆ x 19⅝ in.)
Coppel LT 43
Edition: 18/50
Museum of Fine Arts, Boston, Partial
Gift of Johanna and Leslie Garfield,
2005.1106

71 Lill Tschudi
Boccia (Jeu de Boules), about 1934
(Italian bowling game, French Riviera)
Color linocut
Very thin light-cream Asian paper
23 x 33.1 cm (9¹⁄₁₆ x 13 in.)
Coppel LT 38
Edition: 50
Johanna and Leslie Garfield Collection

INDUSTRY AND LABOR

72 C. R. W. Nevinson
Loading the Ship, 1917
Lithograph
Thick light-cream laid paper
43.8 x 33.3 cm (17¼ x 13⅛ in.)
Leicester 34
Edition: 25
Private Collection

73 C. R. W. Nevinson
Making the Engine, 1917
(From the set of six, "Building Aircraft,"
Nevinson's contribution to the collective
propaganda portfolio *The Great War:
Britain's Efforts and Ideals*)
Lithograph
Thick light-cream wove paper
40.4 x 30.4 cm (15⅞ x 11¹⁵⁄₁₆ in.)
Leicester 27
Museum of Fine Arts, Boston,
Gift of John T. Spaulding, 37.1263

74 Lill Tschudi
Fixing the Wires, 1932
Color linocut
Thin off-white Asian paper
30.2 x 20.1 cm (11⅞ x 7¹⁵⁄₁₆ in.)
Coppel LT 26
Edition: 16/50, USA edition (1937)
The Metropolitan Museum of Art,
New York, Partial and Promised Gift of
Johanna and Leslie Garfield, 2005.470.10

75 Lill Tschudi
Pasting up Posters, 1933
(Paris)
Color linocut
Thin light-cream Asian paper
30.2 x 20 cm (11⅞ x 7⅞ in.)
Coppel LT 33
Edition: 2/50
The Metropolitan Museum of Art,
New York, The Elisha Whittelsey
Collection, The Elisha Whittelsey Fund,
1985.1153

76 Lill Tschudi
Cleaning a Sail, 1934
(Fishermen, French Riviera)
Color linocut
Very thin light-cream Asian paper
25.2 x 30.1 cm (9¹⁵⁄₁₆ x 11⅞ in.)
Coppel LT 37
Edition: 14/50
The Metropolitan Museum of Art,
New York, Partial and Promised Gift of
Johanna and Leslie Garfield, 2005.470.11

77 Sybil Andrews
Oranges, 1929
Color linocut
Very thin light-cream Asian paper
26.3 x 19 cm (10⅜ x 7½ in.)
Coppel SA 3
Edition: 42/50
Johanna and Leslie Garfield Collection

78 Sybil Andrews
Sledgehammers, 1933
(Blacksmiths, Coventry)
Color linocut
Medium-thick cream Asian paper
26.2 x 31.5 cm (10⁵⁄₁₆ x 12⅜ in.)
Coppel SA 26
Edition: 50/60
Museum of Fine Arts, Boston, Partial
Gift of Johanna and Leslie Garfield,
2005.1098

79 Sybil Andrews
The Winch, 1930
Color linocut
Medium-thick light-cream Asian paper
20 x 28.3 cm (7⅞ x 11⅛ in.)
Coppel SA 6
Edition: 35/50
The Metropolitan Museum of Art,
New York, Partial and Promised Gift of
Johanna and Leslie Garfield, 2005.470.4

80 Sybil Andrews
The New Cable, 1931
Color linocut
Medium-thick light-cream Asian paper
31.3 x 42.5 cm (12⁵⁄₁₆ x 16¾ in.)
Coppel SA 17
Edition: 27/60, second state, without
blue background
Johanna and Leslie Garfield Collection

81 Edward Wadsworth
Blast Furnaces, 1919
Woodcut
Thick gray wove paper
12 x 19 cm (4¾ x 7½ in.)
Greenwood W/D 39
Johanna and Leslie Garfield Collection

82 Edward Wadsworth
Black Country, 1919
Woodcut
Medium-thick vermilion-coated
dark-cream wove paper
10.8 x 14.7 cm (4¼ x 5¹³⁄₁₆ in.)
Greenwood W/D 40
Johanna and Leslie Garfield Collection

ENTERTAINMENT AND LEISURE

83 Claude Flight
The Conjurer, about 1933
Color linocut
Thin light-cream Asian paper
31.1 x 25.6 cm (12¼ x 10¹⁄₁₆ in.)
Coppel CF 47
Edition: 1/50
Johanna and Leslie Garfield Collection

84 Sybil Andrews
Theater, 1929
("Old Vic" Theater, London)
Color linocut
Very thin light-cream Asian paper
27.5 x 20.7 cm (10¹³⁄₁₆ x 8⅛ in.)
Coppel SA 2
Edition: 19/50
Johanna and Leslie Garfield Collection

85 Sybil Andrews
Concert Hall, 1929
(Queen's Hall, London, destroyed 1941)
Color linocut
Very thin off-white Asian paper
23.5 x 27.8 cm (9¼ x 10¹⁵⁄₁₆ in.)
Coppel SA 1
Edition: 42/50
Johanna and Leslie Garfield Collection

86 Cyril E. Power
The Concerto, about 1935
(Concert at Queen's Hall)
Color linocut
Very thin light-cream Asian paper
32 x 29.5 cm (12⅝ x 11⅝ in.)
Coppel CEP 43
Edition: 28/50
Johanna and Leslie Garfield Collection

87 Lill Tschudi
Jazz Orchestra, December 1935
Linocut, originally intended to be printed
on cloth
Medium-thick off-white Asian paper
27.1 x 51.8 cm (10¹¹⁄₁₆ x 20⅜ in.)
Coppel LT 45
Edition: 24/50
Johanna and Leslie Garfield Collection

88 Lill Tschudi
Rhumba Band II, April 1936
Color linocut
Medium-thick light-cream Asian paper
26 x 28 cm (10¼ x 11 in.)
Coppel LT 48
Edition: 14/50
Johanna and Leslie Garfield Collection

89 Lill Tschudi
In the Circus, 1932
Color linocut
Thin light-cream Asian paper
24 x 26 cm (9⁷⁄₁₆ x 10¼ in.)
Coppel LT 23
Edition: 5/50, USA edition (1950)
Museum of Fine Arts, Boston,
George R. Nutter Fund, 1984.154

90 Cyril E. Power
'Appy 'Ampstead, about 1933
(Bank Holiday Fun Fair, Hampstead
Heath)
Color linocut
Very thin light-cream Asian paper
34.2 x 27.5 cm (13⁷⁄₁₆ x 10¹³⁄₁₆ in.)
Coppel CEP 36
Edition: Final specimen, Experimental
Proof 3 for an edition of 60
Museum of Fine Arts, Boston, Gift of
Leslie and Johanna Garfield in honor of
Barbara Stern Shapiro, 2002.809

91 Cyril E. Power
Acrobats, about 1933
(Bertram Mills Circus, London)
Color linocut
Very thin light-cream Asian paper
25.3 x 23.2 cm (9¹⁵⁄₁₆ x 9⅛ in.)
Coppel CEP 35
Edition: Experimental Proof printed in
red and blue
Johanna and Leslie Garfield Collection

92 Cyril E. Power
Acrobats, about 1933
(Bertram Mills Circus, London)
Color linocut, printed in red, ocher, and
blue-green
Very thin light-cream Asian paper
25.3 x 23.2 cm (9¹⁵⁄₁₆ x 9⅛ in.)
Coppel CEP 35
Edition: 10/60
Johanna and Leslie Garfield Collection

93 Cyril E. Power
Divertissement, about 1932
(Ballets Russes, London, late 1920s)
Color linocut
Very thin light-cream Asian paper
23.2 x 31.2 cm (9⅛ x 12⁵⁄₁₆ in.)
Coppel CEP 33
Edition: Experimental Proof 3, first state,
for an edition of 60
Johanna and Leslie Garfield Collection

94 Eileen Mayo
The Turkish Bath, 1928
Color linocut
Very thin off-white Asian paper
30.7 x 21 cm (12¹⁄₁₆ x 8¼ in.)
Edition: 30
Johanna and Leslie Garfield Collection

NATURAL FORCES

95 Claude Flight
Spring, 1926, from *The Four Seasons*
Color linocut
Very thin cream Asian paper
25.6 x 30.7 cm (10¹⁄₁₆ x 12¹⁄₁₆ in.)
Coppel CF 16
Edition: 1/50
Johanna and Leslie Garfield Collection

96 Sybil Andrews
Bathers, 1930
Color linocut
Very thin light-cream Asian paper
19.4 x 18.5 cm (7⅝ x 7⁵⁄₁₆ in.)
Coppel SA 7
Edition: Experimental Proof 2 for
an edition of 50 plus 10 proofs
Johanna and Leslie Garfield Collection

97 C. R. W. Nevinson
The Wave, 1917
Lithograph, printed in blue
Light-cream laid paper
34.6 x 42.8 cm (13⅝ x 16⅞ in.)
Leicester 66
Johanna and Leslie Garfield Collection

98 Sybil Andrews
The Gale, 1930
Color linocut
Very thin off-white Asian paper
21 x 24.4 cm (8¼ x 9⅝ in.)
Coppel SA 11
Edition: 36/50
Johanna and Leslie Garfield Collection

99 Sybil Andrews
Windmill, 1933
(Elmer's Mill, Woolpit, near Bury
St. Edmunds)
Color linocut
Medium-thick light-cream Asian paper
32 x 22 cm (13$\frac{3}{8}$ x 8$\frac{11}{16}$ in.)
Coppel SA 27
Edition: 49/60
Johanna and Leslie Garfield Collection

100 Sybil Andrews
Fall of the Leaf, 1934
Color linocut
Medium-thick light-cream Asian paper
36.5 x 25.8 cm (14$\frac{3}{8}$ x 10$\frac{3}{16}$ in.)
Coppel SA 30
Edition: Experimental Proof 3 for
an edition of 60 plus 10 proofs
Johanna and Leslie Garfield Collection

101 William Greengrass
Convolvulus (Morning Glory), 1937
Color linocut
Very thin white Asian paper
24.5 x 25.7 cm (9$\frac{5}{8}$ x 10$\frac{1}{8}$ in.)
Edition: 5/30
Johanna and Leslie Garfield Collection

LINOCUT:
HISTORY AND TECHNIQUE

102 Claude Flight
Boxed linocut tools and instructional
leaflet that accompanied *Lino-Cuts:
A Hand-Book of Linoleum-Cut Colour
Printing,* 1927 (U.S. edition, 1928)
Johanna and Leslie Garfield Collection

103 Claude Flight
*The Art and Craft of Lino Cutting and
Printing,* 1934
Illustrated manual
Published in London by B. T. Batsford
Johanna and Leslie Garfield Collection

104–107 Sybil Andrews
Four linoleum blocks for *Speedway*
(Coppel SA 29), 1934
104: 37 x 29.2 cm (14$\frac{9}{16}$ x 11$\frac{1}{2}$ in.)
105: 36.9 x 30.4 cm (14$\frac{1}{2}$ x 11$\frac{15}{16}$ in.)
106: 37.2 x 31.2 cm (14$\frac{5}{8}$ x 12$\frac{5}{16}$ in.)
107: 36.9 x 31 cm (14$\frac{1}{2}$ x 12$\frac{3}{16}$ in.)
Glenbow Museum, Calgary, Canada,
990.224.500a–d

108 Sybil Andrews
Speedway, 1934
Color linocut
Thin light-cream Asian paper
32.5 x 23.2 cm (12$\frac{3}{4}$ x 9$\frac{1}{8}$ in.)
Coppel SA 29
Edition: 46/60
Johanna and Leslie Garfield Collection
(not illustrated)

PHOTOGRAPHY CREDITS

All photographs are by Damon Beale and
the Imaging Studios, Museum of Fine
Arts, Boston, except for the following:

Cat. nos. 3, 8, 10, 13, 20, 21, 22, 26:
 Digital images © The British
 Museum, London
Cat. nos. 11, 12: Photos: Richard Caspole,
 Yale Center for British Art
Cat. nos. 1, 17, 19, 27, 42, 43, 75: Images
 © The Metropolitan Museum of Art
Cat. nos. 104–107: Collection of
 Glenbow Museum, Calgary, Canada
 [990.224.500 A–D]
Figs. 15, 16, 17, 18, 19, 23, 24:
 Photographs © Rachel Mustalish,
 Courtesy of The Metropolitan
 Museum of Art
Figs. 20, 22: Digital images © Glenbow
 Archives M-8411-138-p.38 and
 Glenbow Archives M-8411-138-p.13

Fig. 21: Photograph © Robert Goldman,
 Courtesy of The Metropolitan
 Museum of Art, Thomas J. Watson
 Library

COPYRIGHT CREDITS

All works by C. R. W. Nevinson are
 © Courtesy of the Nevinson Estate /
 Bridgeman Art Library.
All works by Cyril E. Power are Courtesy
 EB Power & Osborne Samuel Ltd.,
 London.
All works by Edward Wadsworth are
 © 2007 Artists Rights Society (ARS),
 New York / DACS, London.
Cat. nos. 4–5: © the artist's family
Cat. no. 13: © Simon Rendall for the
 Estate of E. McKnight Kauffer
Cat. nos. 20–21: © Tate, London 2007
Cat. no. 101: © 2007 Artists Rights
 Society (ARS), New York / DACS,
 London
Figs. 1–2: © 2007 Artists Rights Society
 (ARS), New York / SIAE, Rome
Fig. 3: © 1938 Artists Rights Society
 (ARS), New York / DACS, London
Fig. 9: © 2007 Estate of Pablo Picasso /
 Artists Rights Society (ARS),
 New York
Fig. 10: © The Munch Museum / The
 Munch-Ellingsen Group / Artists
 Rights Society (ARS), New York
Fig. 12: © 2007 Artists Rights Society
 (ARS), New York / VG Bild-Kunst,
 Bonn
Fig. 13: © 2007 Succession H. Matisse,
 Paris / Artists Rights Society (ARS),
 New York
Fig. 14: © 2007 Artists Rights Society
 (ARS), New York / VG Bild-Kunst,
 Bonn

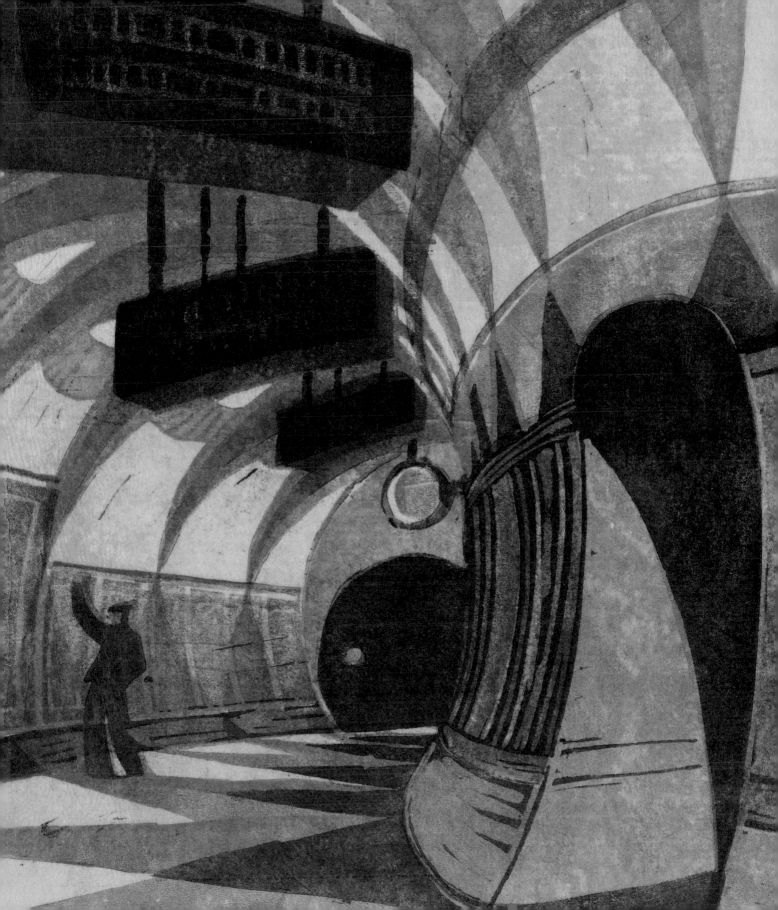

Black, Jonathan. *Edward Wadsworth: Form, Feeling and Calculation; The Complete Paintings and Drawings.* London: Philip Wilson Publishers, 2005.

Carey, Frances, Antony Griffiths, and Stephen Coppel. *Avant-Garde British Printmaking, 1914–1960.* Exh. cat. London: British Museum Publications, 1990.

Cole, Roger. *Burning to Speak: The Life and Art of Henri Gaudier Brzeska.* Oxford: Phaidon Press; New York: E. P. Dutton, 1978.

Coppel, Stephen. *Linocuts of the Machine Age: Claude Flight and the Grosvenor School.* Hants, England: Scolar Press in association with the National Gallery of Australia, 1995.

Corbett, David Peters, ed. *Wyndham Lewis and the Art of Modern War.* Cambridge, England: Cambridge University Press, 1998.

Cork, Richard. *A Bitter Truth: Avant-Garde Art and the Great War.* New Haven, CT, and London: Yale University Press in association with Barbican Art Gallery, 1994.

——. *David Bomberg.* Exh. cat. New Haven, CT, and London: Yale University Press, 1987. Published for an exhibition held at the Tate Gallery, London.

——. *Vorticism and Abstract Art in the First Machine Age.* 2 vols. Berkeley: University of California Press, 1976.

——. *Vorticism and Its Allies.* Exh. cat. London: Arts Council of Great Britain in association with Hayward Gallery, 1974.

d'Harnoncourt, Anne. *Futurism and the International Avant-Garde.* Exh. cat. Philadelphia: Philadelphia Museum of Art, 1980.

Dodgson, Campbell. "Leonard Beaumont." *The Print Collector's Quarterly* 20 (1933): 158–67.

Eates, Margot, ed. *Paul Nash: Paintings, Drawings and Illustrations.* London: Lund Humphries, 1948.

Edwards, Paul, ed. *Blast: Vorticism, 1914–1918.* Aldershot, England: Ashgate Publishing, 2000. Published in conjunction with an exhibition held at the Sprengel Museum, Hanover, 1996–97.

——. *Wyndham Lewis: Art and War.* Exh. cat. London: Wyndham Lewis Memorial Trust in association with Lund Humphries, 1992.

Flight, Claude. *The Art and Craft of Lino Cutting and Printing.* London: B. T. Batsford, 1934.

——. *Lino-Cuts: A Hand-Book of Linoleum-Cut Colour Printing.* London: J. Lane, The Bodley Head, 1927 (U.S. ed. New York: Dodd, Mead, 1928).

Greenwood, Jeremy. *The Graphic Work of Edward Wadsworth.* With an introduction by Richard Cork. Woodbridge, England: Wood Lea Press, 2002.

Hanson, Anne Coffin. *Severini futurista: 1912–1917.* Exh. cat. New Haven, CT: Yale University Press, 1995. Published for an exhibition held at Yale University Art Gallery and the Kimbell Art Museum, Fort Worth.

Haworth-Booth, Mark. *E. McKnight Kauffer: A Designer and His Public.* London: V&A Publications, 2005.

Humphreys, Richard. *Futurism.* Cambridge, England: Cambridge University Press, 1999.

Ingleby, Richard, Jonathan Black, David Cohen, and Gordon Cooke. *C. R. W. Nevinson: The Twentieth Century.* Exh. cat. London: Merrell Holberton in association with the Imperial War Museum, 1999.

Korazija-Magnaguagno, Eva. *Der moderne Holzschnitt in der Schweiz.* Zurich: Limmat, 1987.

Leicester Galleries at the Alpine Club Gallery. *Nash and Nevinson in War and Peace: The Graphic Work, 1914–1920.* Exh. cat. London: Ernest, Brown, and Phillips, 1977.

Mackean-Taylor, Margaret. *Eileen Mayo: Painter/Designer.* Exh. cat. Wellington, New Zealand: National Library of New Zealand, 1992.

Malvern, Sue. *Modern Art, Britain and the Great War: Witnessing, Testimony and Remembrance.* New Haven, CT: published for the Paul Mellon Centre for Studies in British Art by Yale University Press, 2004.

Nash, Paul. *Outline: An Autobiography and Other Writings.* With a preface by Herbert Read. London: Faber and Faber, 1949.

Nevinson, C. R. W. *Paint and Prejudice.* 1937; repr., New York: Harcourt, Brace, 1938.

Postan, Alexander. *The Complete Graphic Works of Paul Nash.* London: Secker and Warburg, 1973.

Salaman, Malcolm C. *Modern Masters of Etching: C. R. W. Nevinson.* London: The Studio, 1932.

———. *The Woodcut of To-Day at Home and Abroad.* Edited by Geoffrey Holme. London: The Studio, 1927.

Samuel, Gordon, and Nicola Penny. *The Cutting Edge of Modernity: Linocuts of the Grosvenor School.* Aldershot, England: Lund Humphries and Ashgate Publishing, 2002.

Severini, Gino. "Get the Inside Picture: Futurism as the Artist Sees It," *Daily Express* (London), April 11, 1913.

Urbanelli, Lora S. *The Grosvenor School: British Linocuts between the Wars.* Exh. cat. Providence: Museum of Art, Rhode Island School of Design, 1988.

Wadsworth, Barbara. *Edward Wadsworth: A Painter's Life.* Wilton, England: Michael Russell, 1989.

Walsh, Michael J. K. *C. R. W. Nevinson: This Cult of Violence.* New Haven, CT: published for the Paul Mellon Centre for British Studies by Yale University Press, 2002.

White, Peter. *Sybil Andrews: Color Linocuts.* Exh. cat. Calgary, Canada: Glenbow Museum, 1982.

MFA PUBLICATIONS
Museum of Fine Arts, Boston
465 Huntington Avenue
Boston, Massachusetts 02115
www.mfa-publications.org

This book was published in conjunction
with the exhibition "Rhythms of Modern
Life: British Prints, 1914–1939,"
organized by the Museum of Fine
Arts, Boston, and the Metropolitan
Museum of Art.

Museum of Fine Arts, Boston
January 30–June 1, 2008

The Metropolitan Museum of Art
September 23–December 7, 2008

The Wolfsonian-Florida
International University
November 21, 2009–February 28, 2010

For a complete listing of MFA
Publications, please contact the
publisher at the above address,
or call 617 369 3438.

Front cover: Cyril E. Power,
The Merry-Go-Round (cat. no. 36, detail)

Back cover: C. R. W. Nevinson,
Banking at 4000 Feet (cat. no. 23, detail)

Trade distribution:
Distributed Art Publishers / D.A.P.
155 Sixth Avenue, 2nd floor
New York, New York 10013
Tel. 212 627 1999 Fax 212 627 9484

FIRST EDITION

PRINTED IN ITALY

This book was printed on acid-free paper.

MANUSCRIPT EDITED BY SARAH MCGAUGHEY TREMBLAY | COPYEDITED BY JODI M. SIMPSON

PRODUCED BY TERRY MCAWEENEY | DESIGNED BY SUSAN MARSH

TYPE COMPOSED IN DIN 1451 BY DUKE & COMPANY | PRINTED AND BOUND AT GRAPHICOM, VERONA, ITALY